Kiah Museum Day of Remembrance

Savannah Georgia

The Quilting Exhibition Catalog

Presented by the CFSAADMC
The Center for the Study of African & African Diaspora Museums and Communities

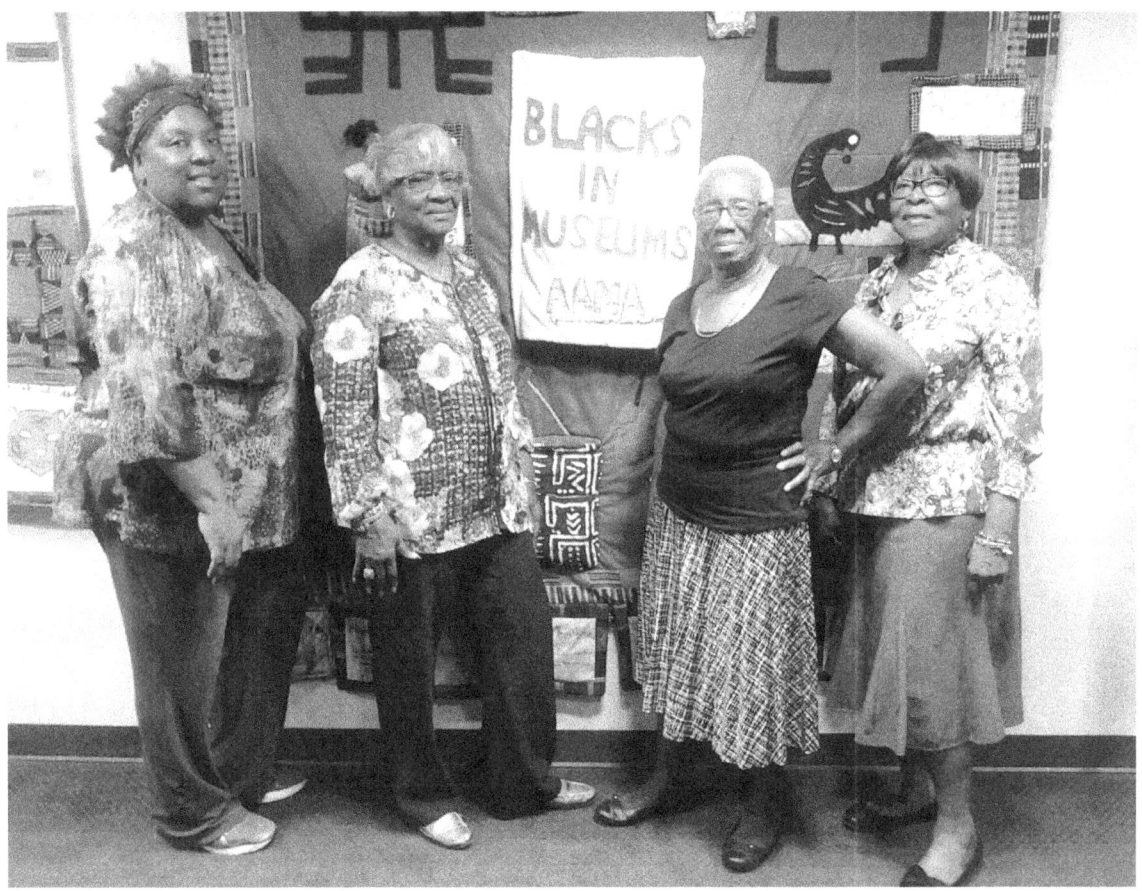

Compiled by Deborah Johnson-Simon, Ph.D., Tina Hicks, and Sauda Mitchell

Copyright© 2017 by **CFSAADMC**
The Center for the Study of African and African Diaspora Museums and Communities, Inc.
P.O. Box 5261
Savannah, GA 31414

The CFSAADMC 1983 Family Reunion Exhibition

Planning Committee

CFSAADMC: Hue Man Research Institute for African Diaspora Museum Anthropology
Damion Wynn—President

CFSAADMC: Collections Archival Management
Sauda Mitchell

CFSAADMC: Georgia Network of African American Museums
Jacqueline Spears

CFSAADMC: Research Institute for African Diaspora Museum Studies
Dashana Lane

Beach Institute
Darlene Wilson

Hudson Hill Golden Age
Tina Hicks—Quilts Curator

Mary Flournoy Golden Age
Deborah Anthony—Quilts Coordinator

Carver Village
Coach Lee Miller—Carver Village Kiah Kids Coordinator

Savannah State University
Dr. Christina Davis
Kai Walker
Winifred Mincey

Savannah Economic Opportunity Authority (EOA)
John Finney - Kiah Stories Coordinator
Patricia Howard - Quilts Coordinator

St. James AME Church
Sadie Williams - Quilts Coordinator
Salathia A. White - Quilts Coordinator

Mt. Zion AME Church
Sealey Hooker- Quilts Coordinator

Greater Gaines AME Church
Betty Johnson - Quilts Coordinator

First Bryan Baptist Church
Patricia Beaton - Quilts Coordinator
Eunice Feagin - Quilts Coordinator
Sabrina Wright - Quilts Coordinator

Asbury United Methodist Church
Henrietta Taylor - Kiah Stories Coordinator
Mildred Hall - Kiah Stories Coordinator
Vincent Hamilton - Kiah Stories Coordinator

City of Savannah Research Library & Municipal Archives
Luciana Spracher, Director

Live Oak Public Library Bull Street
Brenda Poku - Exhibition Coordinator
Alisha Boyd
Naftal Jahannes

Special Editorial Team
Tina Hicks
Clara Elmore Bain
Sauda Mitchell

Exhibition Photographers
John and Eunice Feagin
Dr. Deborah Johnson-Simon
Terrance Grasty
Latonya Hicks

In Loving Memory

 # Leona A. Williams

October 13, 1921 to September 14, 2014

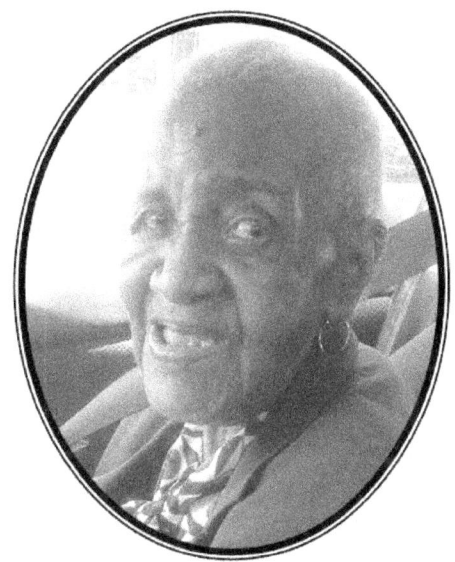

If roses grow in Heaven,
Lord please pick a bunch for me.
Place them in my Mother's arms
and tell her they're from me.

Tell her I love her and miss her,
and when she turns to smile,
place a kiss upon her cheek
and hold her for a while.

Because remembering her is easy,
I do it every day;
but there's an ache within my heart
that will never go away.

Letter from William Billingsley

AAAM Retired Executive Director

Deborah

I am extremely proud of the work you and your team(s) have done with this loving and much needed historical project. If Margaret Burroughs and Charles Wright were still alive, I know that they both would truly be there to honor the fact that you have supported the organization(s) and friends(s) that we have full "heartedly" believed in.
And you my friend, Dr. Deborah Johnson-Simon, please note that I am so sorry that I am not able (health wise) to join you during this wonderful experience of honoring and bringing this exciting structure to the history of the African American Museum World.
Lastly, I am extremely pleased and proud to see how the beautiful and talented women of the "Hudson Hill Golden Age Quilting Team" have come together to support the Savannah State University students from your Introduction to Anthropology Class as well as your CFSAADMC members' and supporters of the "Kiah Museum Day of Remembrance".
Well as usual, I am still talking a little too much. But, Deb, although we tend to forget that the love and respect for the recovery of our life history doesn't always come as a result of just getting/receiving the knowledge from a book or a piece of paper; but rather the ability to recognizing and appreciating the hard work of great educators like you and your team(s) have done to recover the structure and experience of the African American Museum Association History.

Thanks to all,

Friend and Colleague—William (BB) Billingsley

About the Blacks in Museums Research Project
The 1983 Blacks in Museum Reunion Quilt Exhibit Message

I have recently discovered that the museums that I research and the museum professionals who work in them have become my family. I think that my museum families are a lot like quilts. They have layers. The 1st layer is the family of choice. I connected with them at the annual conferences of AAMA, exchanged information and found that someone was always a phone call away from me. It's the people that you pick out of this world of museum professionals and you find that they are stitched together and are as different in outlook and experience as patches in a quilt. Piecing it all together and figuring out how all the pieces fit together takes time and patience. But if you stick with it, before long you will have put together something unique but sturdy that keeps you covered and makes life lovely. That's exactly what I think of John Harmon of White Plains, New York, (now deceased), who came to a planning meeting for the historical society I was developing in Orlando even though we had no money and he was suffering with Parkinson's disease. There was also Joan Maynard who was engaged in the historical preservation of Weeksville in Brooklyn NY. Then there was Bertha Calloway who started the Great Plains Black Heritage Museum in Omaha, NE, who made sure I had materials on all that they were doing with their museum projects. They sincerely wanted me to become knowledgeable about the profession. When I think about family I also think about Bernard Johnson in Los Angeles, and Dr. Harry Robinson II in Dallas, TX, who encouraged me to always attend AAAM because it's family. I would be remiss if I forget to mention John W. Franklin who took me under his wing when I was working on my Master's thesis and circulated my list to people I needed to interview for *Culture Keepers*. There's Gabriel Tenabe at Morgan State University who conceptualized the Blacks in Museums Family Reunion and agreed to partner with me because he says we are long overdue in honoring our pioneers of this work. Had I searched the world over for my pick of sisters and brothers I couldn't have found any better.

Then there's the 2nd layer of this family reunion quilt, my extended family and my kindred who are those who have elected to support the work of the Research Institute. People like you. You are the kind of fabric that comes all in a piece, with the backing of the whole cloth that is delicately stitched into a space that can contain memory because you have made it possible for us at the Research Institute to be the Keepers of the Culture, creating exhibitions that are patterns that stay within visitor memories for a whole lifetime. The colors and designs may vary, and the levels of support are not always to our liking, but I've discovered every level of support serves its purpose. Without a good backing your quilt's stuffing falls out. What this extended family does makes it possible to continue to do what we do even if we must adjust it a little, maybe even take out a few stitches and take the design in a new direction. A three-strand thread of love for our Black museum family, honesty about what you need to see us do, and forgiveness when we don't always live up to your expectations, goes a long way in evening mismatched seams and quilting out the bumps. That's what the CFSAADMC family has been doing this last year: stitching it all together, joining all the layers one to another, making them fit as we try to put faces on our 1983 Blacks in Museums pioneers. We're creating a Memory Quilt that's something that will last. I love having a big family. Save the date **September 9, 2016** and be a part of the 1983 Blacks in Museums Reunion Quilt Exhibition Day.

For Love of Family
Deborah
Dr. Deborah Johnson-Simon
CFSAADMC Founder and CEO

The Proclamation
Proclaiming September 9, 2016 as
AAMA 1983 Blacks in Museums Day of Recognition
And
Kiah Museum Day of Remembrance

Whereas, September 9th represents the official date the Association for the Study of African American Life and History (ASALH) the Savannah organization that produced three African American museums under the leadership of Wesley Wallace Law as well as the Negro Heritage Trail and significant historic preservation efforts in Savannah that will be the focus during the week of September 19-23, and

Whereas, in 1959 Dr. Calvin L. Kiah a Dean at Savannah State College, and his wife Virginia opened the first museum in Savannah operated by African Americans and in 1974 were recognized as one of the Reader's Digest Treasures of America, and

Whereas, 1983 marks a significant publication of Black professionals involved in the African American Museum Movement. It was titled "**Blacks in Museums**". The African American Museum Association (AAMA) was the first network to create a directory that represented over 300 professionals including Virginia Jackson Kiah and the Kiah Museum the only museum listed in Savannah, and

Whereas, the history of this organization of the early Black museum movement offers an opportunity for students and others to reflect on the stories surrounding the Blacks in Museums and their pioneering as Culture Keepers, and

Whereas, we the people of the City of Savannah should always remember the terrible events of slavery and the triumphs of the Civil Rights Movement and remain vigilant against hatred, persecution, and tyranny and know that African American museum professionals have been actively caring for this history and protecting this legacy through the creation of programs and exhibitions, and

Whereas, the stories of these Culture Keepers are rarely told in museum studies and other degree programs; the study of these individuals that has begun to take place needs to be showcased and who better than those who are our artist and craft people, and

Whereas, the Day of Remembrance has been set aside for the people of the City of Savannah to remember the participants of the 1983 Blacks in Museum Directory and specifically the Kiah Museum of Savannah, and

Whereas, the CFSAADMC youth division known as the CFSAADMC-Hue-Man Research Institute and the Friends of the Kiah Museum in partnership with the Hudson Hill Golden Age quilters has set aside Friday, September 9, 2016, designates this day as its official Day of Remembrance for the Kiah Museum in Savannah and the AAMA 1983 Blacks in Museums Day of Recognition

Now, therefore, I Eddie DeLoach, Mayor of the City of Savannah, do hereby proclaim Friday, September 9, 2016 as the Kiah Museum Day of Remembrance and the AAMA 1983 Blacks in Museums Day of Recognition.

Contents

Acknowledgments ………………………………………………….. 10

About the CFSAADMC ……………………………………………. 11

Meet the Hue-Man Research Team……………………………….. 12

Meet the Hudson Hill Golden Age Girls …………………………… 17

Getting Ready for the Show…………………………………….… 28
 Hudson Hill and CFSAAADMC Hue-Man

Quilt Stories……………………………………………………….… 43
 St. James AME Church
 Greater Gaines Chapel AME Church
 First Bryan Baptist Church
 Mt. Zion Baptist Church
 Mary Flournoy Golden Age Center

AAMA Blacks in Museums Day of Recognition………………….136
 Savannah State University

Kiah Museum Day of Remembrance………………………………150
 The Beach Institute
 Hudson Hill and Hue-Man do Juneteenth
 Carver Village Kiah Kids
 Asbury United Methodist Church
 Live Oak Bull Street Library
 Wreath Ceremony Hillcrest Abby East

The Folks Who Made It Happen………………..……………….210

Acknowledgments
Special Thanks and Appreciation

The CFSAADMC board members contributed much time and advice from the planning stages to the day of Recognition and Remembrance on September 9, 2016. Mr. Gabriel S. Tenabe, Director of Museums Morgan State University, and Chair of the CFSAADMC Board of Advisors conceptualize this event in 2011 when we introduced the research on the AAMA 1983 "Blacks in Museums Directory" at an AAAM panel session during the Annual Meeting in Tallahassee, Florida. Board members Tim and Catherine Williams, Family Representatives of Leona A. Williams our founding board member and staunch supporter, deserve special appreciation for the lovely page they created in her honor. Thanks to Jackie Spears a CFSAADMC supporter through thick and thin. We are indebted to the members of the Calvin L and Virginia Jackson Kiah family for their support with family stories of the founders of the Kiah Museum in Savannah: Ret. Senator Michael Mitchell, Keiffer Mitchell, Jr., Lyndsey Kiah, Gregory Kiah,

 Savannah Churches provided exhibition sites in the creation of a quilt heritage trail for our special day of recognition in Savannah. Our thanks and appreciation to Rev Doreen Smalls - Asbury United Methodist Church, Rev. Will Thomas - Greater Gaines AME Church, Rev. Chekibe Holmon - St. James AME Church, Pastor Aaron James - First Bryan Baptist Church, and Pastor Michael Champs - Mt. Zion Baptist Church. It would have been impossible to have the day that we envisioned without the following supporters at the Community Centers in Savannah who opened their facilities for us to present the project to their constituents, so please know that we couldn't have done it without you: Barry Baker - Director Parks and Recreation Services, City of Savannah, Nicole Fuller - Golden Age Coordinator, City of Savannah, Carver Village Recreation Center, Mary Flournoy Golden Age, and Hudson Hill Golden Age.

 Students' research of the 1983 Blacks in Museums Directory was enthusiastically encouraged by administrators, faculty and staff at Savannah State University. Thank you wholeheartedly, Dr. Cheryl Davenport Dozier, President, Dr. Julius Scipio—Interim Dean, CLASS, Dr. Sametria McFall Dickerson-Assistant Dean CLASS, Dr. Peggy Blood, Dr. Richie D. W. Smalls Reed, Dr. Amir Jamal Toure, Dr. Otilia Iancu, Dr. LaRhonda Odom, and Mrs. Amelia Baker Savannah Community Quilt Exhibition Supporters who opened their hearts, their cedar chests, went into their attics and basements for family quilts, photographs of quilters, shared memories of Savannah Culture Keepers W. W. Law and Virginia Kiah, it's because of you we were able to see those things that were precious to you and the history of the Black Experience hidden in Savannah and more importantly that you cared about Blacks in Museums. We are Family, Gracie Brown, Carolyn Davis, John Feagin (photographer), Patricia K. Glover and Mikell Glover, LaTonya Hicks, Theodosia Johnston, Mattie Jones, Gloria McKine, Gloria Williams, President Cuyler Brownville Neighborhood Association, Deana Miles, Jackie Mungroo, Mary Scott, Mary Simmons, Israel Small, Dorris Weaver, and Frank Wright.

About The CFSAADMC

By Alexandrea Vereen

Savannah State University Independent Study Student (China Study Abroad 2015)

CFSAADMC stands for The Center for the Study of African and African Diaspora Museums and Communities. This collective of anthropologists and others use museum anthropology to study different perspectives of the African Diaspora. It is the first and only institute of its kind. Its sole purpose is to research and disseminate information about African and African Diaspora museums and their communities.

There are four distinct departments within the CFSAADMC which include; The Friends of the Kiah House Museum, The Georgia Network of African American Museums, The African Diaspora Children Museum of Anthropology, and The Research Institute for African Diaspora Museum Studies. Each department has its very own missions and objectives correlated to their research initiatives.

The Friends of the Kiah House Museum aims to preserve the Kiah House Museum and to strengthen the Cuyler/Brownville Neighborhood through community revitalization and economic development. The Georgia Network of African American Museums (GNAAM) aims to enhance the museums ability to serve the public interest and address needs of Georgia's African American museums. The Research Institute for African Diaspora Museum Studies functions as a research lab whose job is to document museums, and the history and culture of these museums in the communities they serve. Lastly, the African Diaspora Children's Museum of Anthropology or ADCMA will provide traveling and museum in the classroom exhibitions for children on the African Diaspora utilizing the four subfields of anthropology.

Meet the Hue-Man Research Team

Always remember the past for therein lies the future, if forgotten...we are destined to repeat it

The Hue-Man Research Institute for Museum Anthropology

CFSAADMC

Mission: To illuminate the core values that guided the historical misconception that Black Museums are primitive and to advance these values as part of educating society about the history of African and African Diaspora Museums and communities

Vision: To educate, acknowledge, and preserve history of Black Museums worldwide.

On February 22, 2016 Damion Wynn, Clay Hodges, Derrick Williams, Tori Becks Shiraya Robbs, Ngozi Obata, and Jermecia Davis former students (except Shiraya Robbs) of Dr. Deborah Johnson-Simon came together at the Gordon Library on the campus of Savannah State University to officially form an organization they conceptualized in the Introduction to Anthropology. They adopted the colors of red black green and gold representative of African Nationalism presented by Clay Hodges. Tori Becks was asked to create the log after the group researched a range of Adrinka symbols and finally selecting the Sankofa. A slate of officers was presented and voted in at the following meeting: Damion Wynn, President, Shiraya Robbs, Vice President, Jermecia Davis, Secretary, and Derrick Williams, Treasurer. The students were charged with coming up with a name that would be representative of a youth organization that would continue the programs they learned about while taking the anthropology class. Not only were they introduced to field of anthropology but learned about the African American pioneers in anthropology and how there are so few Black anthropologist who study Black museums. The team that Damion Wynn, Jermecia Davis and Ngozi Obata researched the Blacks in Museums Directory category of Development Specialist where they learned about the work of Emma Jones who agreed to be one of the featured speakers for the special celebration on September 9, 2016. It was Jermecia Davis who suggested that the name for the youth research team should use a combination of Blacks in anthropology. They then decided on Hue for the shades of African Descended Peoples and "anthro" which means man or humankind. They officially voted to become the Hue—Man Research Institute for Museum Anthropology on February 29, 2016. They continue to work on special projects to support the work of the CFSAADMC.

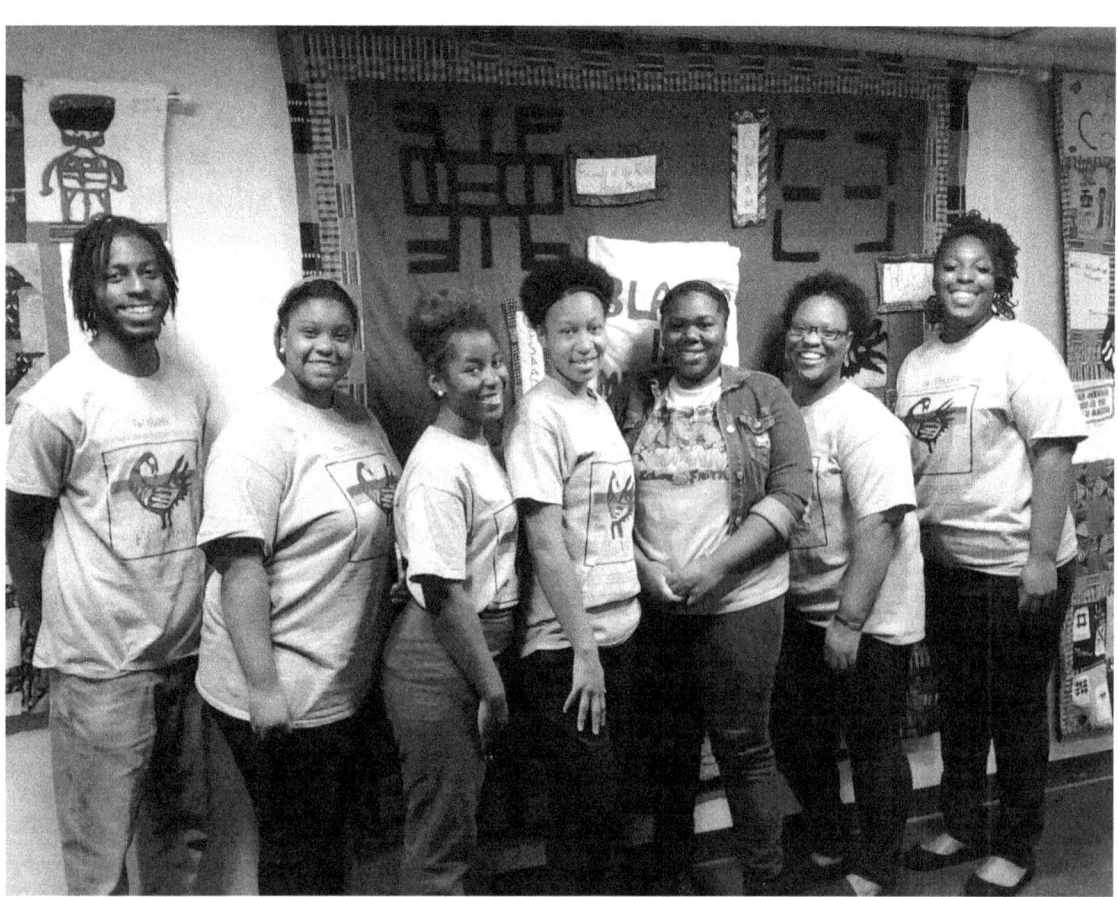

(L-R Damion Wynn, Mia Woodson, Jasmine McCray, Shiraya Robb, Tori Becks, Wilkeata Brown and LaTonya Hicks)

(L-R Damion Wynn, Jasmine McCray, Jermecia)

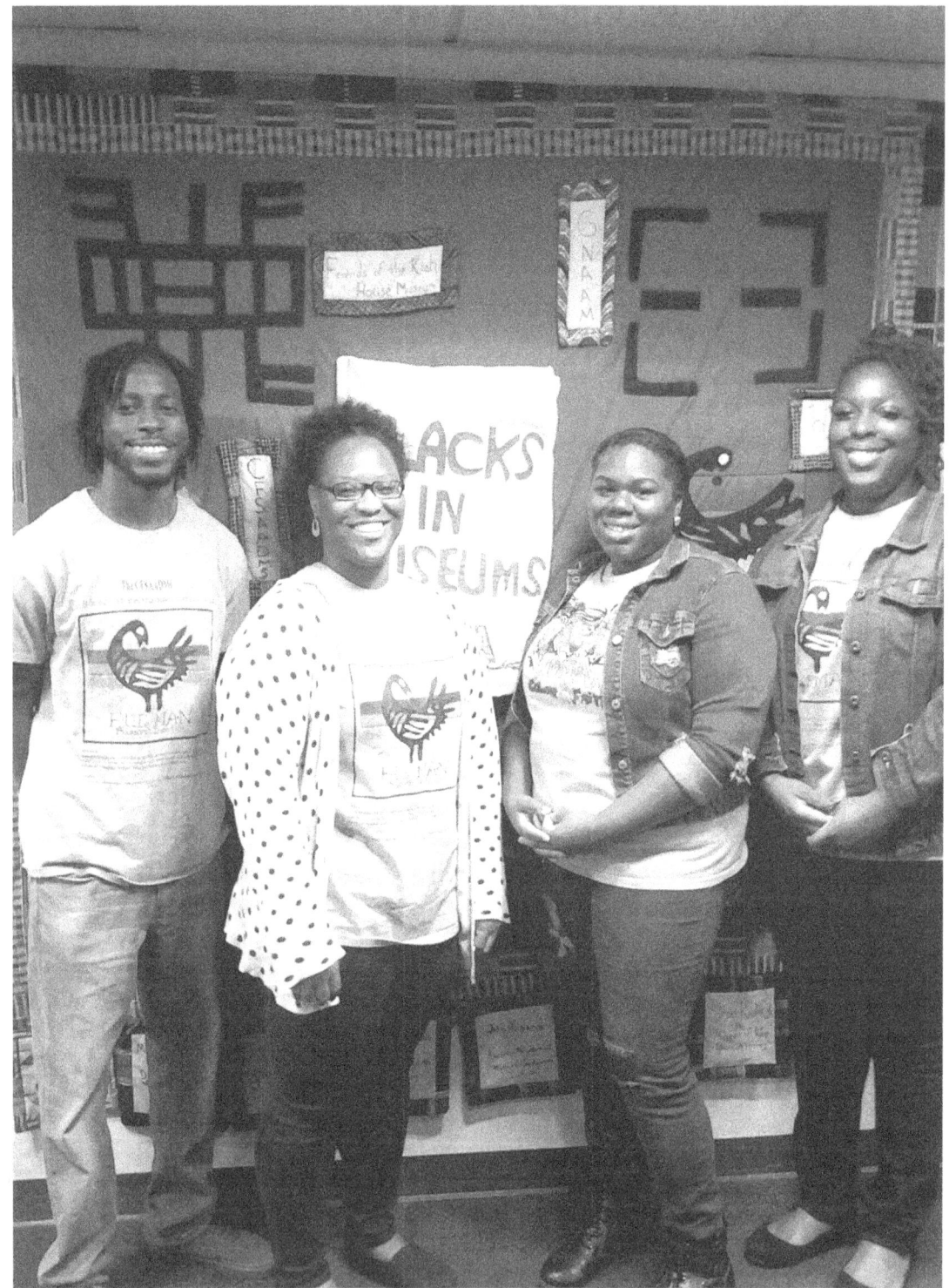
(L-R Damion Wynn, Wilkeata Brown, Tori Becks, LaTonya Hicks)

Meet the Hudson Hill Golden Age Girls

Patricia Beaton
Patricia Beaton is a 1965 graduate of Beach High School. She is a retired baker and cake decorator and a seamstress specializing in window treatments. She has been a member for 50 years at First Bryan Baptist (Yamacraw), where she serves as an usher. In the 1990's she was a Community Organizer for EOA, and Summer Camp Leader at the Salvation Army. She was involved in the "Weave a Dream Crazy Quilt Project" with the City of Savannah Cultural Affairs, and a 2010 participant in the "Beloved Community Quilt Project" where she shared stories about the neighborhood she lived in as a child, and a story quilt was made that she named, " Neighborhoods"

Ruth Brown
Mrs. Brown learned to quilt from her mother, Mrs. Catherine Sullivan. Mrs. Brown recalls as a young woman her father built a quilting frame and put it under the carport. When her mother put the quilt together on the quilting frame, Mrs. Brown and her sisters would sit around the frame and start quilting. It would take them one day to finish quilting a quilt. Mrs. Brown gained a love of quilting from her mother that continues to this day.

Eunice L. Jefferson Feagin
Eunice Feagin is a Savannah native who grew up in Yamacraw. I began sewing at seven years old. My uncle, Willie White, was a tailor, and taught me how to sew. I continued to sew in high school where I advanced my skill. I am a 1970 graduate of Beach High School. I often would sew for my clients at the Department of Family and Children's Services. After retirement I joined the Hudson Hill Golden Age Center. I continue to make quilts, and other beautiful items.

Tina Hicks

I see the world as a place where I can create, the beauty of my surroundings with a rainbow of fabrics. The stories that crown my head fill me with creative power. The saying "Do something you have never before" leads me like my mother's voice.
1981 graduate Groves High School
1982 - 1984 attended Armstrong State College
2004, Employed by the City of Savannah as a Recreation Leader for Golden Age,
Teaching a Quilting, Crocheting, and a variety of crafts, Beginner Computer Class.
Hudson Hill Golden Age became my permanent assignment in 2005.
2010, led seniors at Hudson Hill to participate in Loop it Up Savannah "Beloved Community Story Quilt Project ".

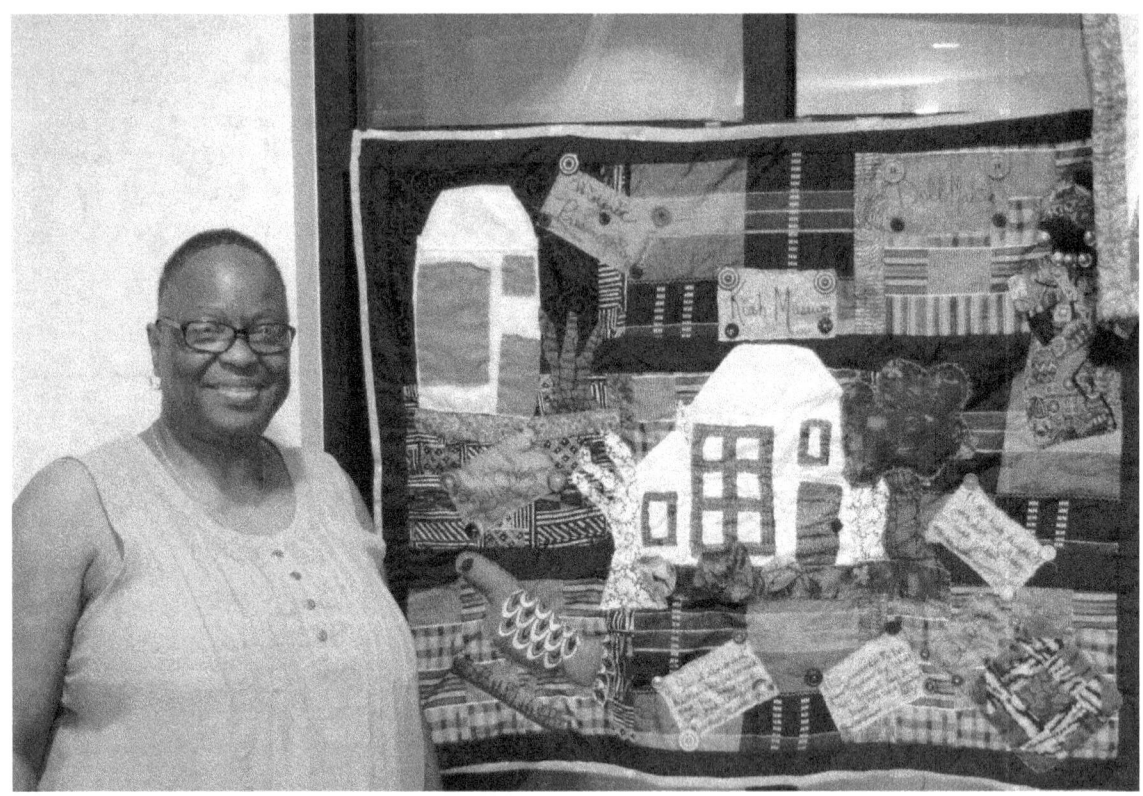

Patricia Howard

Mrs. Patricia Howard, 1968 graduate Thompkins High School, retired from the City of Thunderbolt, 2002. She was instrumental in organizing a group called "Grandmother's Elite". The group formed to assist in providing affordable family vacations, and to assist grandmothers caring for grandchildren. Mrs. Howard currently serves as the treasurer for the group and has been a member for 14 years. After retirement, Mrs. Howard joined the Golden Age Center and made her first quilt, she says, "I am working for me now".

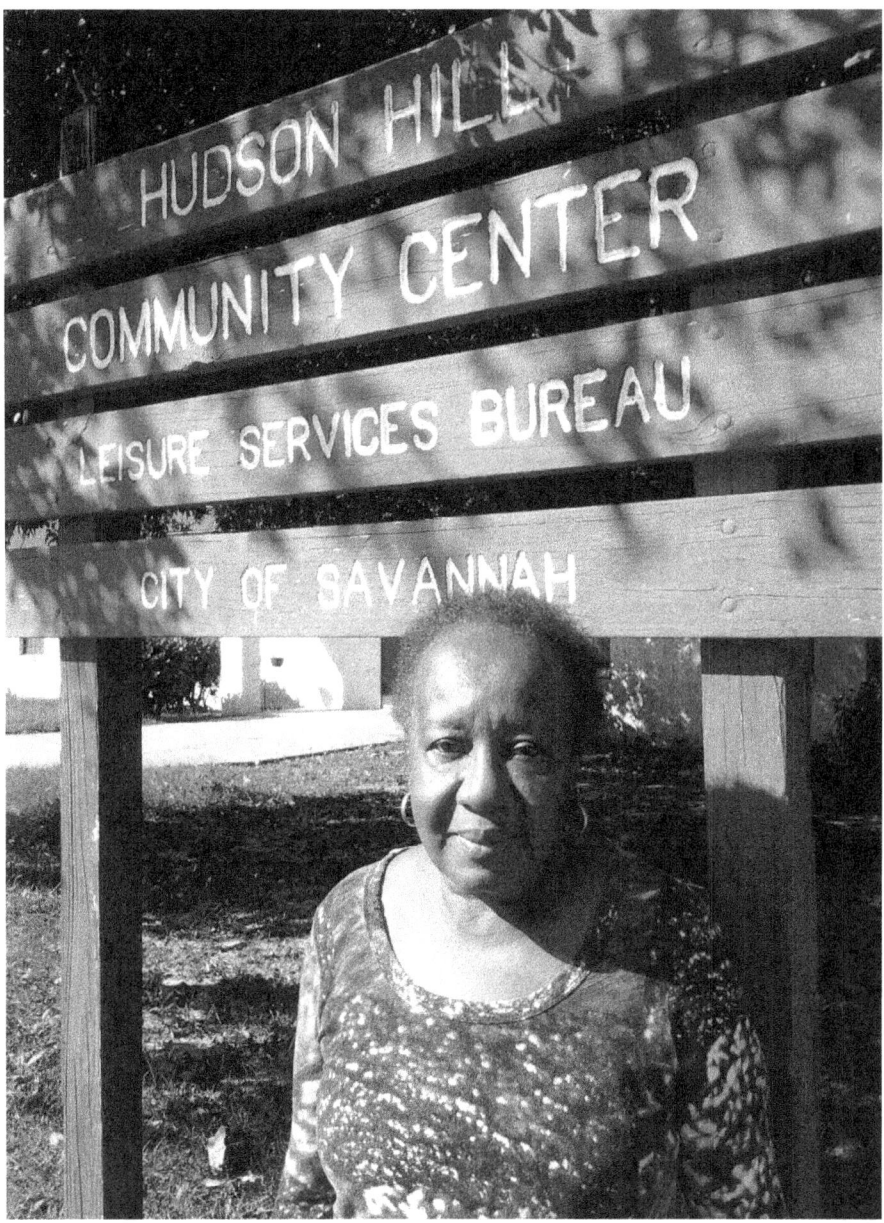

Rebecca Johnson

Mrs. Johnson made her first quilt at Hudson Hill Golden Age Center; "The Monkey Wrench". Mrs. Johnson grew up watching her grandmother make quilts. The quilt she is most proud of is her "Family Reunion Quilt". The family is very proud of it too and it has made a special appearance at several family reunions. Since becoming a part of the Hudson Hill family Mrs. Johnson has made quilts for all of her grandchildren.

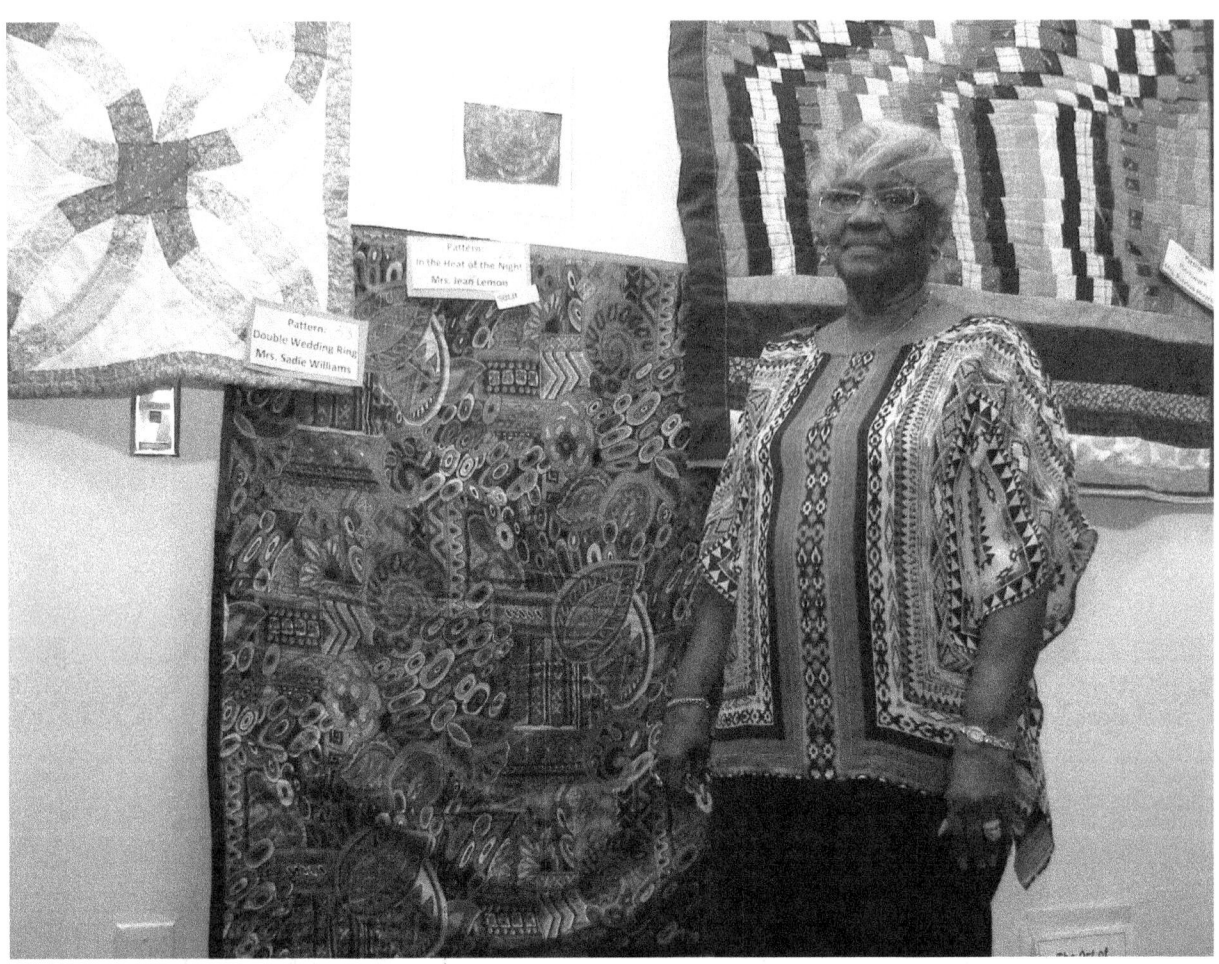

Jean Williams-Lemon

Mrs. Lemon is a 1961 graduate of Sophronia Tompkins High School. She retired from the Board of Education. She made her first quilt after becoming a member of Hudson Hill Golden Age. Then she started making beautiful baby quilts. She has a passion for flower arranging, wedding bouquets, and beautiful table centerpieces. She is known for decorating for many events for family and friends. She also makes aprons for all occasions especially holidays. All of her items are sewn with style.

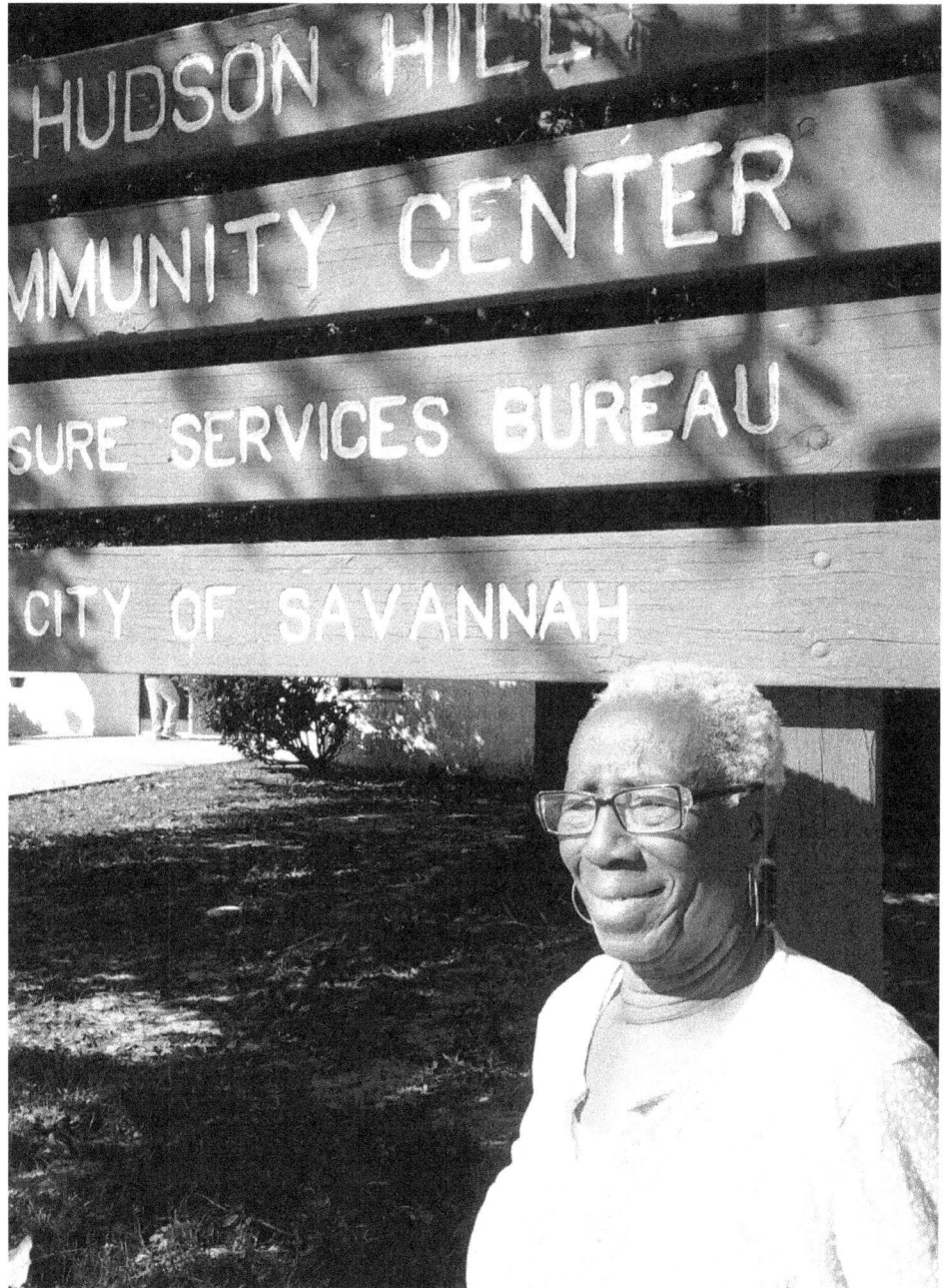

Sadie Williams

Ms. Sadie is a native Hilton Head S.C., who moved to Savannah GA in the mid 1950's. She is a 1955 graduate of Beach High School. She retired from Candler Hospital in 1993 after 26 years of service. After retirement she joined the Golden Age Center, making many quilts. She is known for the technique of "Tailor Tacking". She was a 2010 participant in the "Beloved Community Quilt Project ". She told the children stories about the hard times growing up when she was a girl, "Hard Times" story quilt was made. This year, 2016 Mrs. Williams made the Saint James A.M.E Church 150th Church Anniversary Quilt. This quilt was made at the Golden Age Center. Mrs. Williams is a long-time member of Saint James A.M.E Church.

Marie Wright

Mrs. Wright made her first quilt in 1998. It was "The Cathedral Quilt". She was very proud of the quilt and embraced all opportunities to show the quilt to all who came to visit. When she joined the Hudson Hill Golden Age, she made her second "Cathedral Quilt". She's added quilted handbags, boro quilts, and t-shirt quilts to her repertoire. She now boasts that she's made quilts for most of her eight children.

Sabrina Ware Wright

Sabrina is a Savannah native, and grew up in the Woodville Community in West Savannah.
I began sewing at an early age. I was six years old when my sister and I began making pillows for my grandmother and, I made doll clothes. In High School my love for sewing began. I attended Sophronia Tompkins High School. I made all my clothes. I would also sew for friends and family. Later on as years passed I began to quilt. I find quilting to be very relaxing, and fulfilling.

Getting Ready for the Show
Hudson Hill Golden Age Center

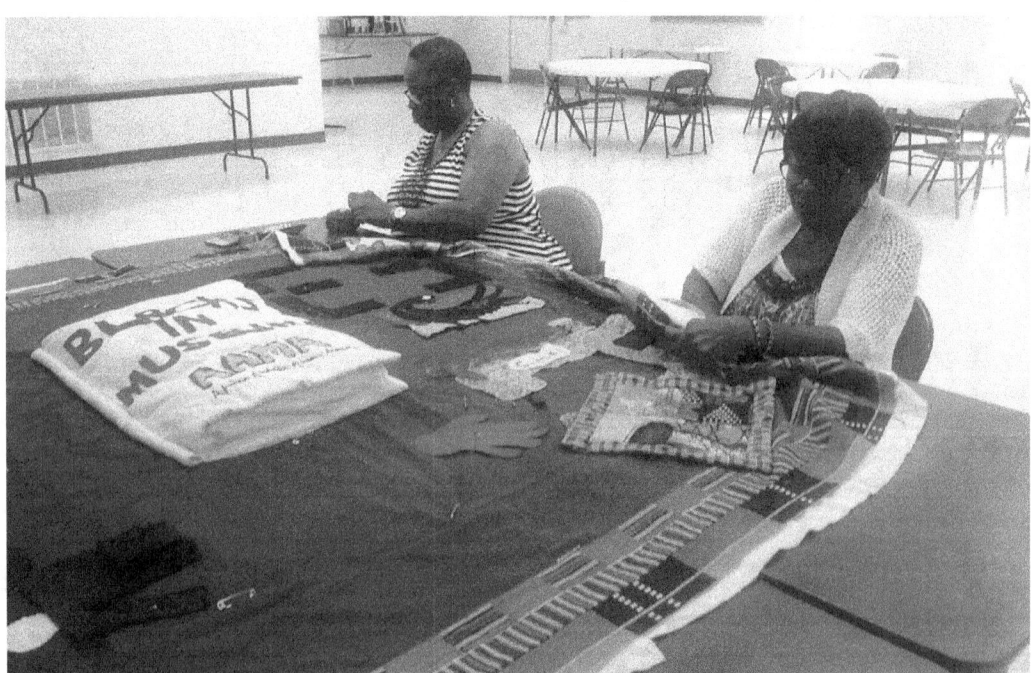

Hudson Hill Golden Age Getting Ready for the Show

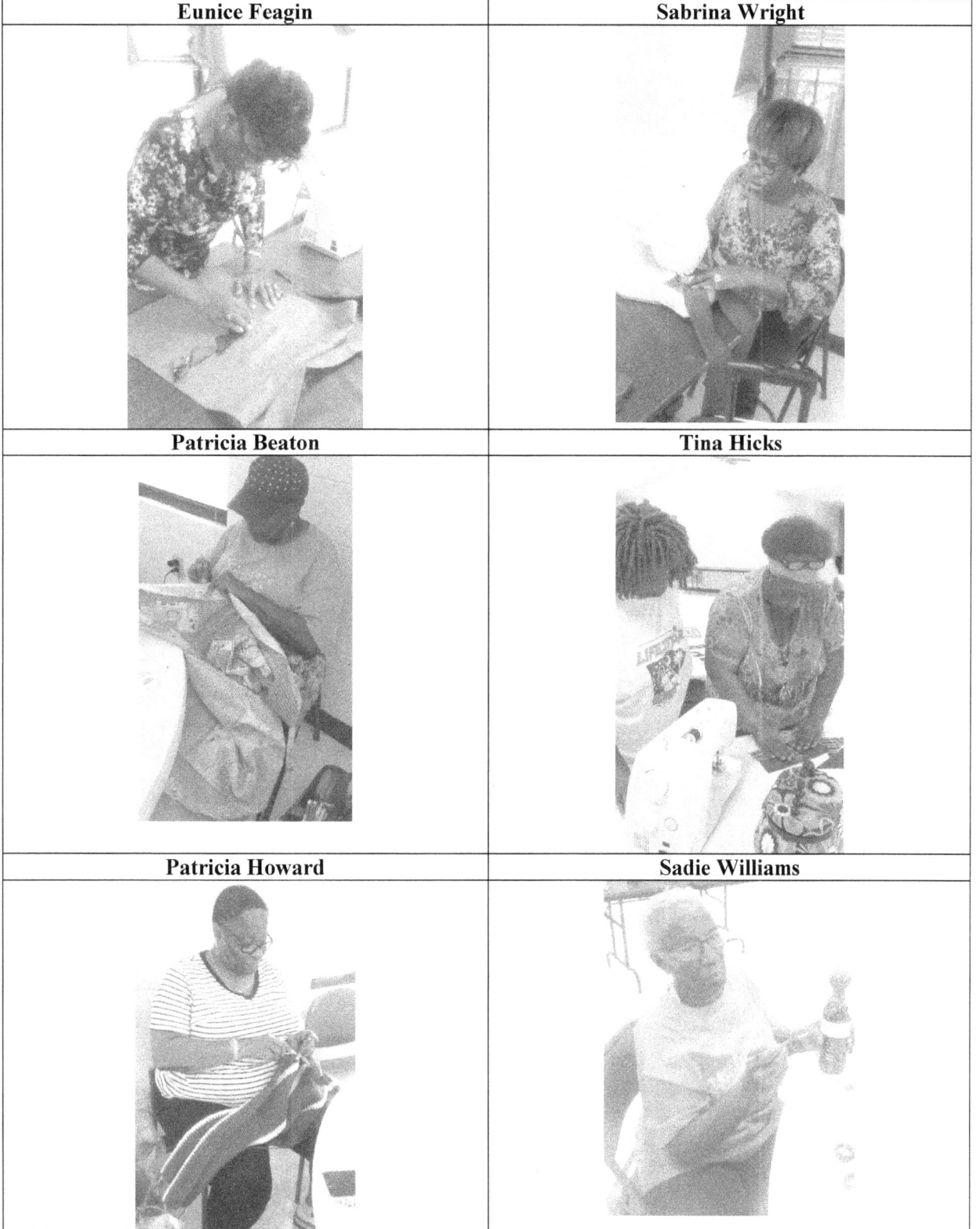

Eunice Feagin	Sabrina Wright
Patricia Beaton	Tina Hicks
Patricia Howard	Sadie Williams

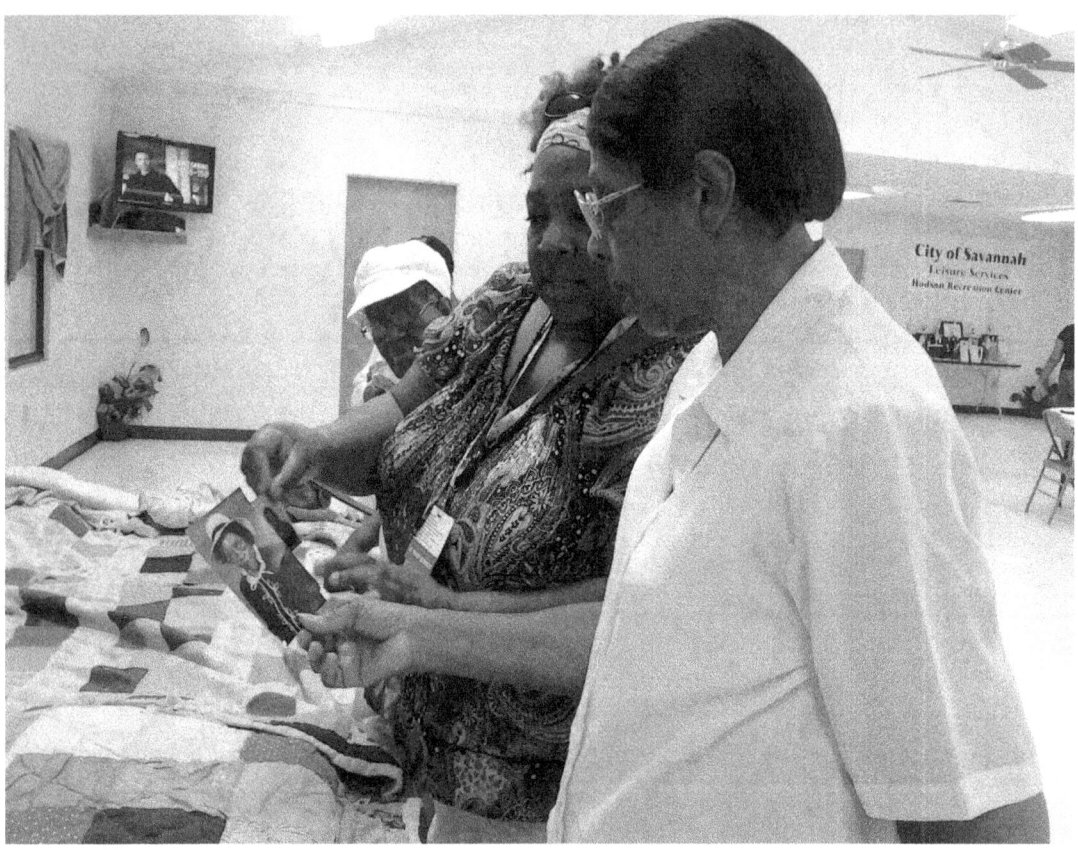

Selecting quilts and getting the stories that go with them was a big part of preparing for the show. After the participating churches would put something about the show in their bulletin or an announcement was made during Sunday service people were encouraged to drop off their quilts

(L-R) Patricia Beaton, Rebecca Johnson, Marie Wright, Jean Lemon, and Tina Hicks
The announcement was made during Sunday service at First Bryan Baptist Church and the ladies got to work on the first quilt story.

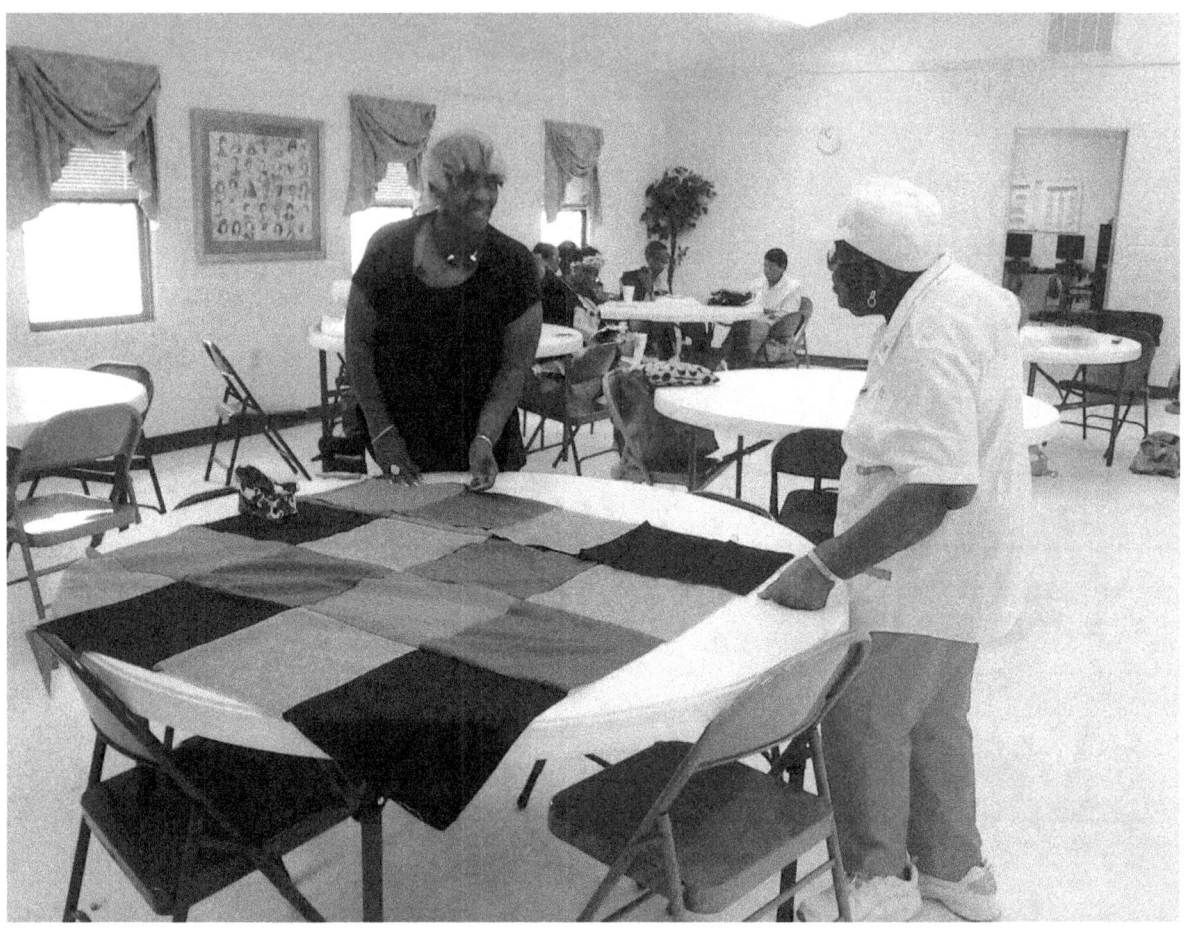

In addition to taking in quilts for the show the ladies were also working on special quilts of their own. Jean Lemon consults with Marie Wright about a quilt she is designing in memory of Kiah Museum co-founder and Savannah State College Dean of Education, Dr. Calvin L. Kiah.

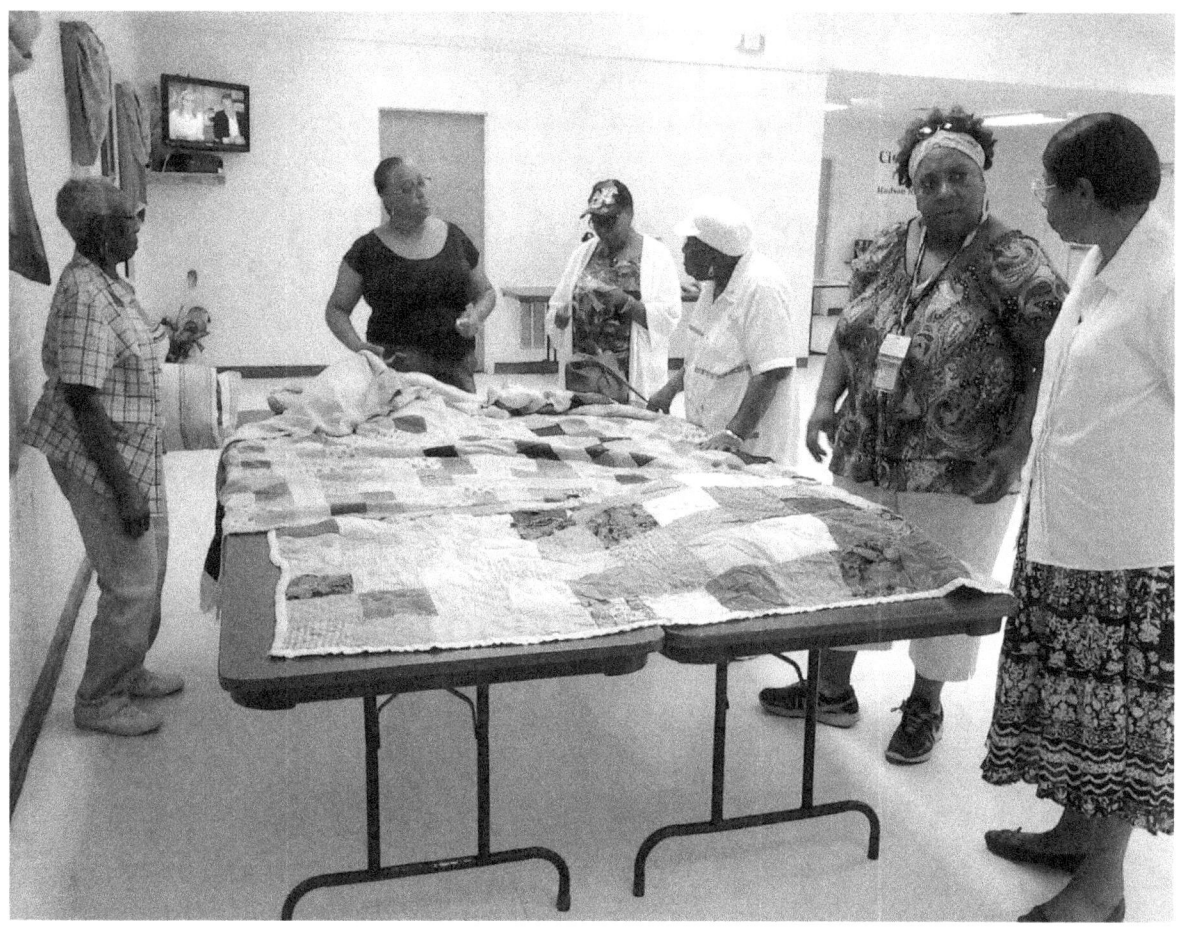

(L-R) Sadie Williams, Gloria Davis, Patricia Beaton, Marie Wright, Tina Hicks, and Ruth Brown
Sadie Williams joins the ladies as Gloria Davis shares the stories of her family and the four generations of quilters represented in the quilts she brought in for the show.

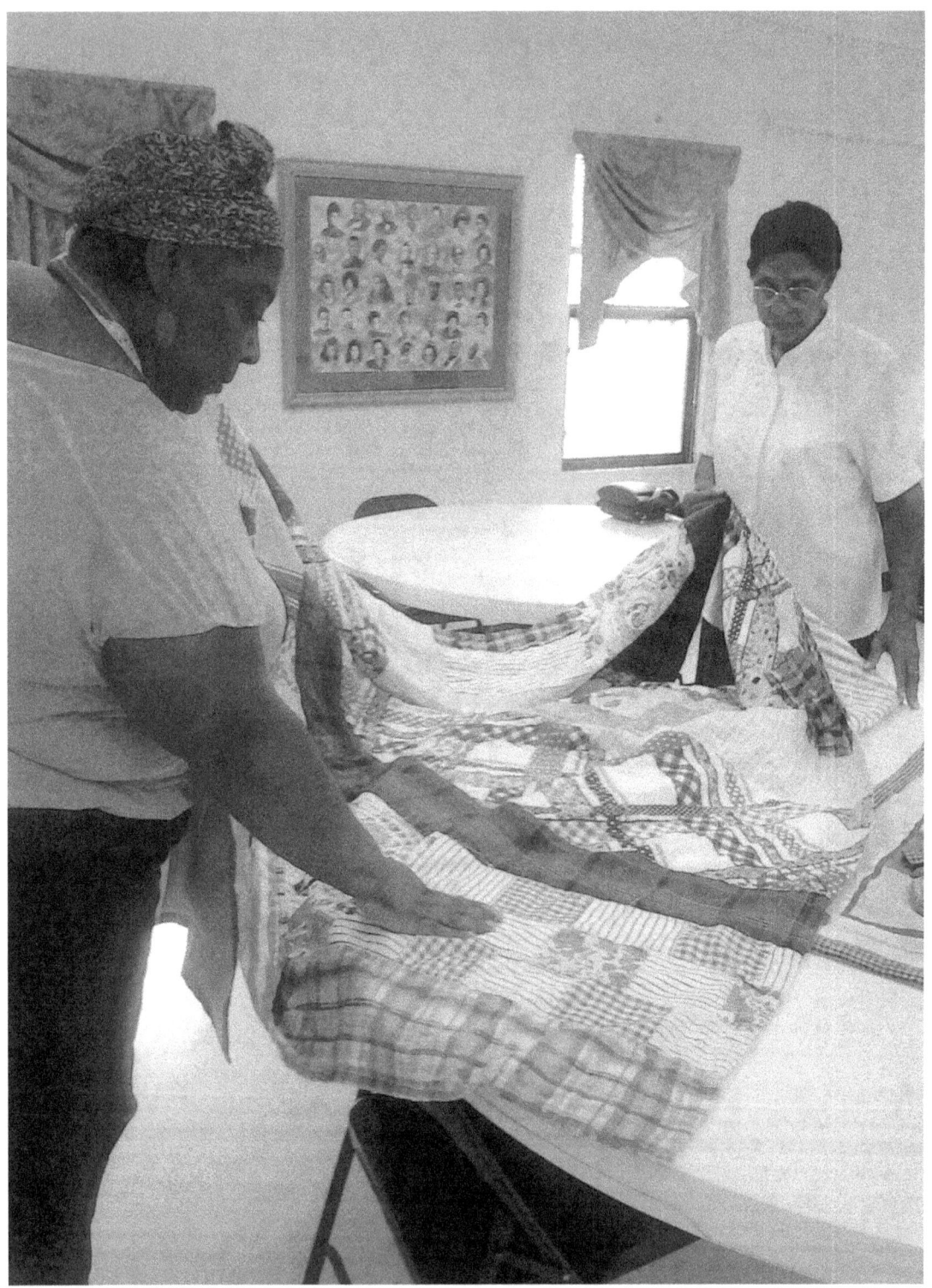
Tina Hicks and Ruth Brown review the patchwork quilt to see if it is ready to go in the show

Carver Village visits Quilting Kiah Stories at SSU

Prior to the September show Hudson Hill Golden Age had an exhibition at Savannah State University during the month of June called *Quilting Kiah Museum Stories* to raise awareness to the fate of the museum as well as raising funds to help with the upcoming event.

Cuyler Brownville resident Jessie Stevenson shared her memories of the Kiah Museum during the "Quilting Kiah Museum Stories" at SSU and pledged to support the September show.

Dr. Clyde Hall colleague and friend of Dr. Calvin Kiah visits the *Quilting Kiah Museum Stories* show at SSU and reviews scrapbooks with Dr. Johnson-Simon.

Maud Hall

Maud Hall's collection included eight quilts and one afghan that was the first crochet piece her daughter made while waiting for her first child. Maud remembers how her friend Virginia Kiah praised Lydia for its artistry. Another quilt she loaned for the show was created by her mother and given to her and her husband Clyde to keep them warm in their marriage. They have been married for 68 years. Pictured above she holds a picture she had taken with her friend Virginia Kiah during one of the visits the Kiah's made to her home.

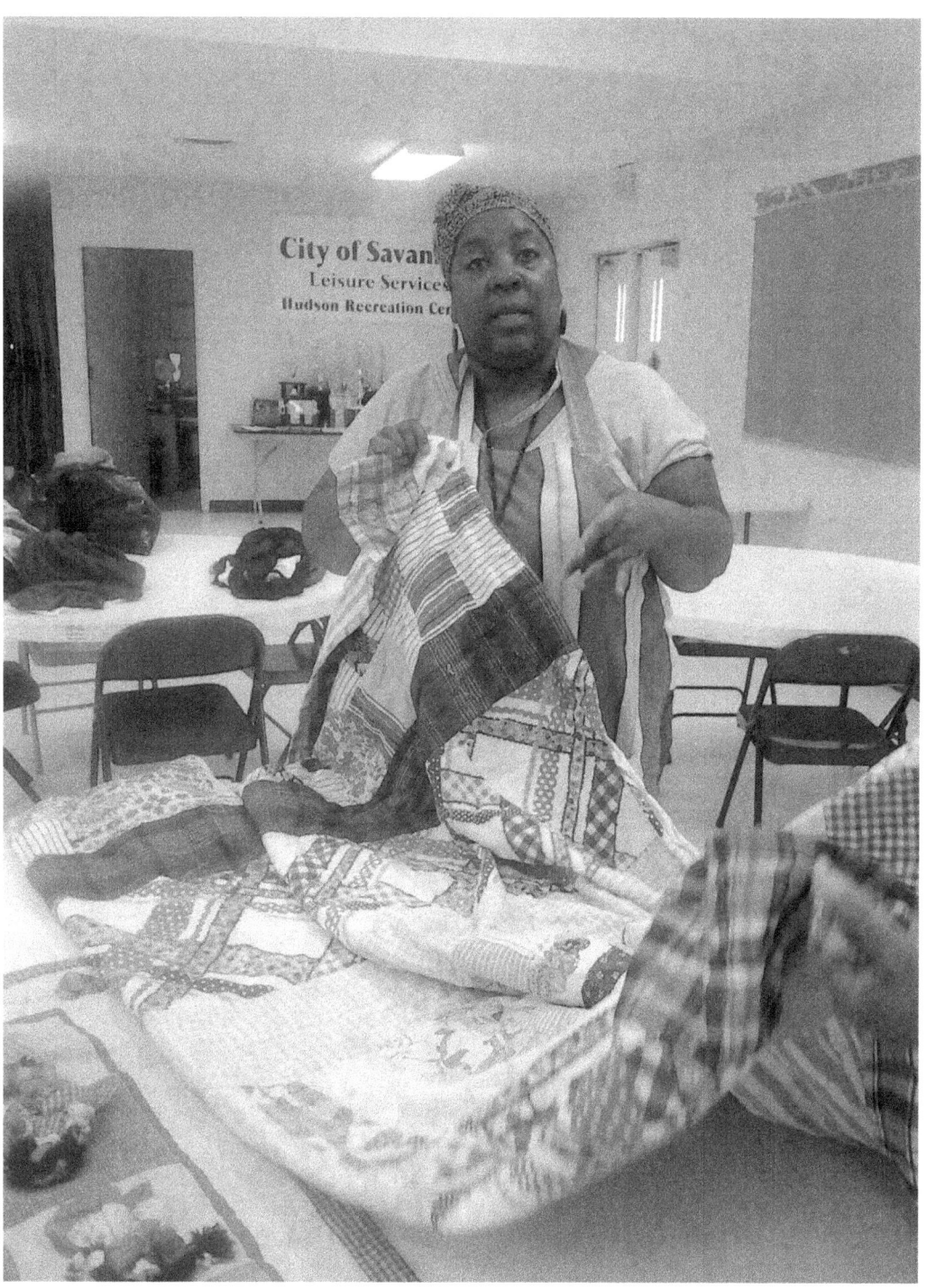
Tina Hicks reviews several quilts brought in for the show.

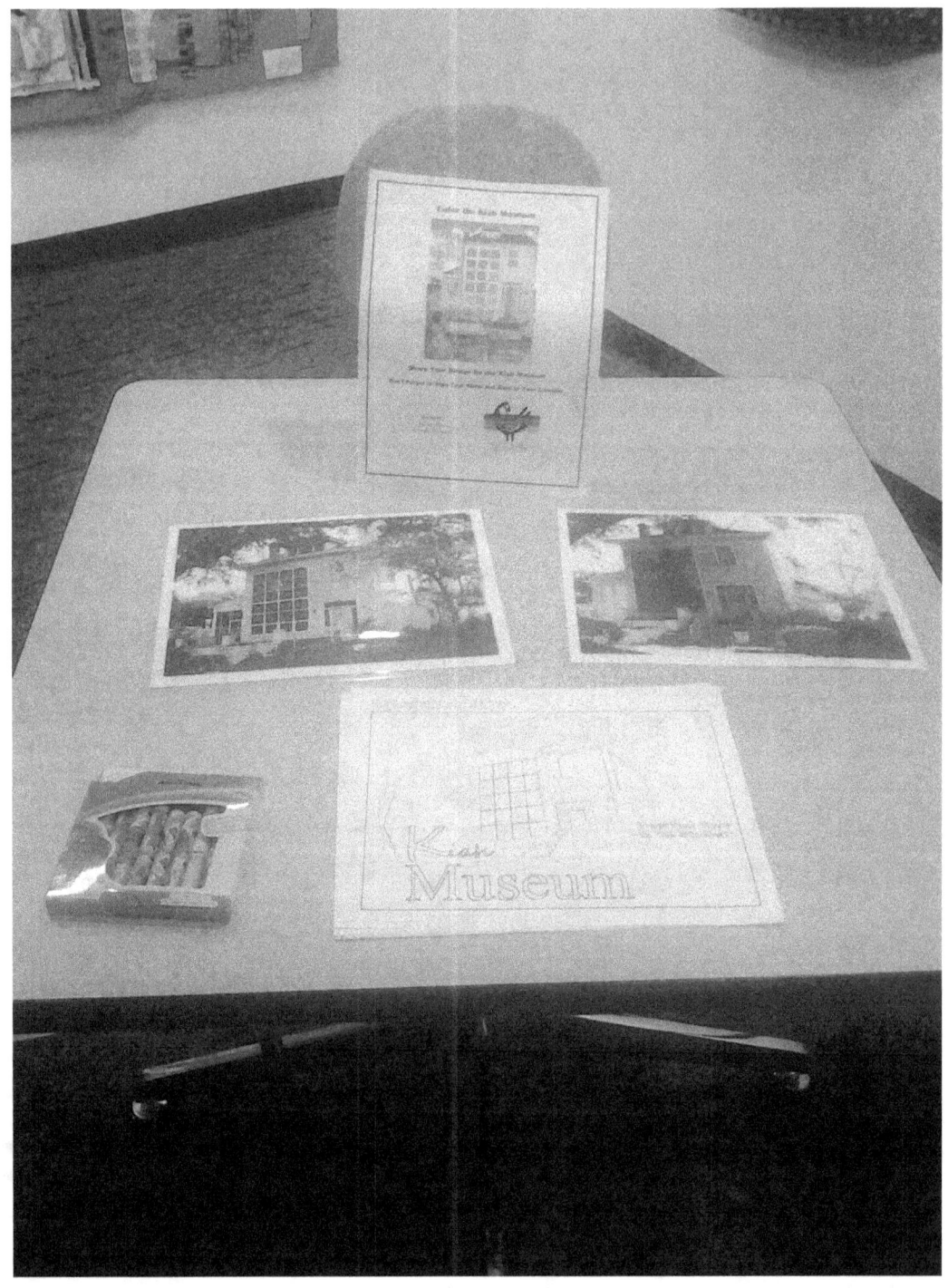

Sauda Mitchell prepared coloring pages of the Kiah Museum and Hue Man member, Tori Becks, shares a page from her book "*Discovering the Kiah Museum*" for kids. This was a highlight at the SSU "Quilting Kiah Museum Stories" show.

A young visitor to the "Quilting Kiah Museum Stories" tries out one of Sauda Mitchell's Coloring Activity Pages

Ariana Knight, SSU Mass Communication major, learns about the Kiah Museum during the show and vows to work with CFSAADMC and the Hudson Hill Golden Age quilters to get the word out.

Quilt Stories

Churches Support Quilting the Blacks in Museums Family Reunion Exhibition

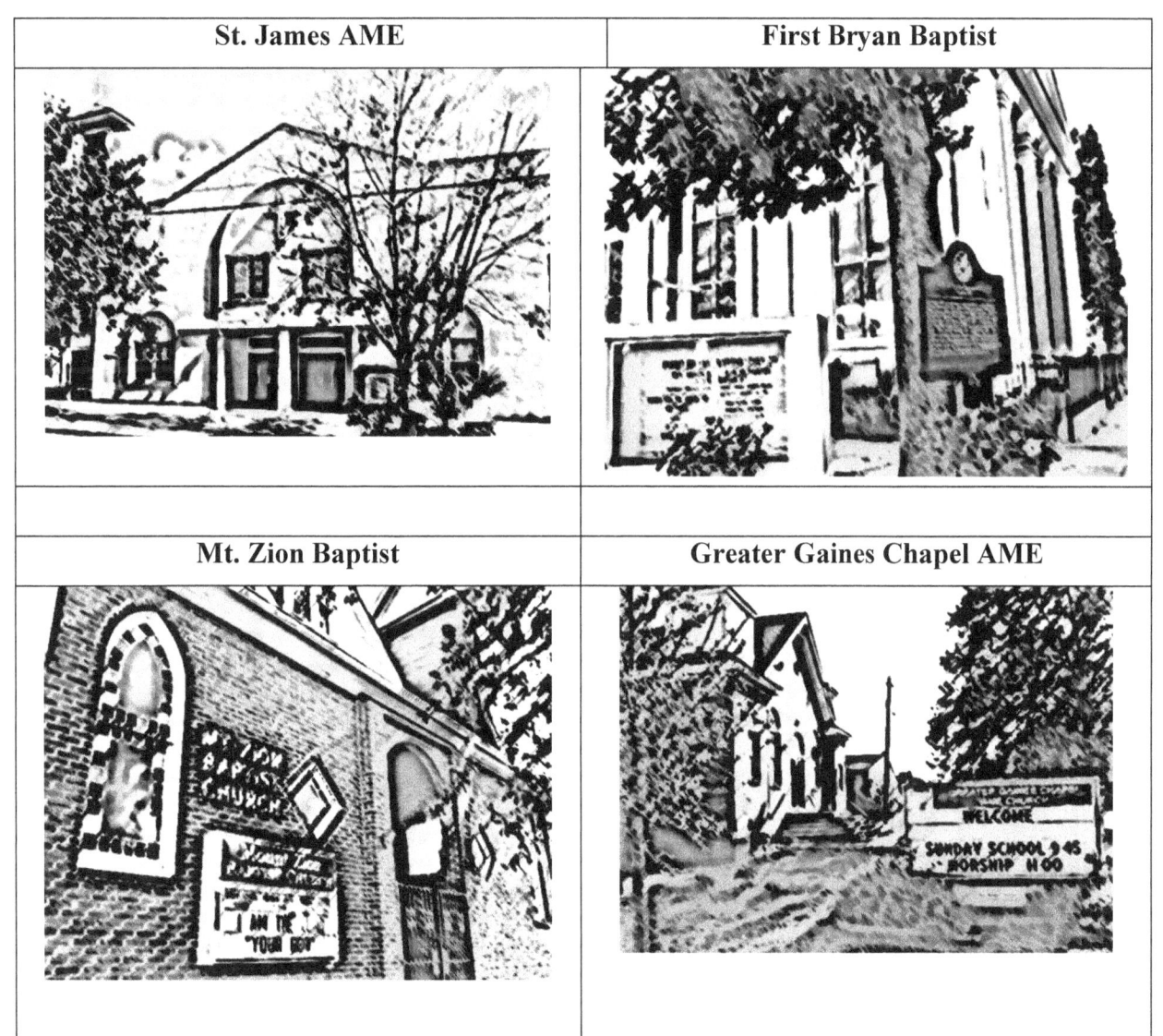

St. James AME Church Quilt Stories

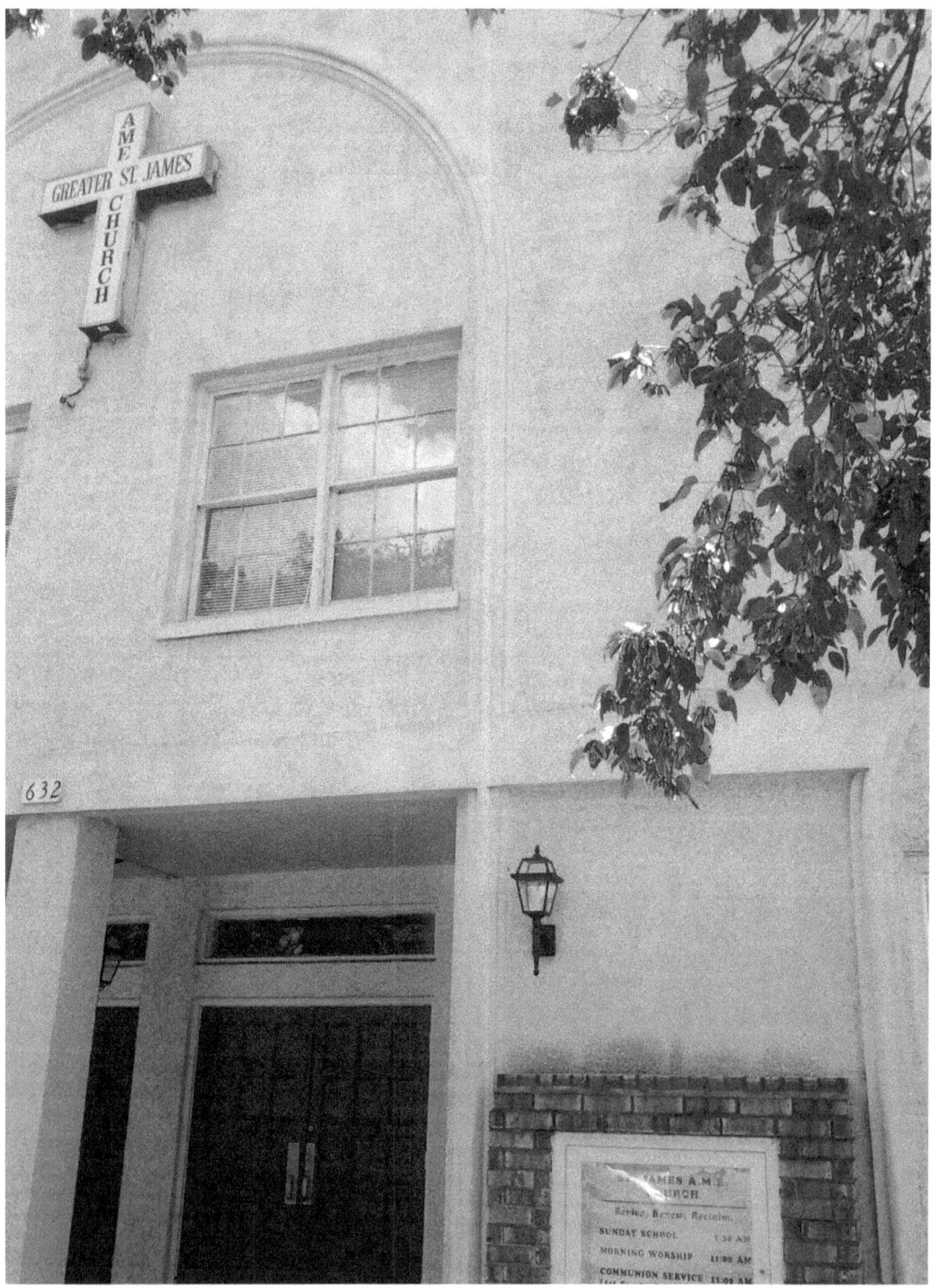

632 E. Broad Street, Savannah, GA

St James AME Church Quilt Stories

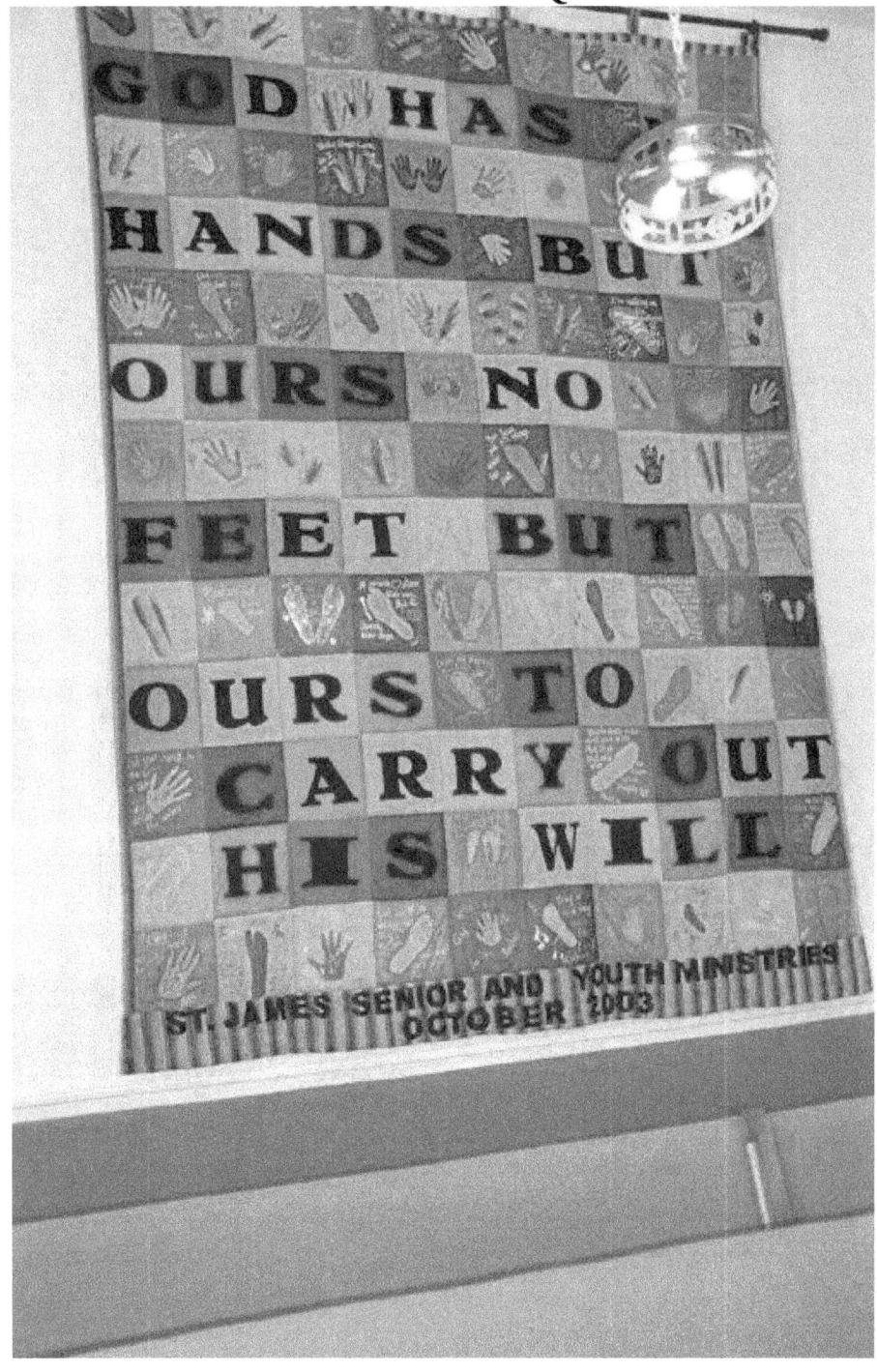

"God Has No Hands But Ours -No Feet But Ours To Carry Out His Will"
St. James Senior and Youth Ministries October 2003

Salathia A. White

Ms. White is a life-long member of Saint James A.M.E. Church. Her warm smile and radiant personality fills you with excitement when you come in contact with her. She was baptized at 4 years old at Saint James. She is very active in the church today, serving as church secretary. However, church secretary is just one of many duties Salathia performs at her church, where she also holds the position of President of the Rosalind M Kent Exceptional Women's Ministry. The love of quilts comes from her mother, who made many quilts. Her mothers' quilts where often used by her father to transport prisoners in the winter. Officer John A. White was one of the first nine African Americans to be hired by the Savannah Police Department

Sadie Williams

Ms. Sadie is a long-time member of Saint James A.M.E Church. She is a graduate of Beach High School. She is an avid quilter, a skill she learned from her mother. She is well known for the technique of "Tailor Tacking". In 2016 Mrs. Williams made the Saint James A.M.E Church 150th Church Anniversary Quilt. This quilt was made at the Golden Age Center.

Patchwork quilt made by Sadie Williams at the Senior Center

Tailor Tacking Pattern Quilt made by Sadie Williams at the Senior Center

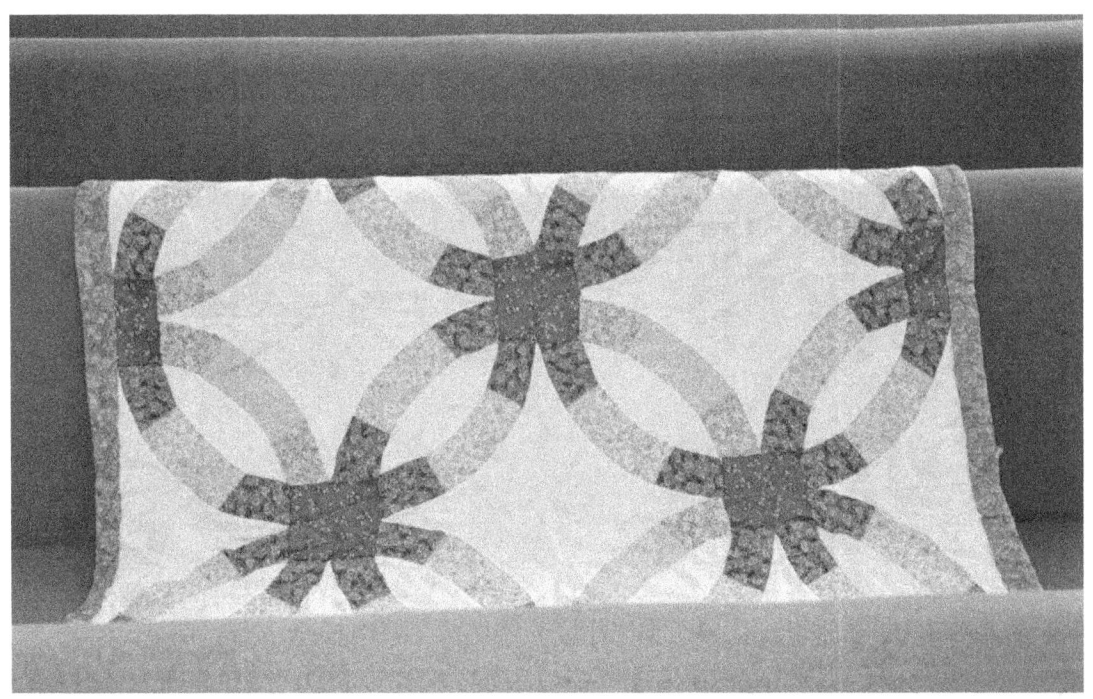

Mrs. Sadie Williams Wedding Ring Pattern Quilt made at Hudson Hill Golden Age

Breast Cancer Quilt made by Sadie Williams

Mrs. Patricia Beaton Boro Quilt

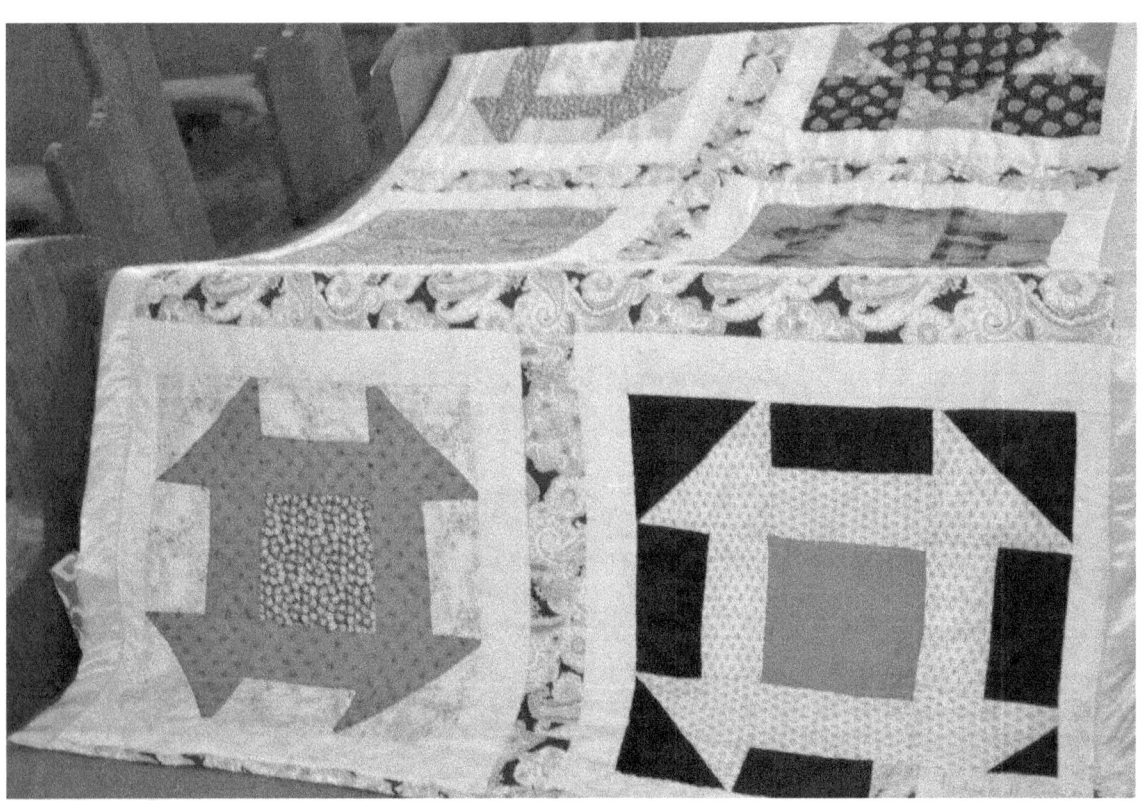

"Ladies at the First Table"
Monkey Wrench pattern quilt made by the Hudson Hill Golden Age quilters

Tailor Tacking pattern quilt made by Alice White mother of Sadie Williams. Mrs. White was a native of Hilton Head, SC. She moved to Savannah, GA as a young woman. She was active in church. She served as an usher and the secretary of the Usher Board. She was a quilter and found tailor tacking a passion. She also loved to do embroidery. Alice White worked for Trade Wind Shrimp Factory in Thunderbolt, GA.

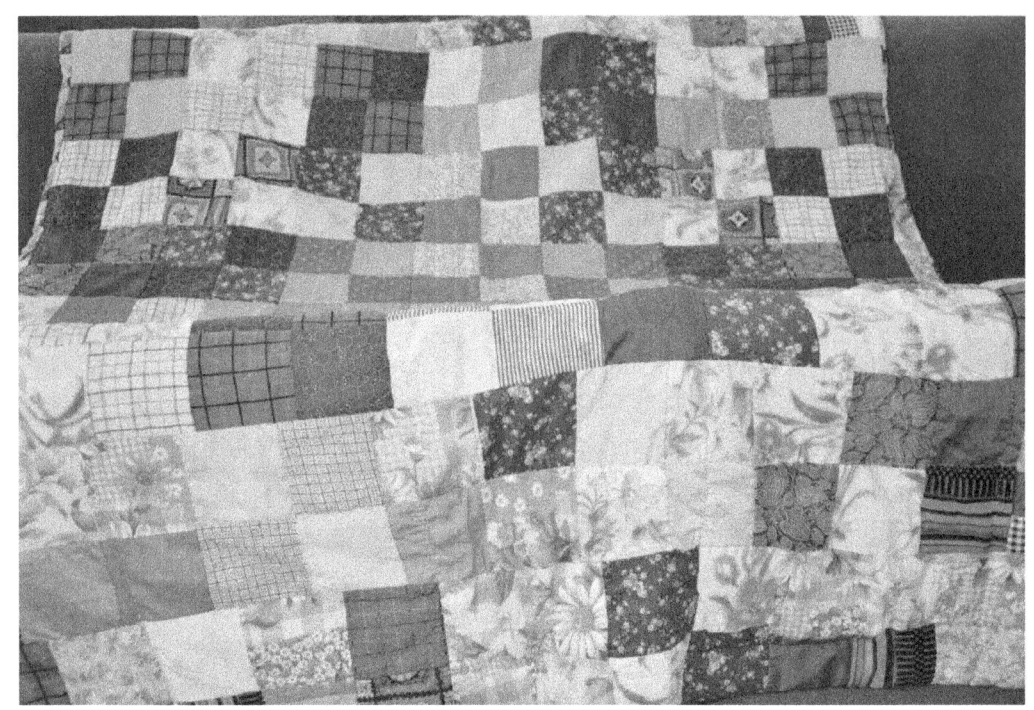

Patchwork Quilt

Salathia White Special fabric quilt

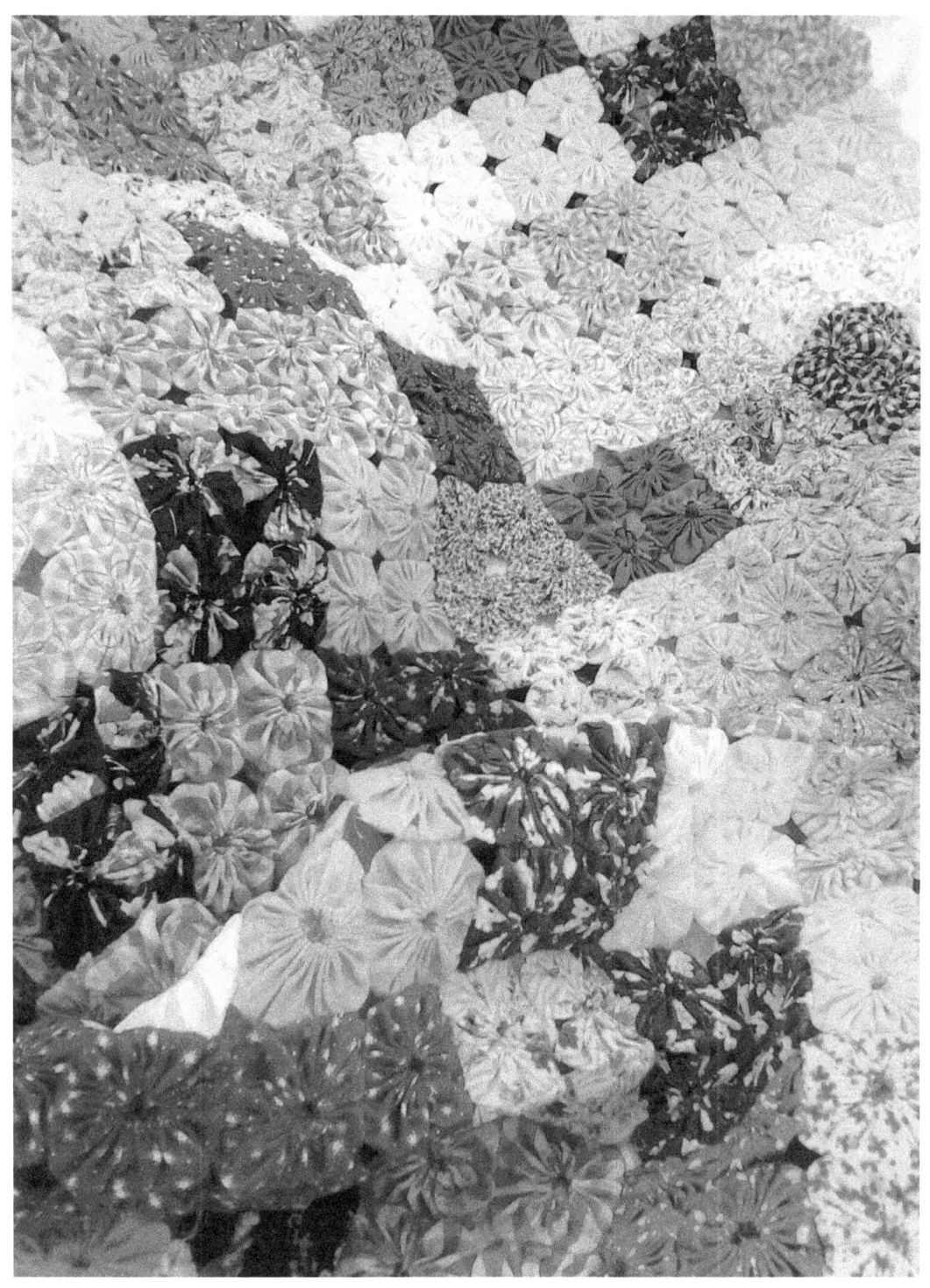

Yo-Yo Pattern Quilt made by Catherine Sullivan mother of Hudson Hill Golden Age quilter Ruth Brown

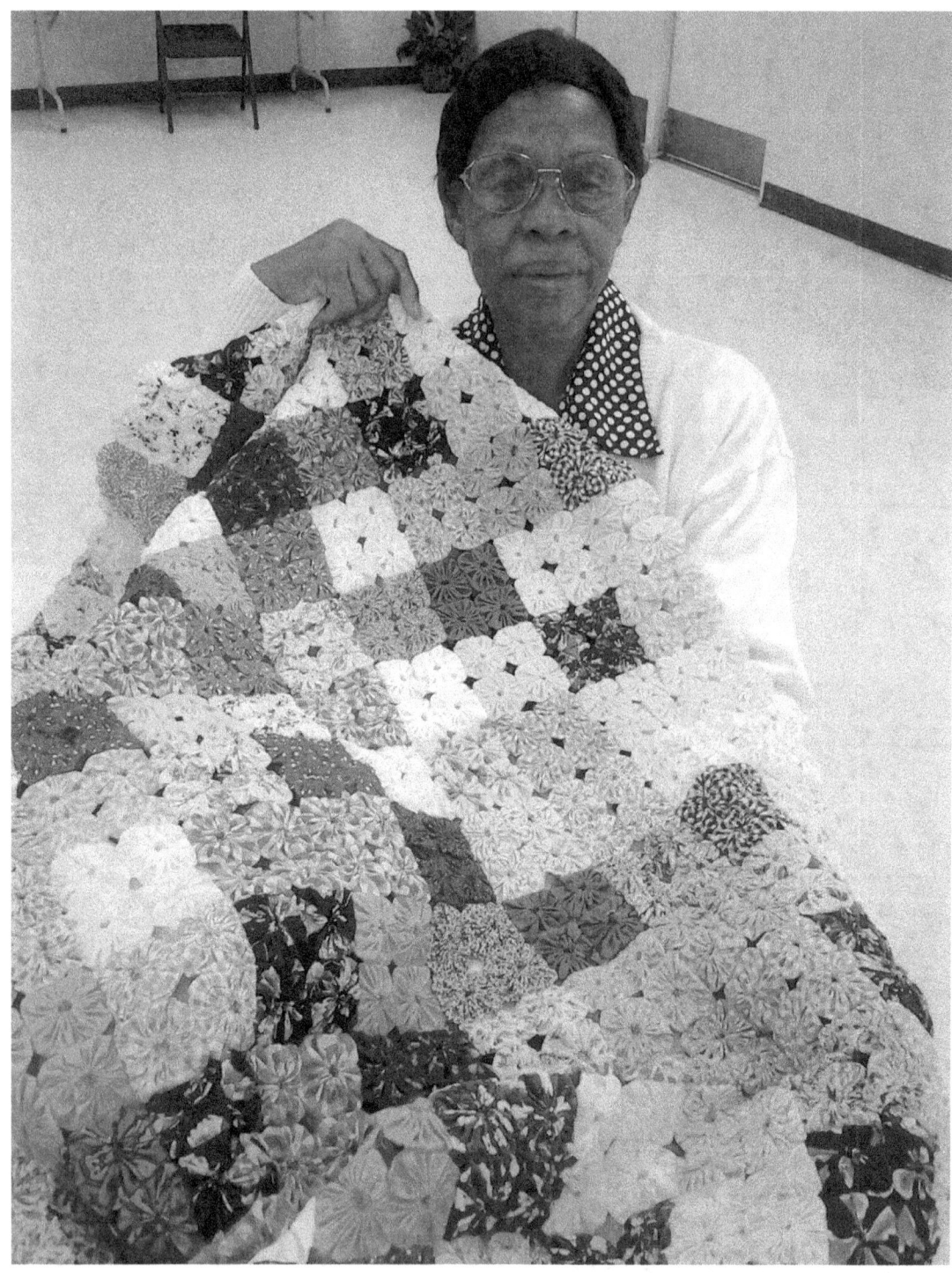

Hudson Hill quilter Ruth Brown pictured with her mother's Yo-Yo pattern quilt. This is one of four quilts her mother made with this pattern when she retired. This quilt is about 12 years old. Mrs. Sullivan is now deceased.

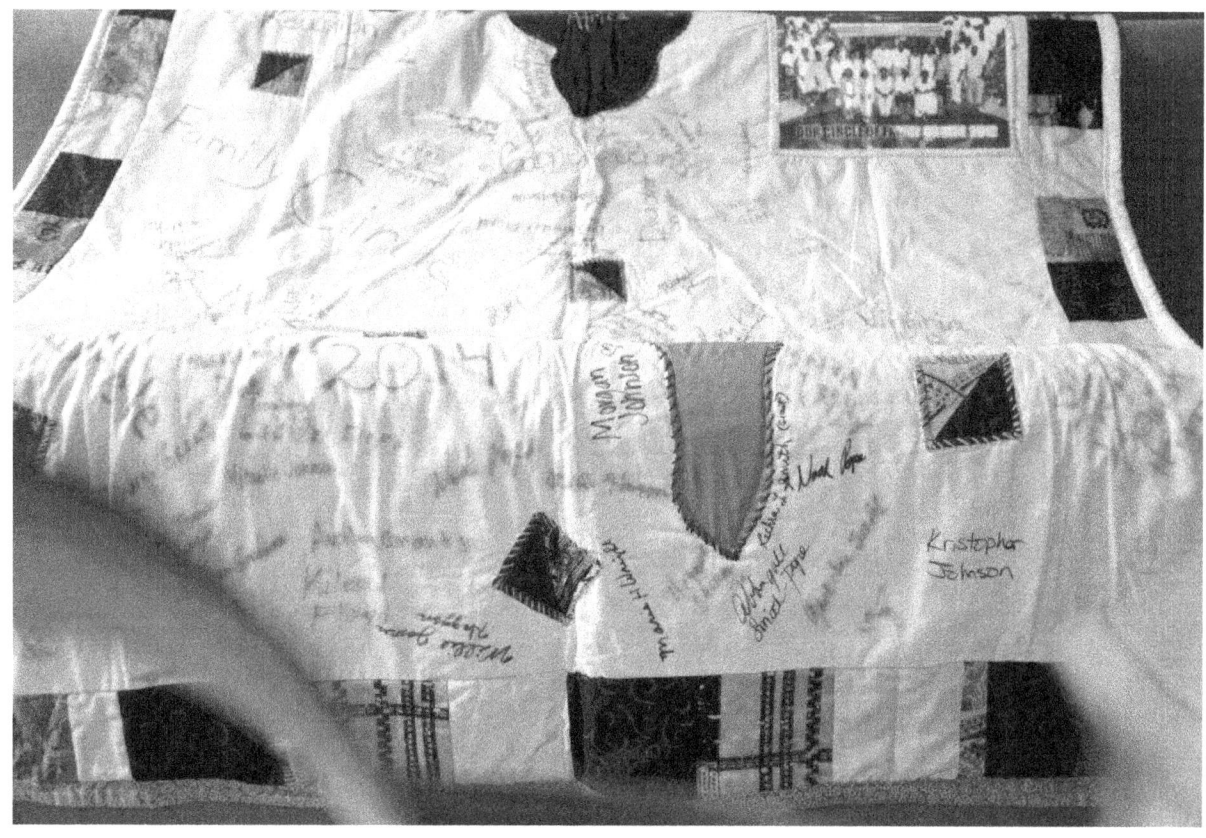

Family Reunion Quilt made by Rebecca Johnson Hudson Hill Golden Age Center

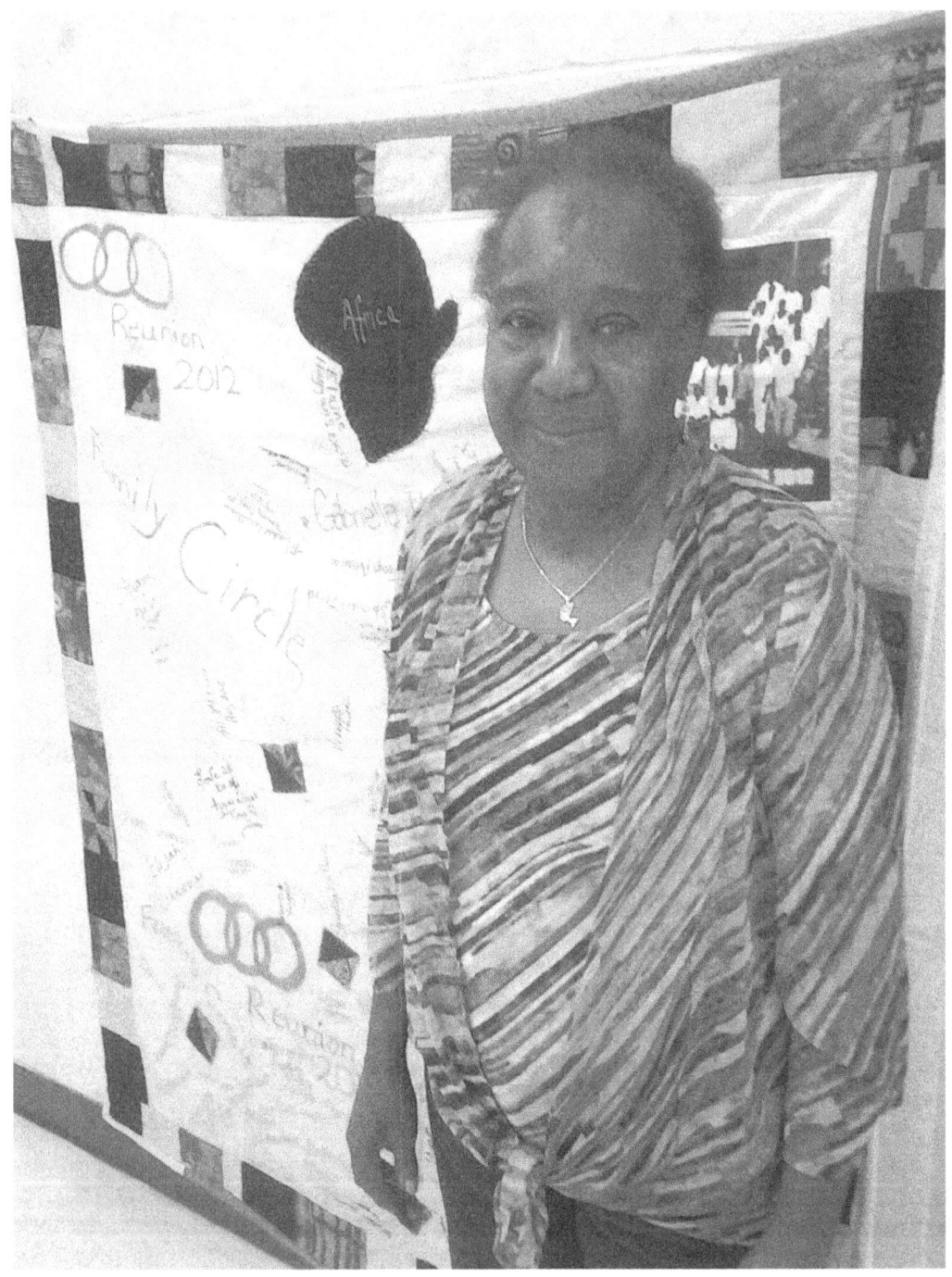

Rebecca Johnson pictured with her Family Reunion Quilt

Greater Gaines Chapel AME Church

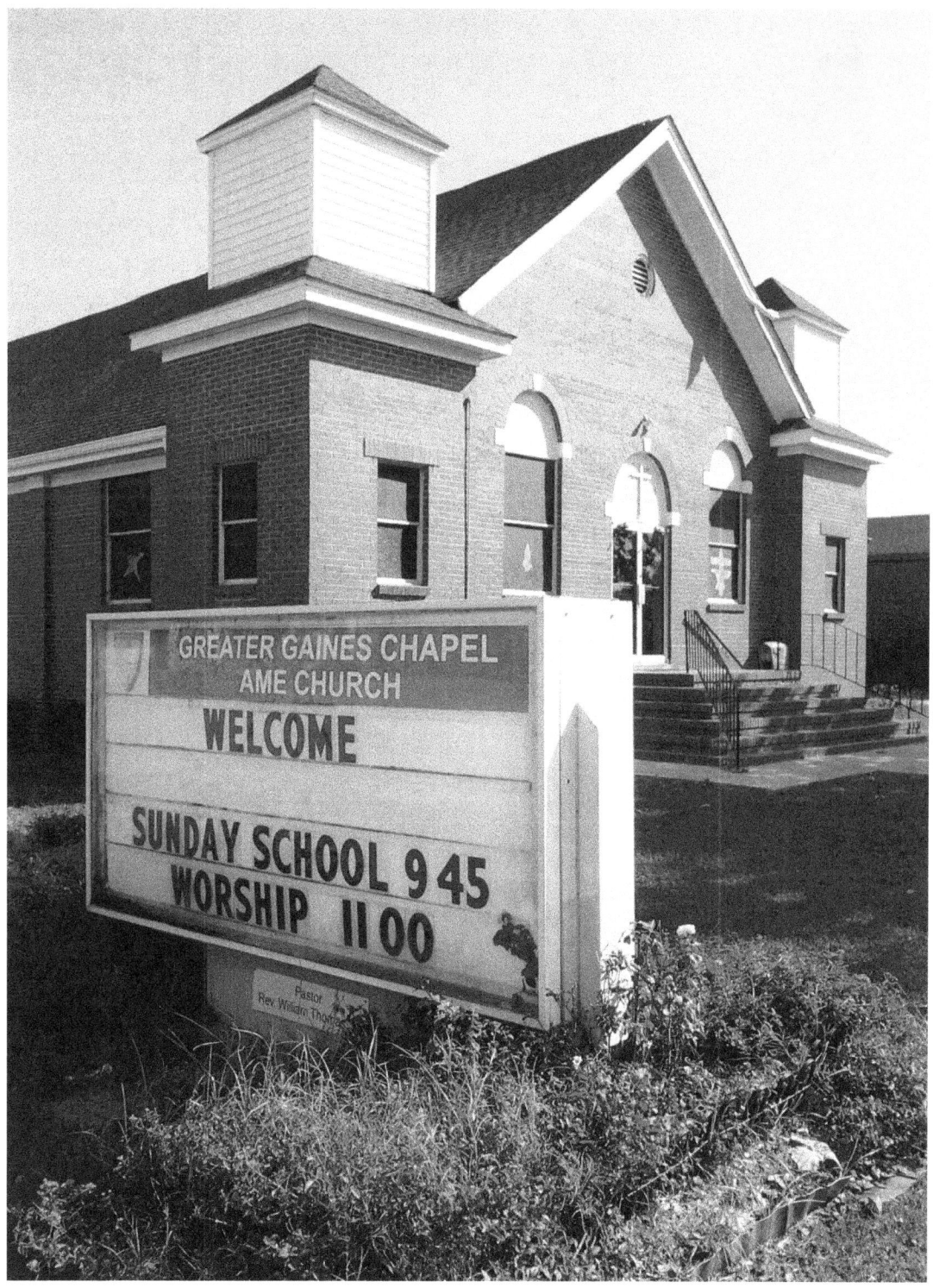

1006 May St., Savannah, GA

Betty Johnson

Betty Jean Young Johnson

Betty Young Johnson the third oldest child of Augustus Young and Idessa Delores Young.

Betty was born at Charity Hospital in Savannah, Georgia on December 27, 1951.
She is a graduate of Richard Arnold Adult School in Savannah Georgia.

In 1990 she attended Savannah State College after completing one year she decided to enroll at Saint Leo College on line to complete an Associate Degree in Liberal Arts. Later, she said that wasn't enough, and something was missing Betty enrolled at Michigan State College for one year. Next, she returned to Saint Leo to complete her Bachelor of Business Administration with a specialization in Management. That did not stop Betty she continued to work at her present job with City of Savannah and received training in her other interests, such as carpentry, ceramics, health care, jewelry design, sewing and her passion floral designs and interior décor.

During her tenure, she was the first Black women to be employed in the Traffic Engineering Department, first Black women and only women to work with the first Total Quality Management Team for City of Savannah.

Being employed with City of Savannah, she was promoted to various positions within the city, the last position was with the Vehicle Maintenance Department as a parts administrator and she retire after 39 years of service in 2010.

Betty and her daughter joined Gaines Chapel A.M.E Church in 1985 under the leadership of Pastor T. J Patterson. She became involved in several activities. She was a member of the Chapelettes, Greater Gaines Chapel Mass Choir, Class Leader, member of the Class Leadership Council, President of December Birth month, Special Event Committee member, and a Trustee.

In 1993 her beloved husband George M. Johnson passed away and in 2010 her lovely daughter Letechia Valetta Johnson said good bye.

She is the mother of two wonderful sons, Kenneth Octavious and Shawn Lamar, and a proud grandmother of Gabriella Marie (Gabby) and De Vie Na Vania, and great grandmother of Tavonta Keith.

Patchwork quilts made by Flora Belle Danielly, grandmother of Greater Gaines AME Church member Wanda Small.

Flora Belle Danielly
(02/21/1911 – 09/06/2001)

The Good Grandmother

My Grandmother was an original – among the last of a vanishing breed of folk.

She stood only 5 ft., if she stood an inch, but she had so much spirit, fire and determination packed into that small frame. Anybody who knew her knows exactly what I mean.

My Grandmother was fiercely loyal to her husband of almost 40 years, Brown "Buster/Bill" Danielly, who also departed this life just a few short months prior to her own. She was a total eccentric, who steadfastly refused to acknowledge the advancement of time. She loved to barter and sell goods – Most especially --- her handmade QUILTS!

"Grandma Flo'Belle" began each of my visits by proudly showing me her latest quilt squares – The "Gentleman's Bowtie" was one of her most cherished designs.

Oh, how I WISH I'd paid more than lip service as my Grandmother tried to interest me in sharing her craft…

So, I hope you will enjoy viewing this quilt, made circa 1985 by Grandmother for me, a priceless and cherished remembrance of her.

Always,

Wanda J. Small, Granddaughter.

Boro Stitching Quilt

Boro Quilt made by Hudson Hill Golden Age quilter Tina Hicks

While Hudson Hill Golden Age Center members were participating in the "Loop it Up Savannah" program, and "The Beloved Community" we were introduced to Boro stitching by Molly Lieberman. The quilts we made were displayed at the Asian Festival at the Savannah Civic Center. These quilts were made from recycled blue satin and denim fabrics.

Rag Quilt

In 2010 I attended a textile event at Savannah College of Art & Design, Sharon Cooper-Murray; a storyteller, introduced us to Rag Quilting as it was done by the ladies of Johns Island, South Carolina. This quilting technique was passed down from slavery. She told us that this type of Rag Quilting is a dying art in the Gullah culture. It is her goal to keep it alive. I told her
The Hudson Hill Quilters would take it on as a project. The ladies of Johns Island used feed sacks and a nail to loop the strips of fabric though the sack. We used burlap and a crochet hook to loop the strips of fabric. It is our goal is to continue working on this Rag Quilt to bring this art form back to life. (Tina Hicks)

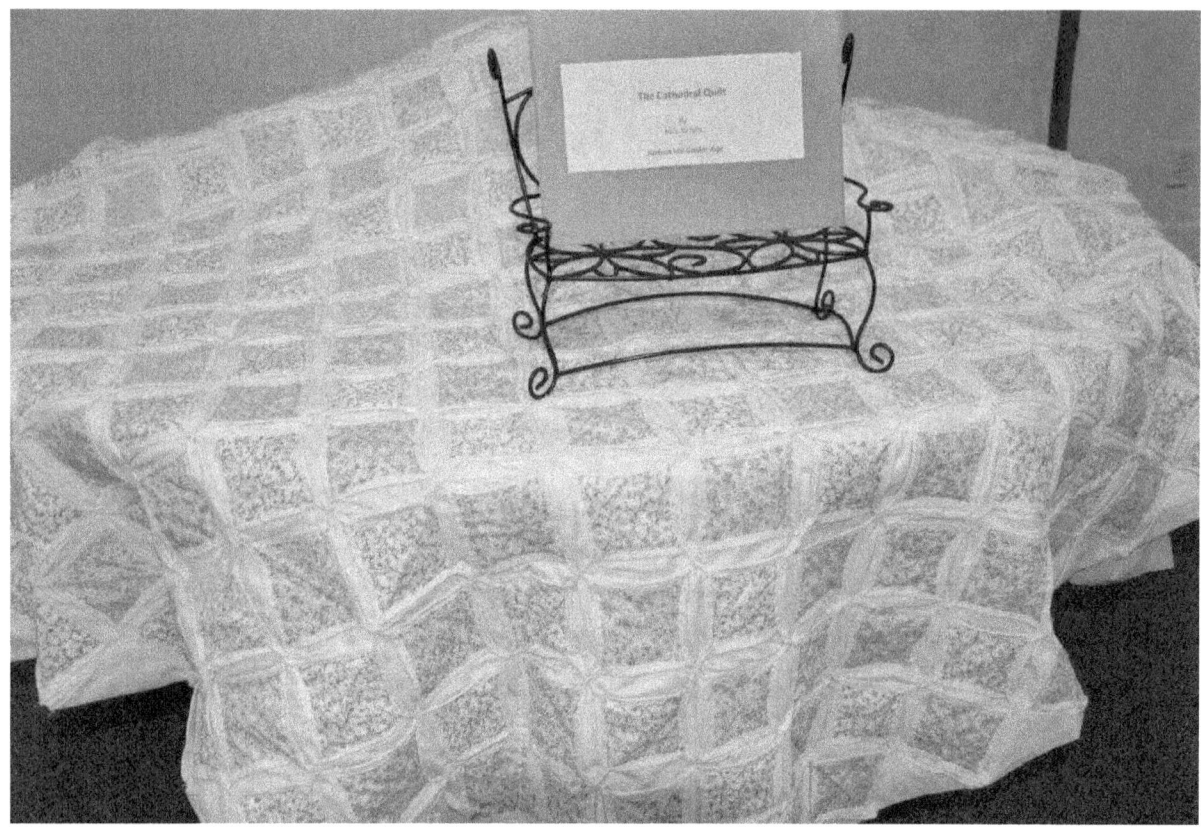

Mrs. Marie Wright Catherdrel Quilt

Marie Wright and the Pink Cathedral Quilt

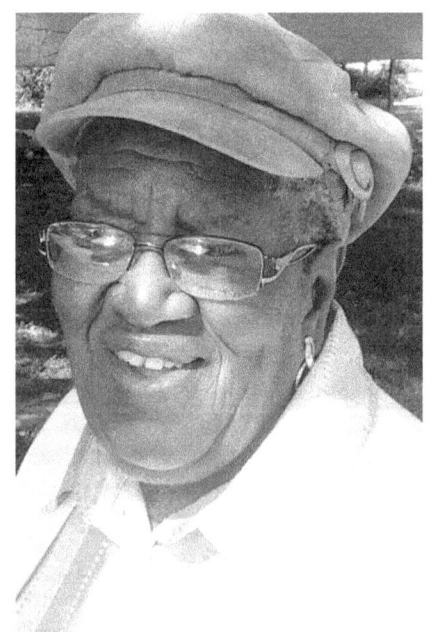

Marie Wright is a Savannah native who grew up in West Savannah. She has lived in the Hudson Hill Community for 67 years. She is a member of Saint Paul C.M.E. Church. She learned the cathedral quilt square pattern from the Senior Ministry Program at Saint Paul C.M.E. Church. That is where she made her first cathedral quilt. It was a multicolor quilt. Her husband was very proud of it, and would show it to everyone who came to their home to visit. The second cathedral quilt she made she finished as a member of the Hudson Hill Golden Age. When she joined Hudson Hill Golden Age she had only one row finished. The second cathedral quilt is pink print fabrics in the middle and bordered with a solid pink fabric.

Marie Wright Hudson Hill Golden Age Quilter

Cathedral quilt made by Marie Wright (detail)

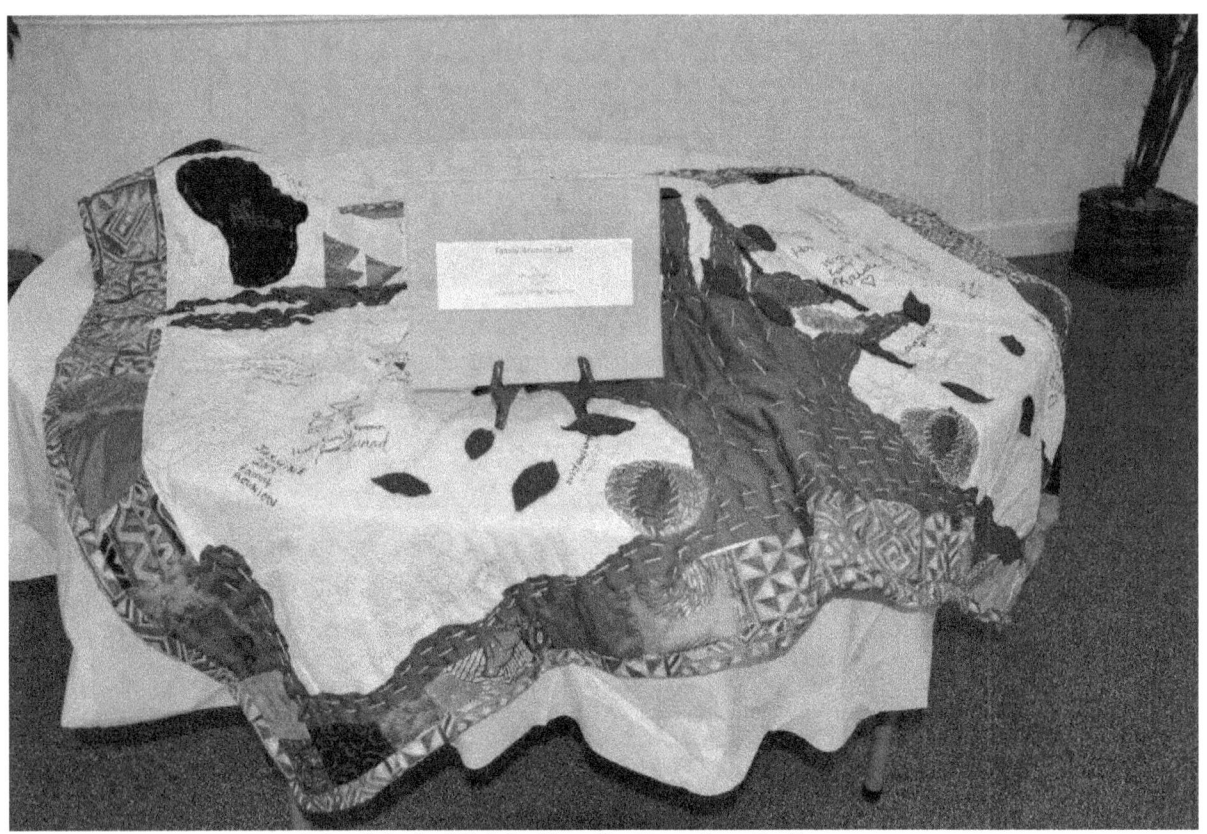

Mrs. Marie Wright Family Reunion Quilt

Mrs. Marie Wright
Howard and Wright Family Reunion Quilt

The tree was placed in the middle of the Quilt to represent the family. The leaves on the tree carry the names of the family starting with great relatives now passed on to present day oldest relative to the youngest. The appliqued people represent the family. The quilt is hand sewn. The topstitching on the quilt was done with gold #10 crochet thread. The quilt was made at the Hudson Hill Golden Age Center.

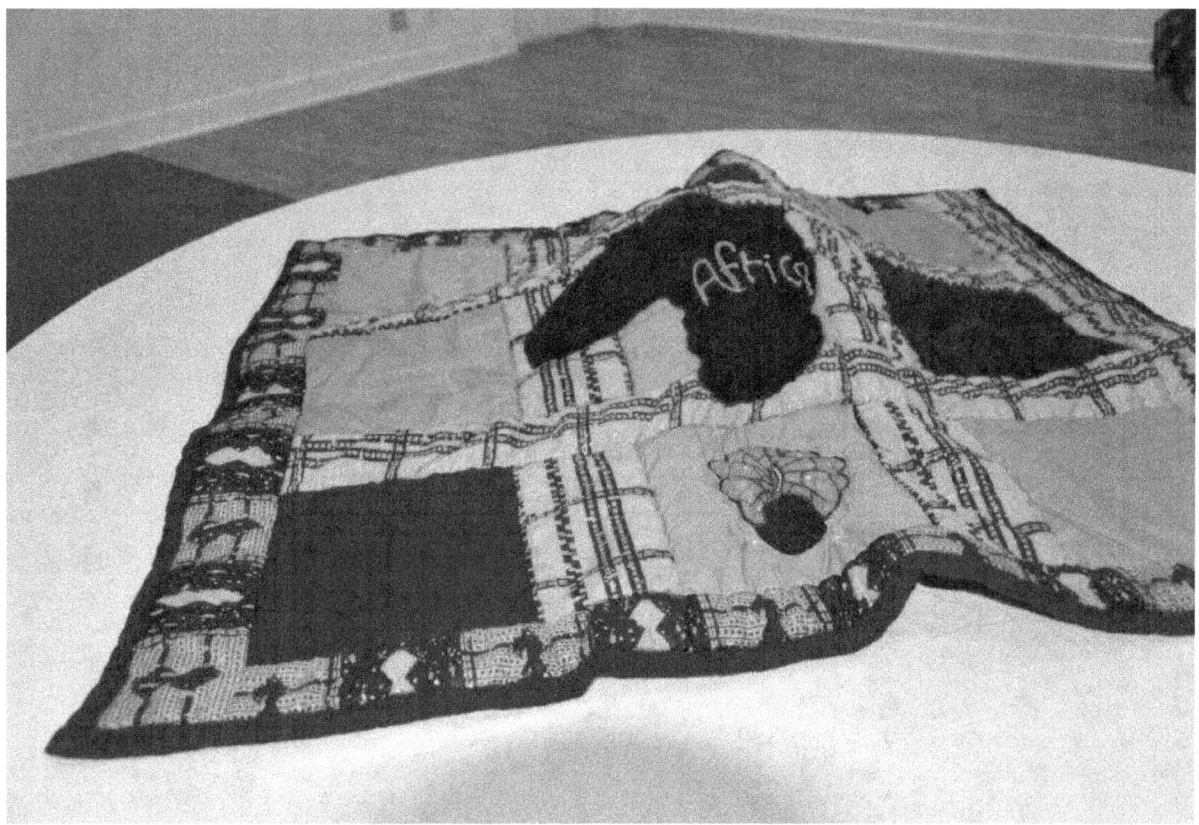

Tina Hicks, Kwanzaa Quilt

In December of 2010 I conducted a workshop at Hudson Hill Golden Age on Kwanza Quilts. The Kwanza Quilt is a nine patch quilt made from black, red, green, and African print fabric. It is embellished with appliqué of masks or symbols of the participant's choice. Each participant made their own unique quilt. Some quilts were used for decoration for Feast Day, the special celebration that takes place at the end of the Kwanza 7-Day Celebration.

First Bryan Baptist Church

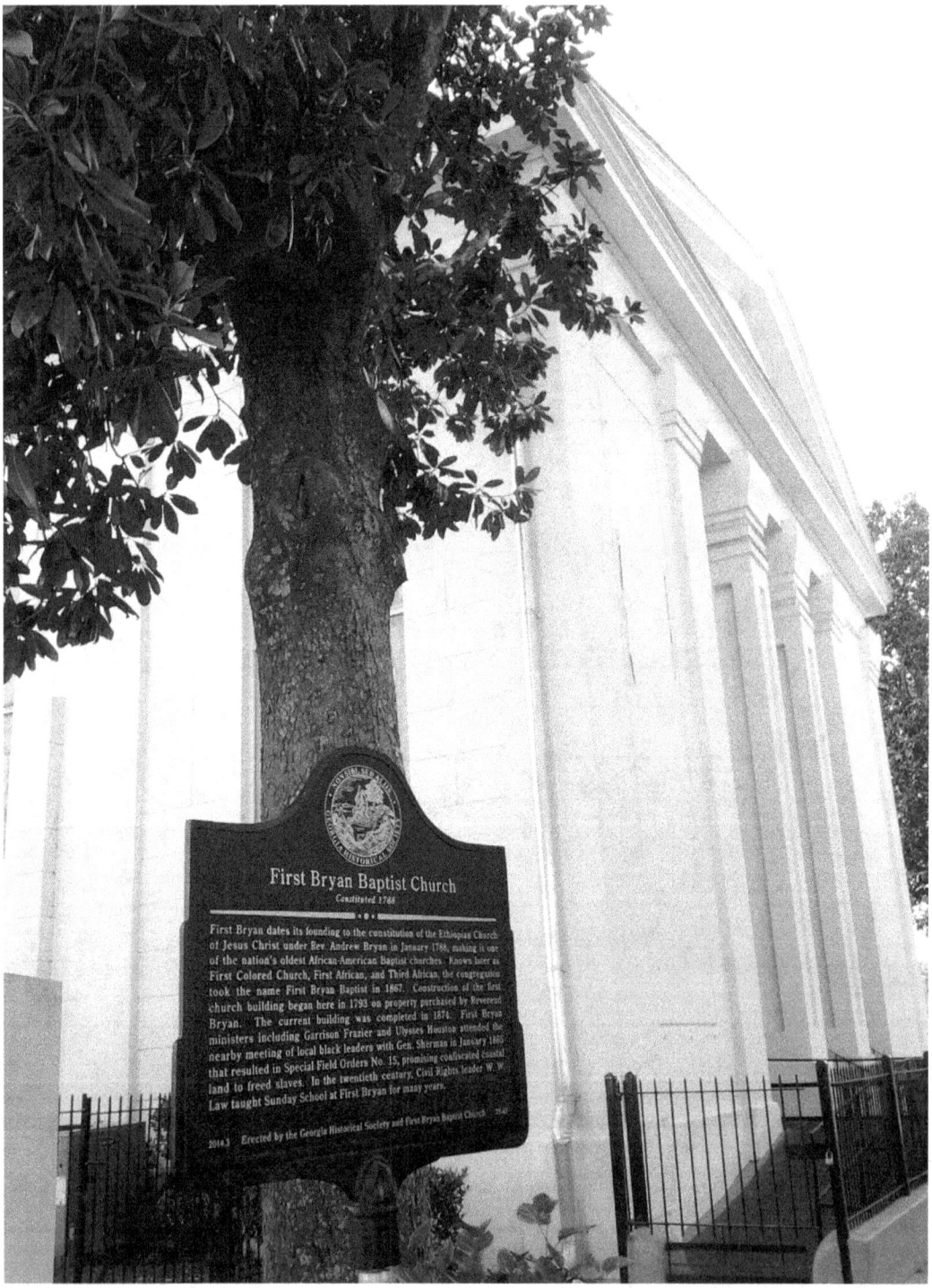

575 W. Bryan Street, Savannah, GA
Opened: 1873 and part of Savannah Historic District

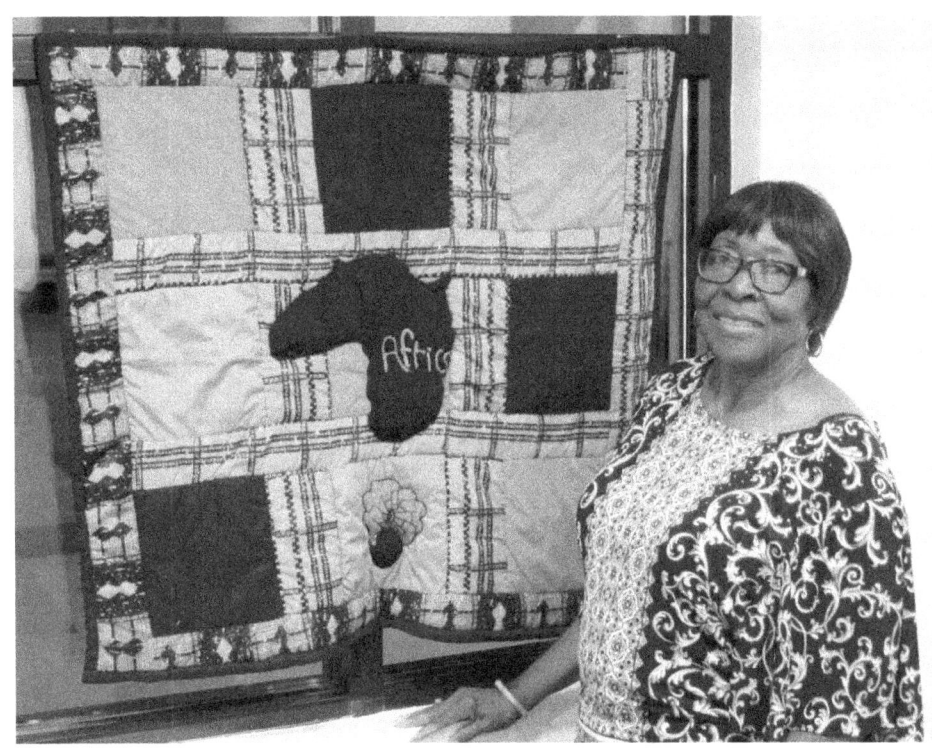

Patricia Beaton-Quilt Coordinator

Mrs. Eunice L. Feagin and Mrs. Sabrina Wright
Coordinators

Gloria Davis

Gloria is married to Kenneth Davis for 35 years and is the mother of two children and eight grandchildren. She graduated from Sol C. Johnson High School and received her higher education at Draughons Junior College. She has been employed with Kroger for over 33 years. Gloria learned to sew watching her mother make clothes as she was growing up. Her grandmother was always doing different craft projects and this is where she began her love for doing all types of arts and crafts. Gloria wanted to learn how to make quilts so she started to attend a class at Wesley Community Center in 2001. After attending the class for about 4 years she was asked to teach it. She was the instructor for over 8 years. Now in her spare time she enjoys making quilts for family and friends.

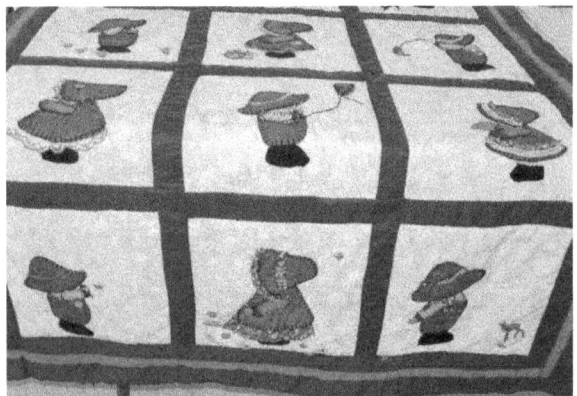

Gloria Davis Sue Bonnet Quilt

Gloria Davis Princess Tiana Quilt

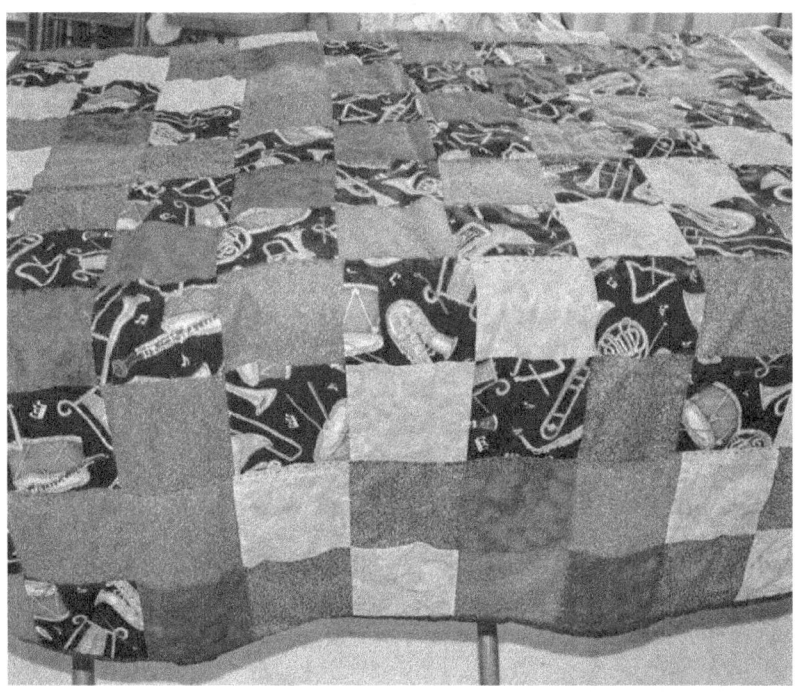

Olympia Davis Jazz Music Quilt

Olympia U. Davis

Olympia is the mother of two children. She graduated from Savannah High School in 2000. While attending Savannah High School she was in the Marching Blue Jackets Band which helped her obtain a music scholarship to Morris Brown College in Atlanta, Georgia. As a music student at Morris Brown she was awarded the opportunity to be in the movie "Drumline". Several years later she decided to go back to school to further her education. Olympia then attended and graduated from Virginia College of Savannah in 2013. She grew up watching her mother and grandmother sewing different items like clothing, blankets, etc. She occasionally likes to make quilts for family, friends and co-workers. She is the daughter of Gloria Davis.

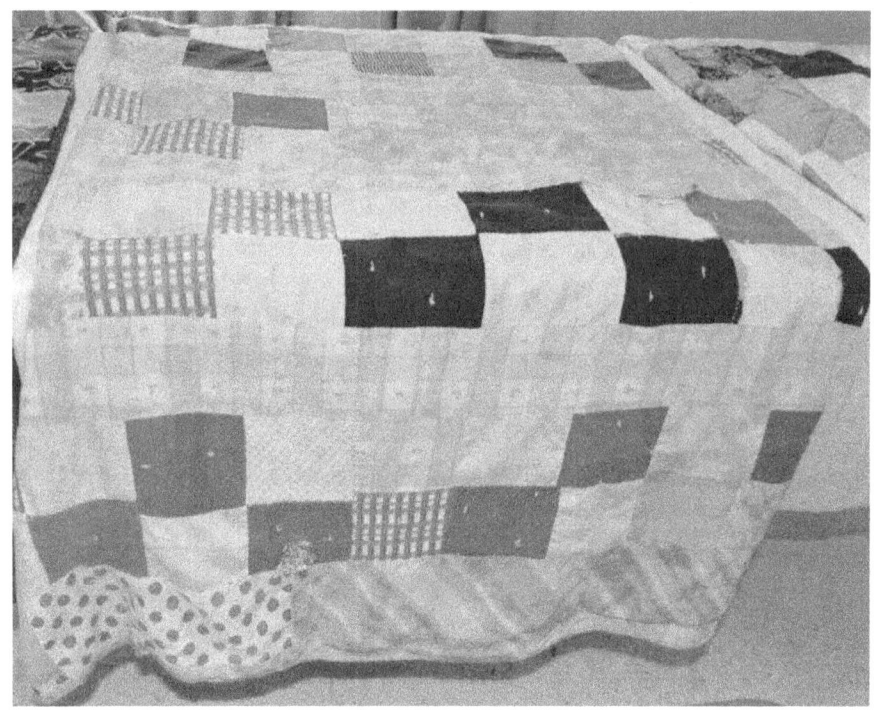

Patchwork Quilt

Miffie Jane Johnson

She was the Dietitian cook at Memorial Hospital for 20 years. Ms. Miffie loves to sing in the choir at her church Connor's Temple Baptist Church and the family church, New Hope Baptist Church. She was the mother of four children. After she retired from Memorial Hospital she devoted her time with several senior citizen programs—Moses Jackson, Salvation Army, Savannah Baptist Center, Wesley Community Center, and Feed the Hungry. At this time in life she rekindled her love for sewing and began to make quilts for her family. Her quilts may not have been perfect but the love and time she placed in them will be forever in her family's hearts.

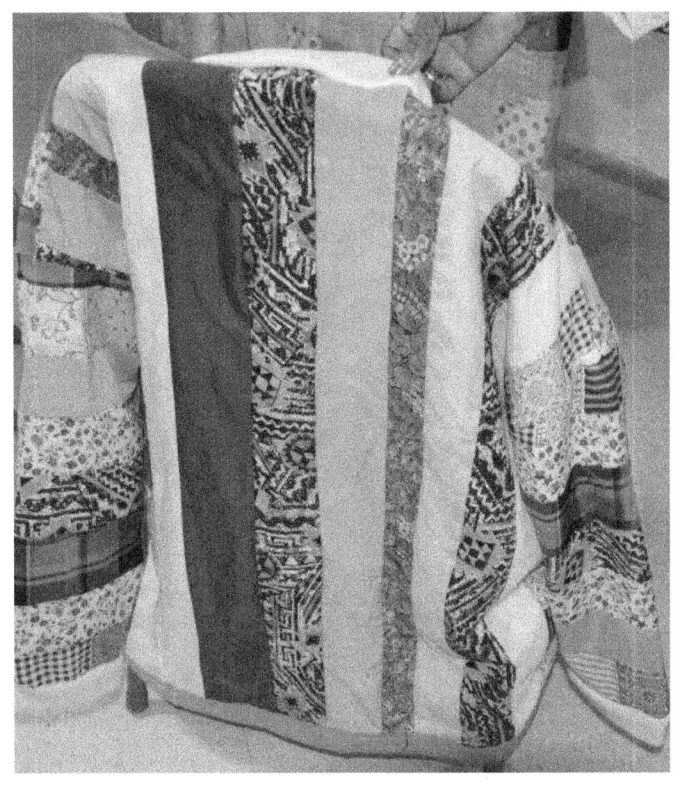

Patchwork Jacket by Miffie Johnson mother of Gloria Davis

Gloria Davis Block Quilt made by Grandmother—Sally Sawyer

Sally Mae Tremble Sawyer

Ms. Sally was a homemaker and mother of seven children. She raised her family in Statesboro, Savannah, and Rincon, Georgia. She loved to participate in all kinds of crafts. She especially loved to make quilts for her family. This quilt has been handed down several generations; to her granddaughter Gloria, her great granddaughter Olympia, and now to her great-great grandchildren to enjoy the comfort and love from Ms. Sally.

Sally Sawyer Gloria Davis's Grandmother

Patchwork Quilt

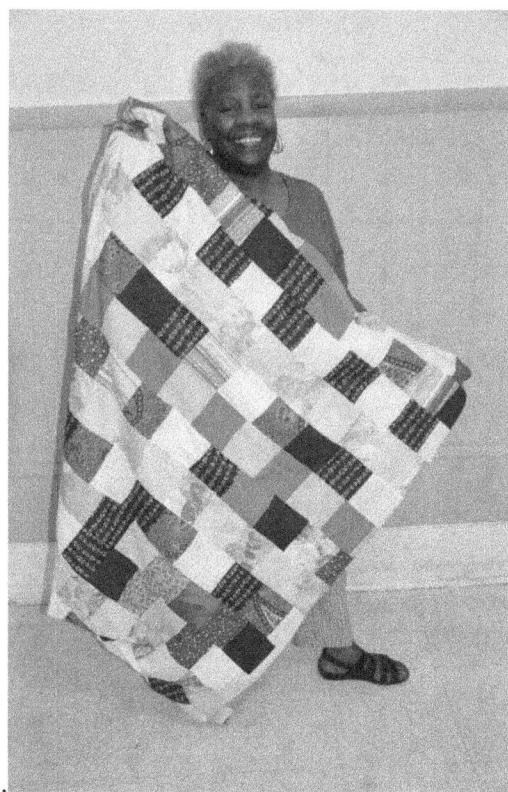

Renea K Williams with "Patchwork Quilt"

Emma Jean Milton Baby Doll Quilt (Nurse Elizabeth Holmes)

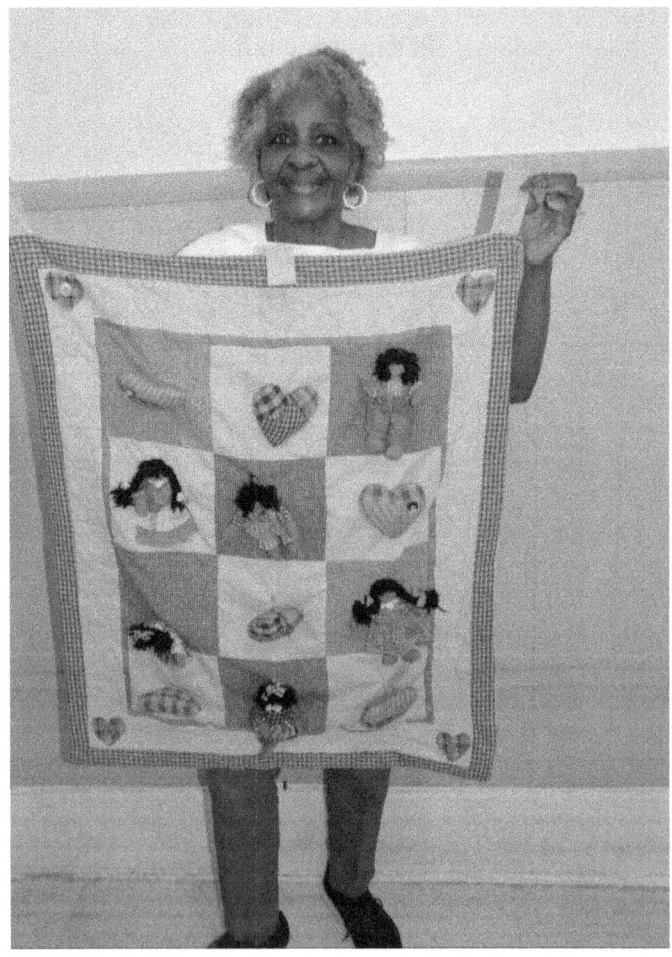

Emma Jean Milton

Patchwork Quilt made by Mrs. Virginia Griffin Stallings

This quilt was entered into the show by Carletha Durham who is the great granddaughter of Mrs. Virginia Griffin Stallings. This quilt was made for her when she went away to college. She is the granddaughter of Mrs. Cleo Stallings White of Rocky Mount, NC.

Mrs. Cleo Stallings White 65
Mrs. Virginia Griffin Stallings 85 (seated)

Annie Lee Robinson Young's Tailor Tack Quilt Mrs. Young is the mother of Lula Wilson

Annie Lee Robinson Young mother of Lula Wilson

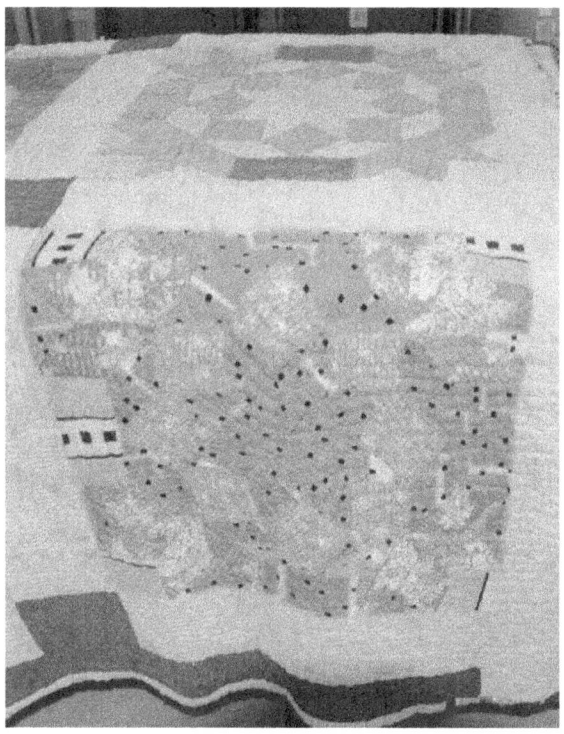

North Star Quilt made by Rosa Lee Bryant inherited by her daughter Mrs. Willie Nell Johnson. Quilt is 80 years old

Rosa Lee Bryant

Ms. Bryant moved to Savannah in 1952 and became a member of First Bryan Baptist Church. She joined the Usher Board and served for 50 years. In 1985 she retired from Georgia Regional Hospital as a cook.

Patchwork Quilt made by Mary Cochran mother of Beatrice Williams

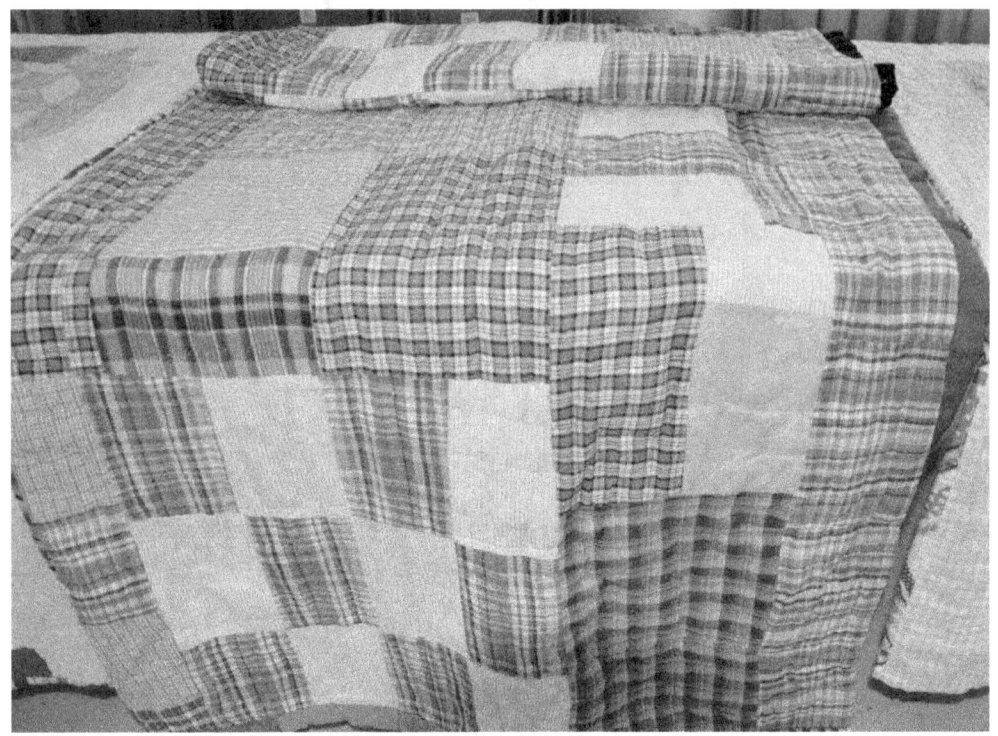

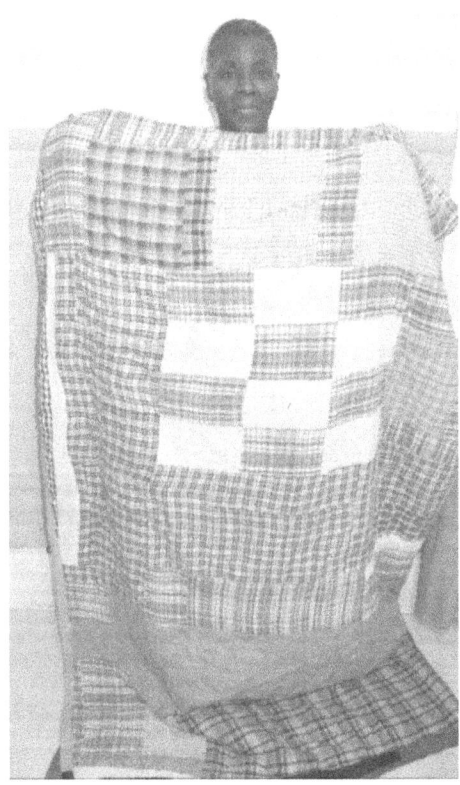

Beatrice Williams

Emma Jean Milton

Emma Jean Milton with patchwork quilt made by Elizabeth Holmes (Nurse Holmes)

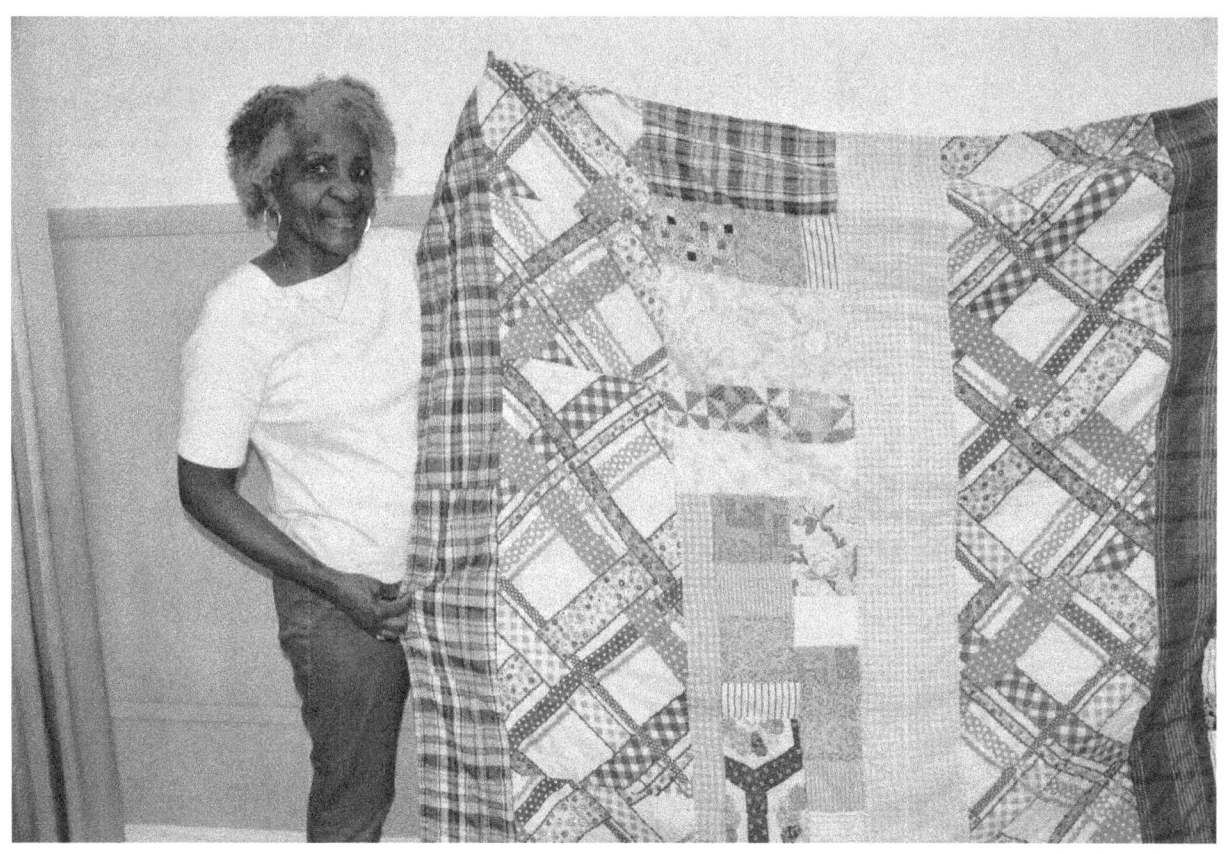

Renea K. Williams

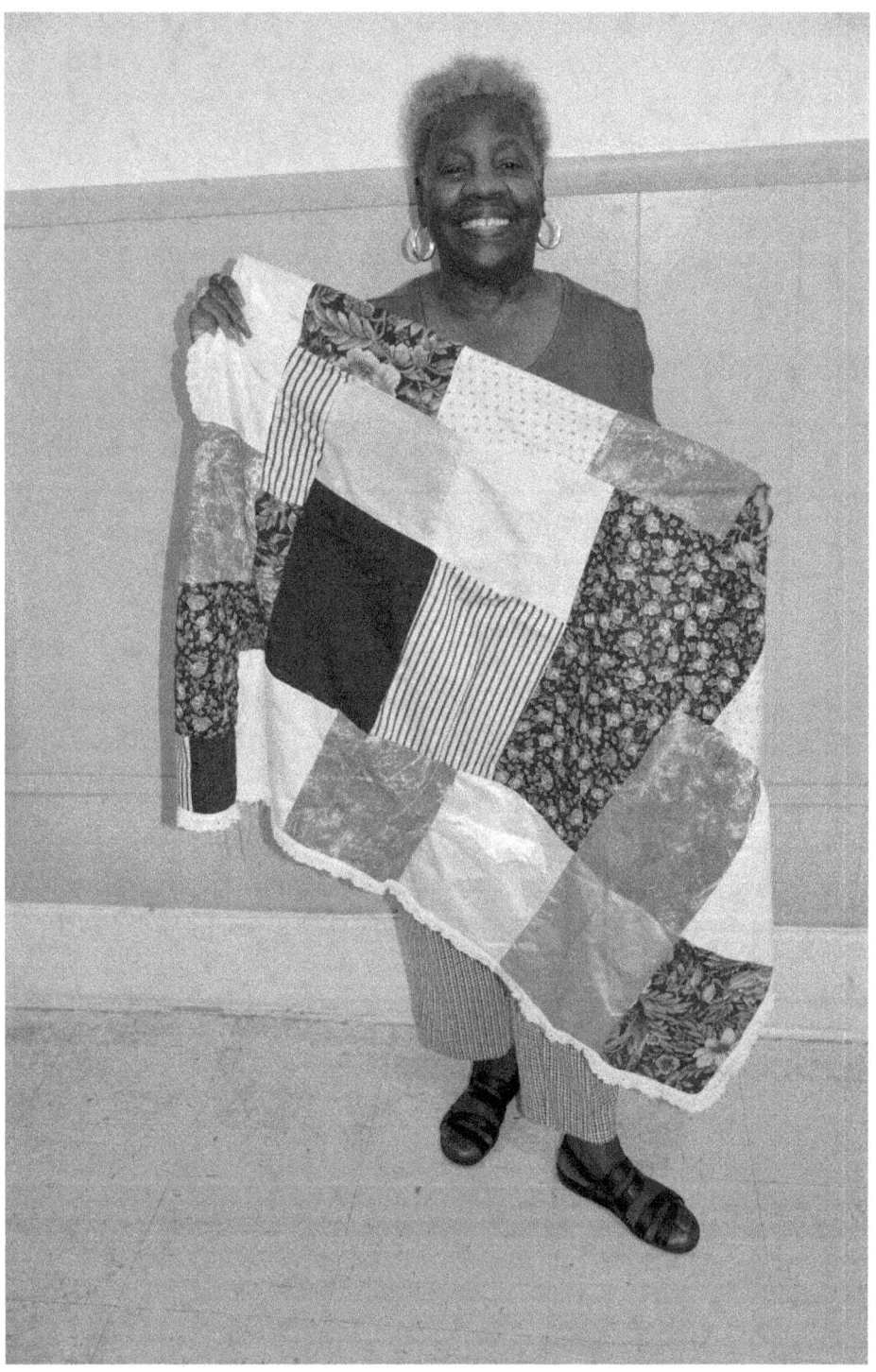

Renea K Williams with patchwork quilt
This quilt was made by her daughter, Sadatra Kitt, for her baby doll's bed

Crazy Quilt by Josephine Greene

Mikell Glover's grandmother, Josephine Greene, made this Crazy Quilt.
(quilt over 70 years old)

Josephine Greene (on left)
She is the mother of 11 children. She lived on a farm and sold produce to Red Top Community in Charleston, SC

Edna Brown

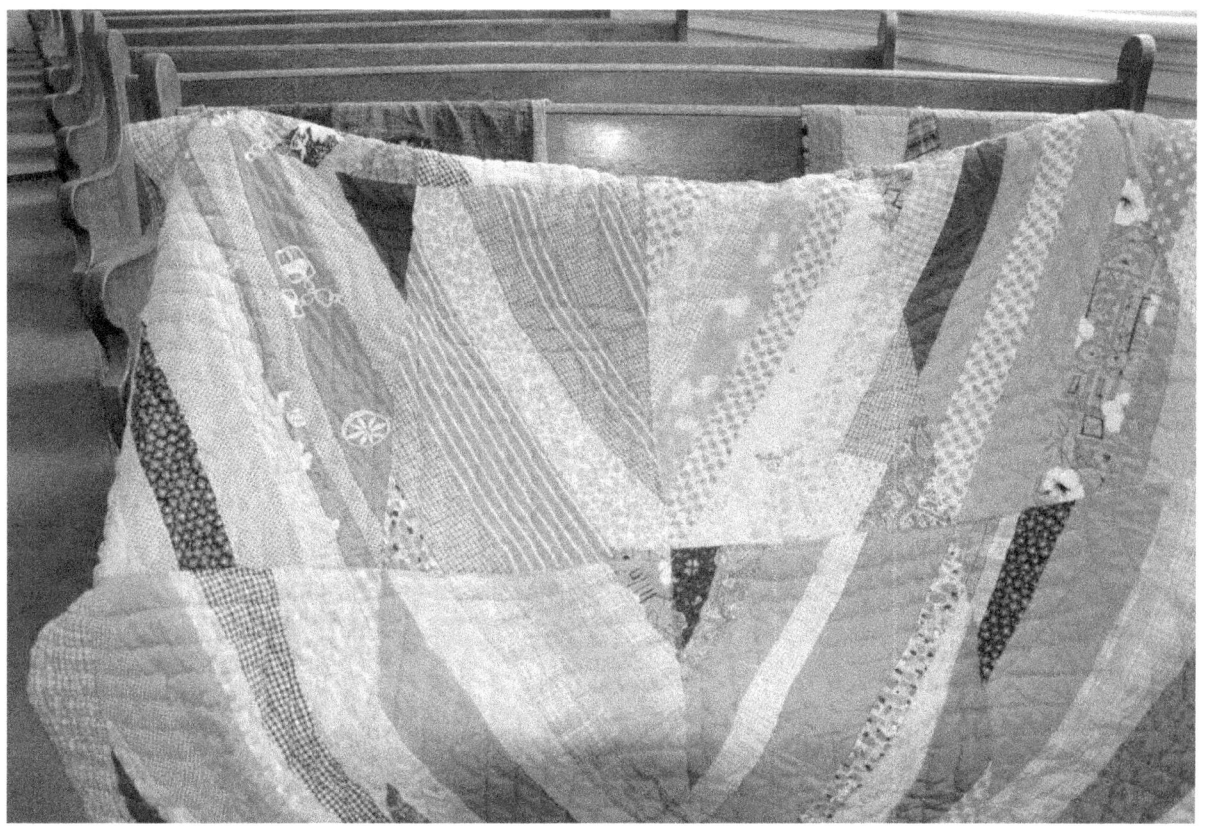

Scrappy Quilt made by her grandmother Mrs. Indiana Brigham in November 1975

Indiana Brigham

Eunice L. Feagin

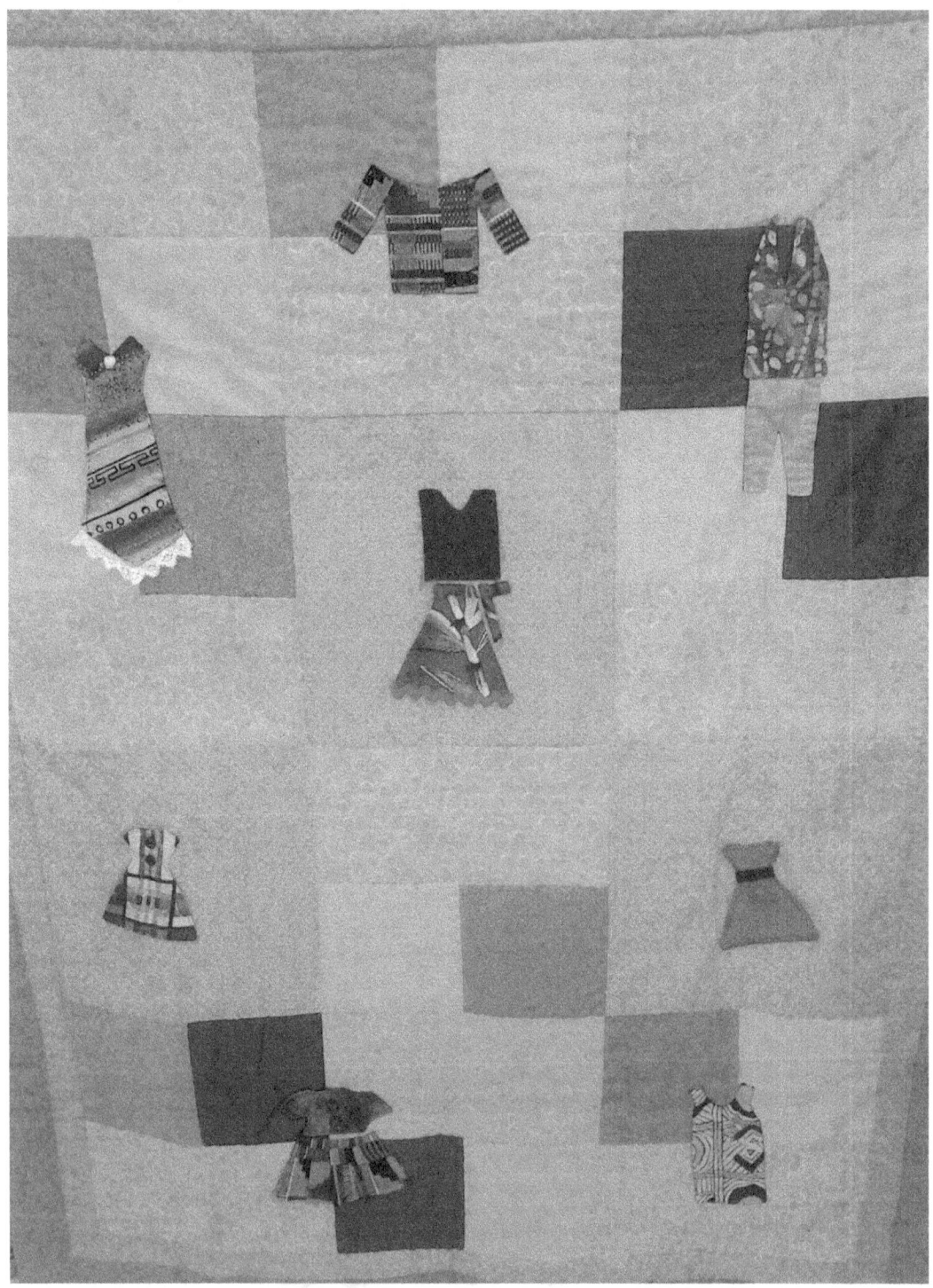

Clothes of Fashion Quilt

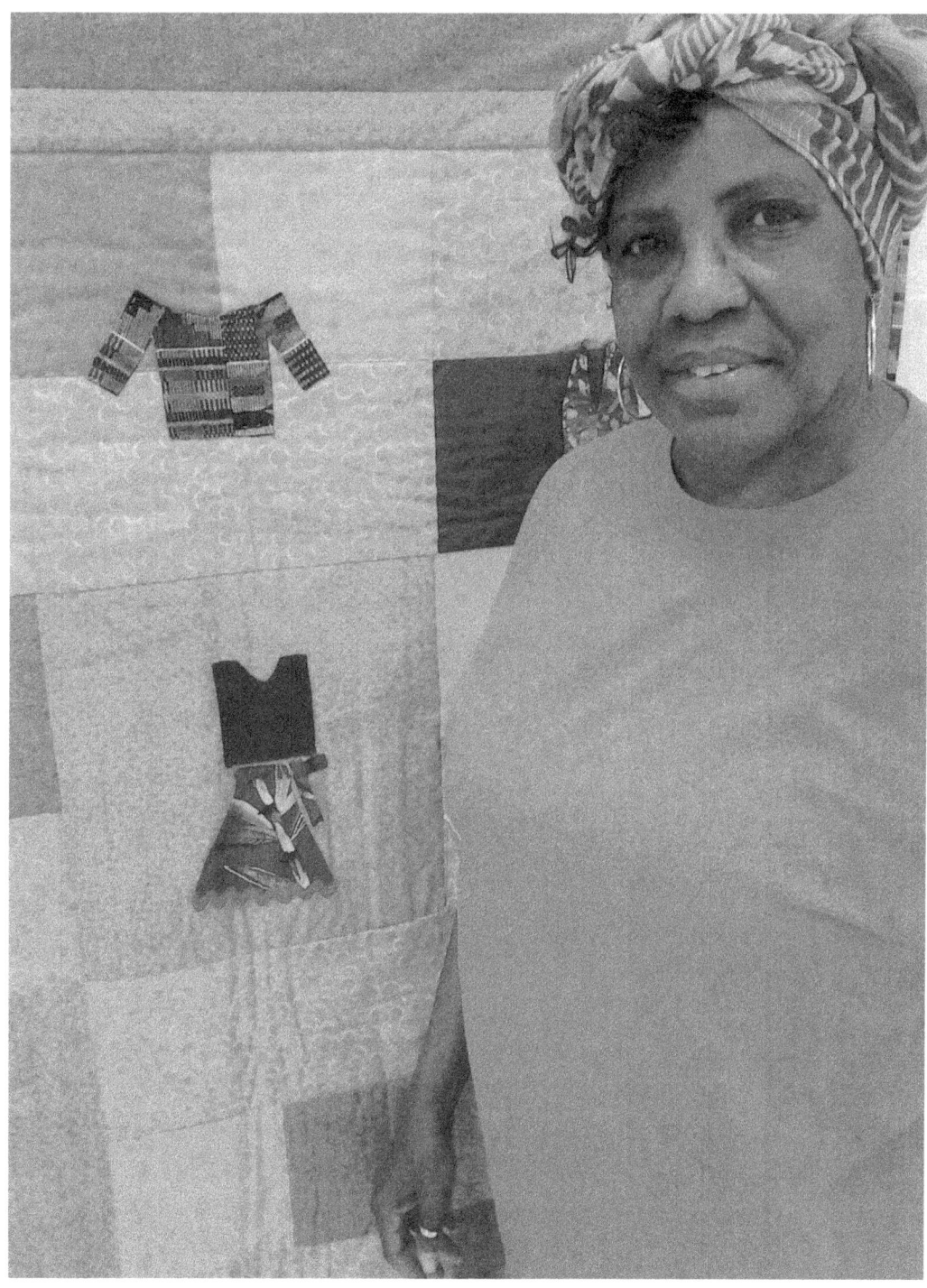

Eunice Feagin with her Clothes of Fashion Quilt

Sabrina Ware Wright

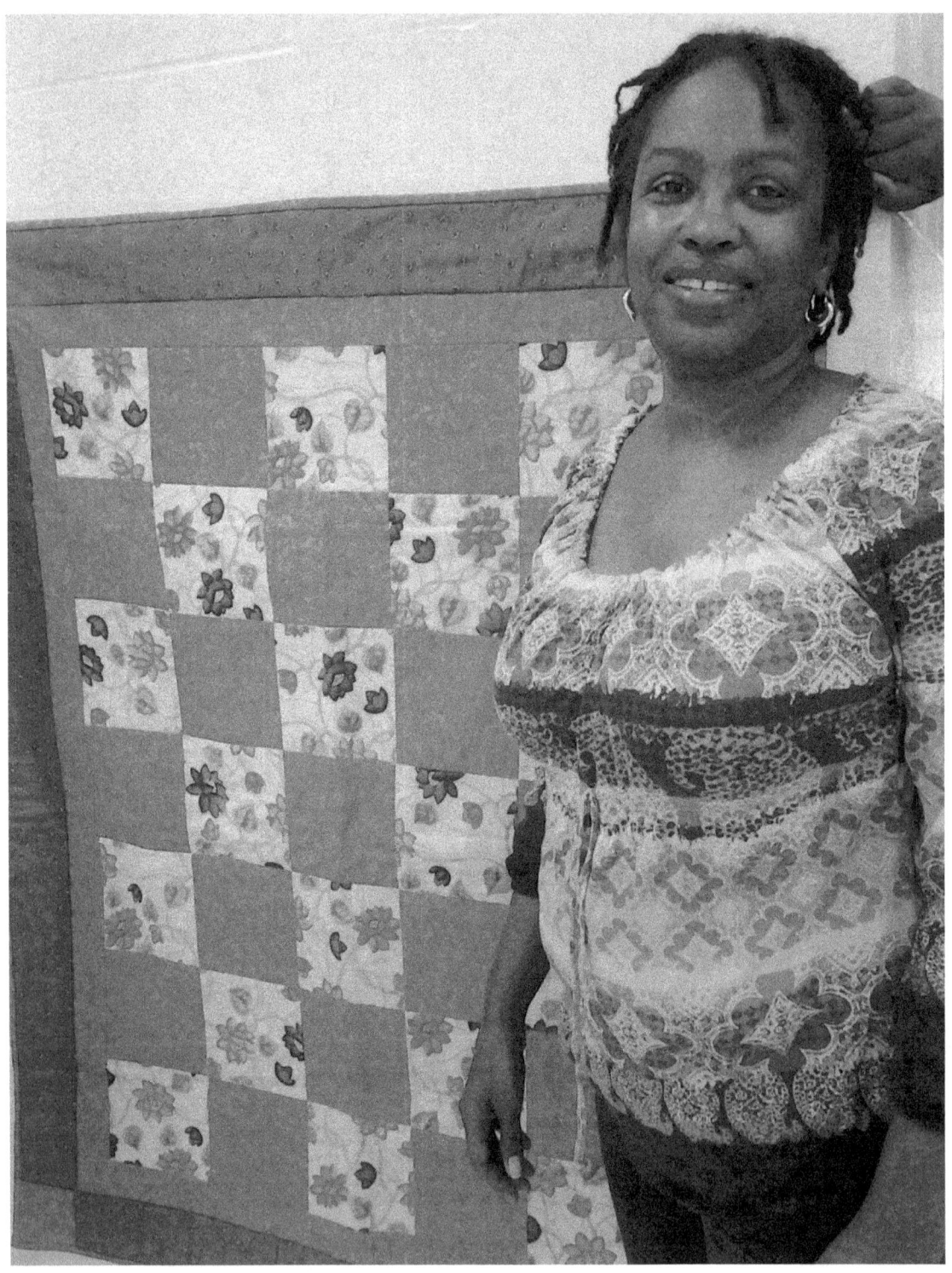

Sabrina Wright Checker Squares Quilt

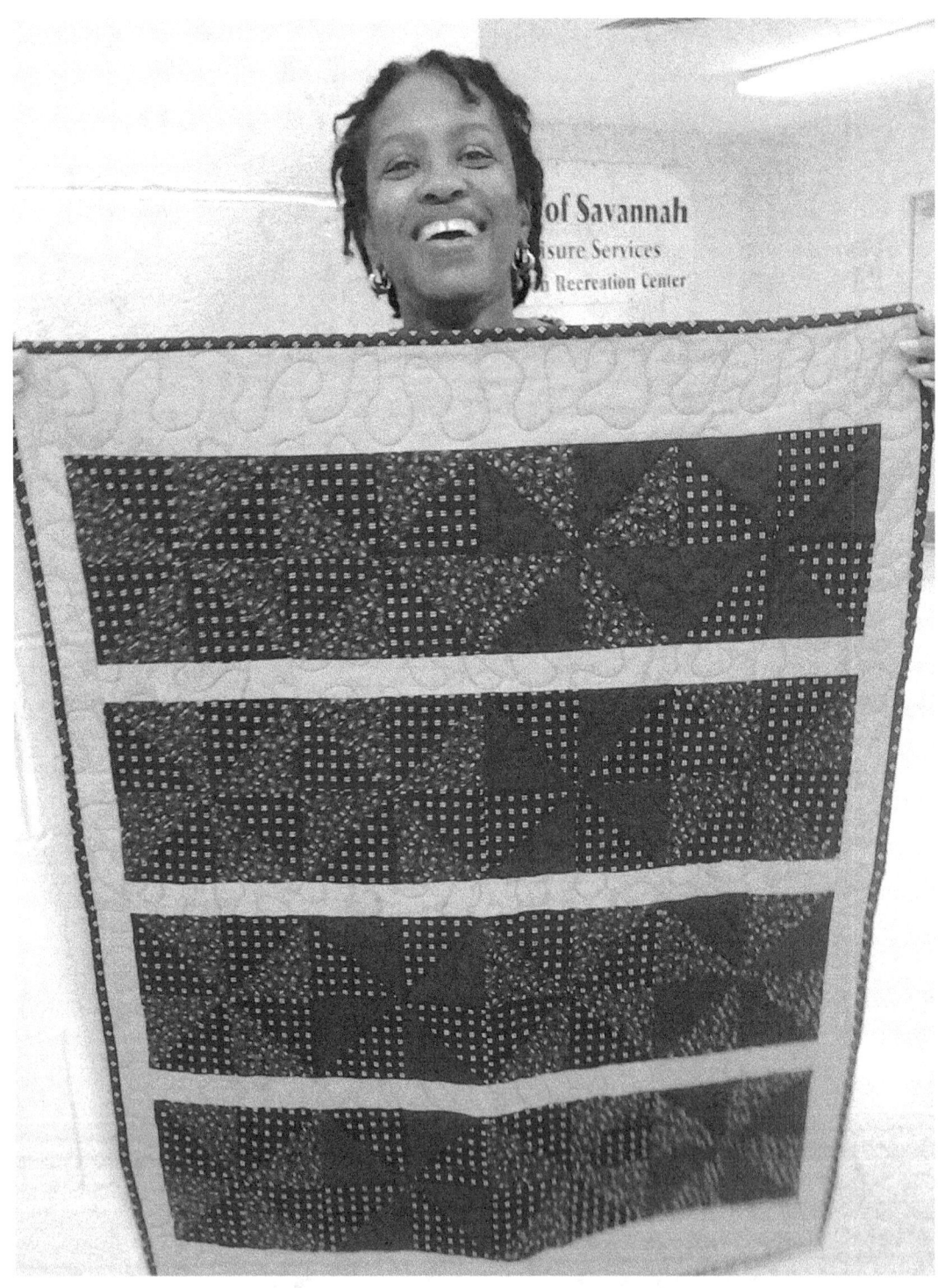

Sabrina Wright with her Green Pinwheel Quilt

Mt. Zion Baptist Church

1008 Martin Luther King Jr. Blvd., Savannah, GA

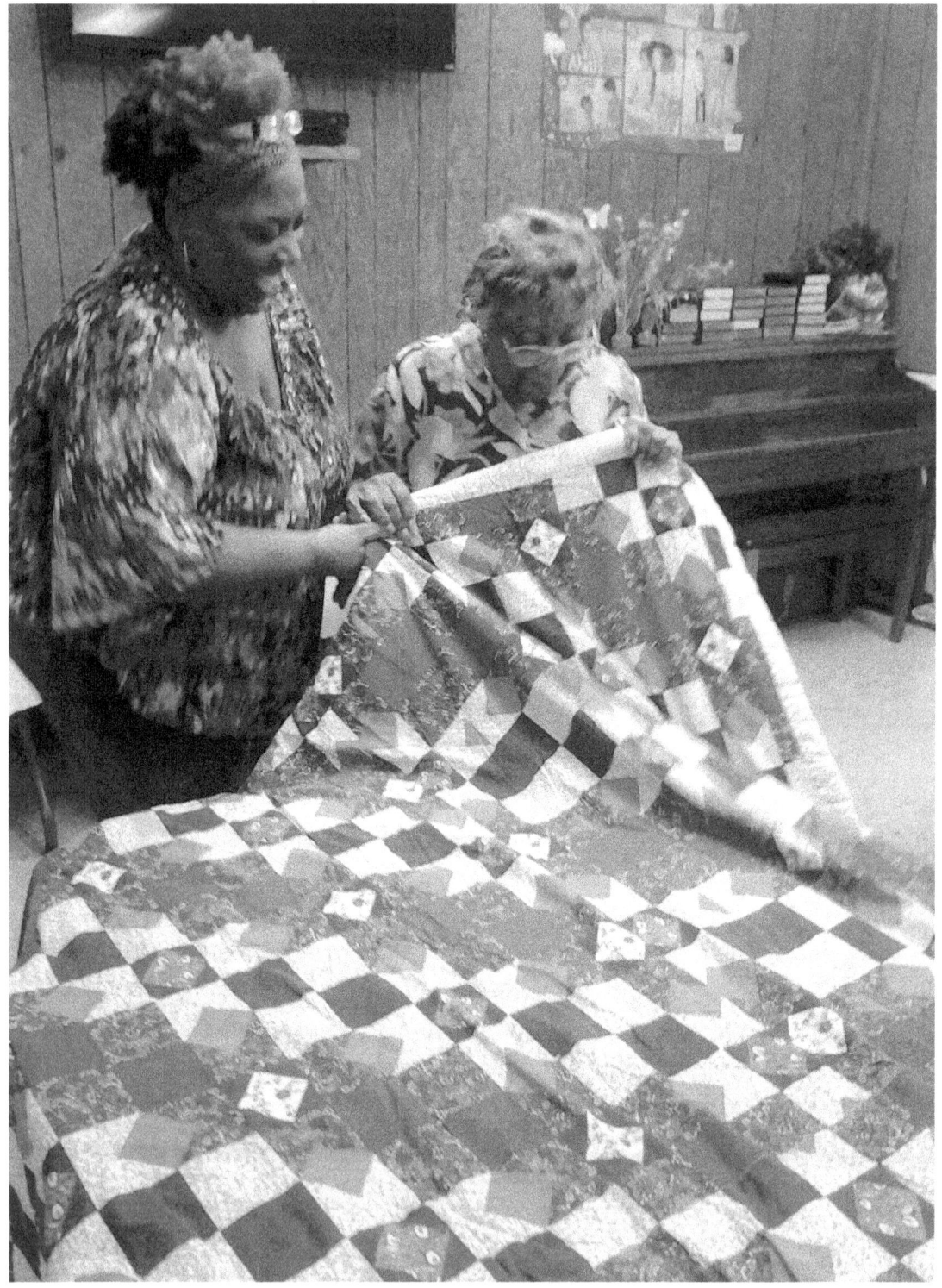

Tina Hicks helps Mrs. Clark get her quilt ready for the show

Beverly Smith

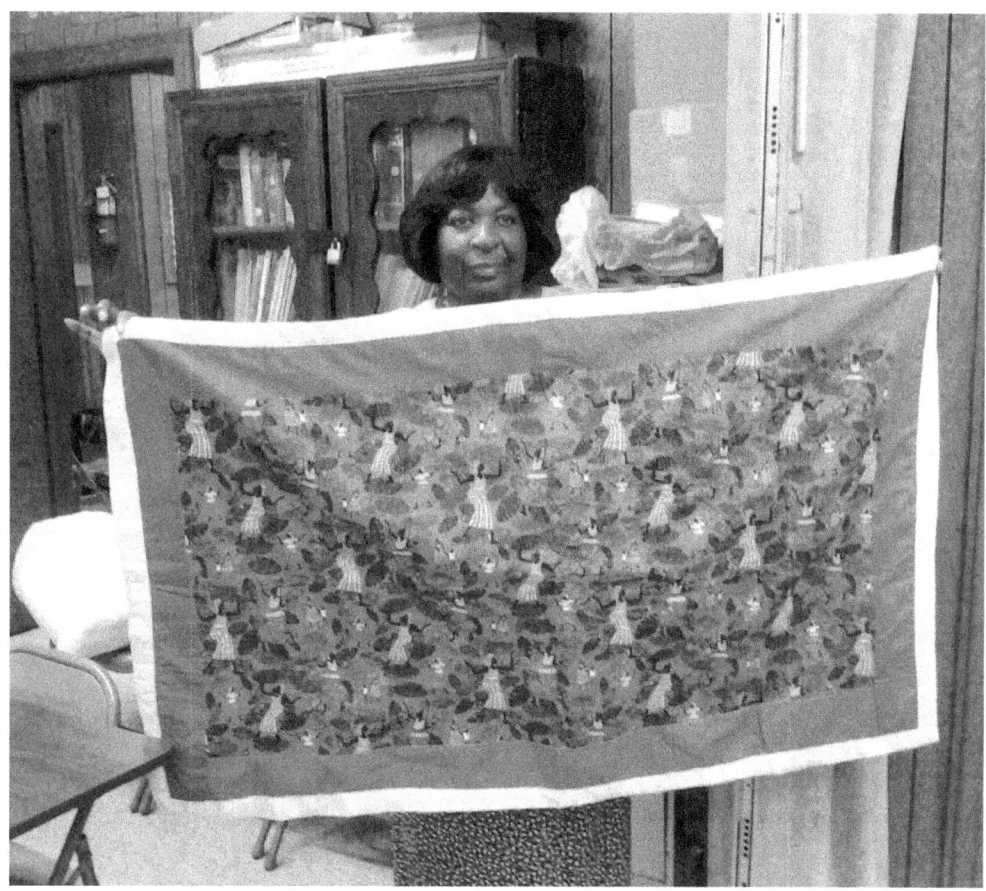

Beverly Smith Quilted Dancing Ladies Wall Hanging
She was a student of Mrs. Virginia Kiah and remembers her saying "Art is in Everything".

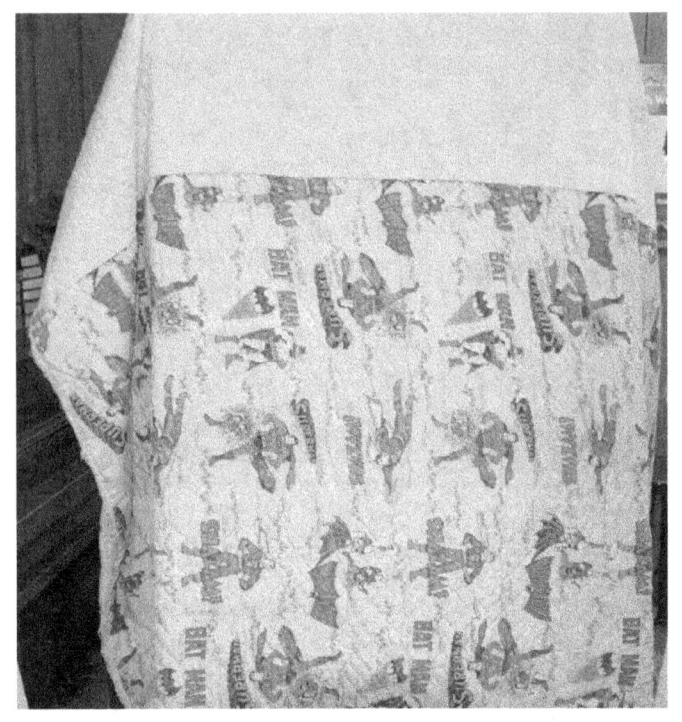

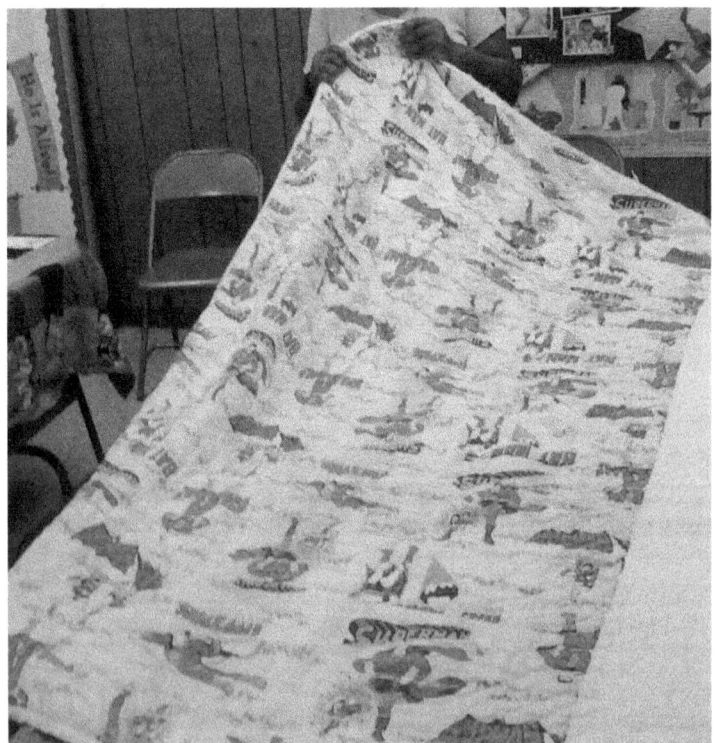

Mrs. Beverly Smith Superman Quilt

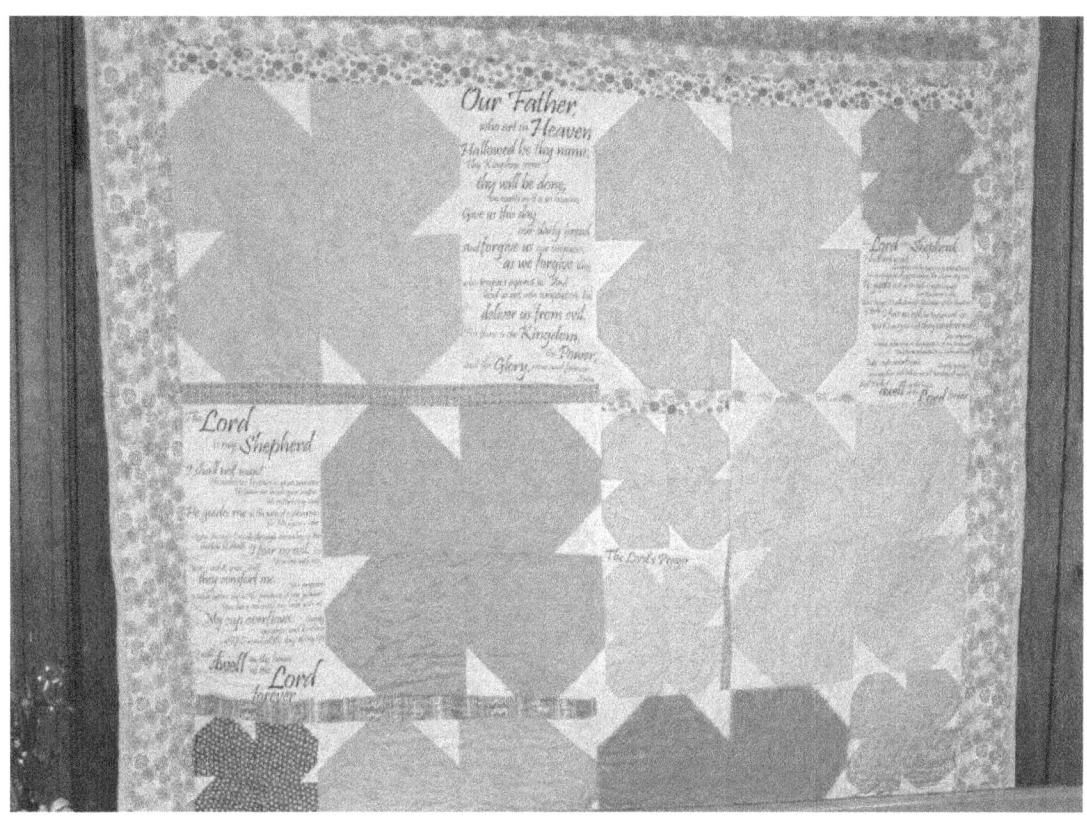

Mrs. Beverly Smith Patchwork Quilt

Mrs. Elaine Winbush

Mrs. Elaine Winbush, daughter's grandmother in law is Mrs. Queen Jackson, made this quilt and the quilt style is called "Prairie Points"

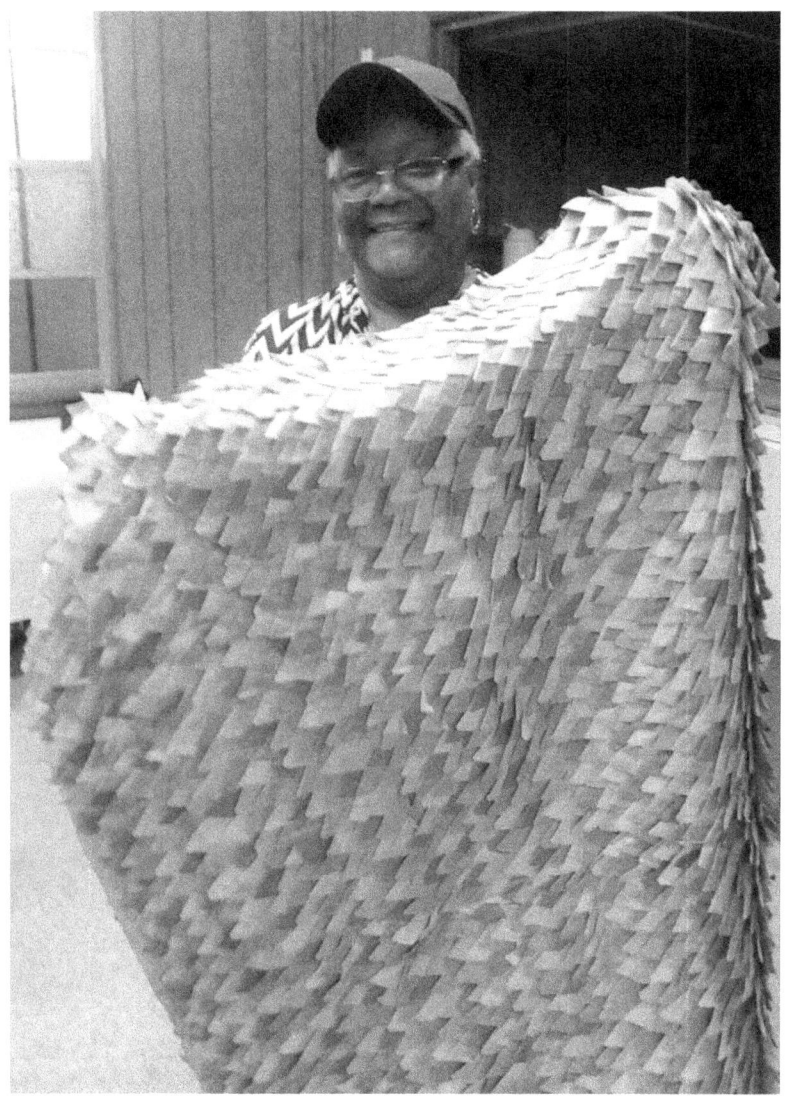

Prairie Points Pattern Quilt

Mrs. Winbush displayed the Prairie Points quilt which was made by her daughters' grandmother in law. This is a very unique display of fabric manipulation. Mrs. Winbush was born in Pompano Beach Florida. Her family moved to Savannah Georgia when she was a kindergartner. She's a graduate of Savannah High School, and Savannah State College. She taught at Hodge Elementary School. She has been married to Deacon Gregory Winbush for 50 years. They have 3 children, six grandchildren, and four great-grandchildren. They are also expecting to new arrivals. Mrs. Winbush has been a member of Mt. Zion Baptist Church since age 12. She lives by the affirmation, "Make Christ the Head of Your Life".

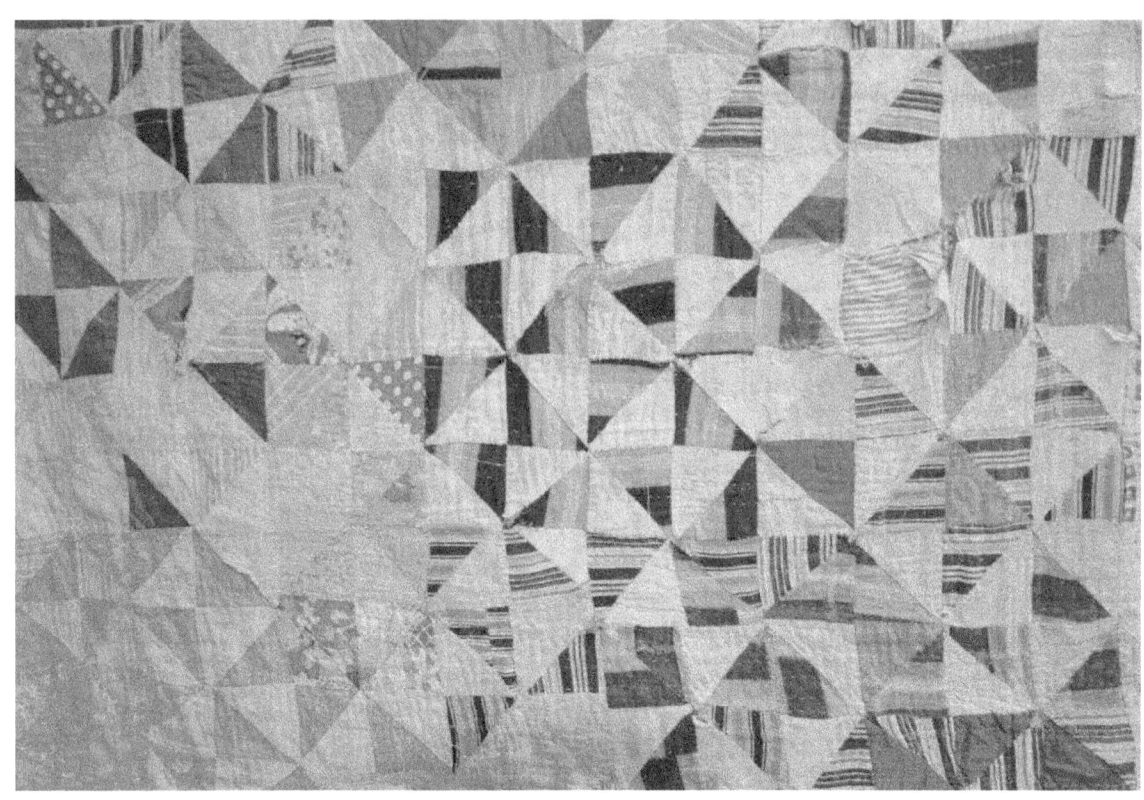

Pinwheels and Bowties Pattern Quilt

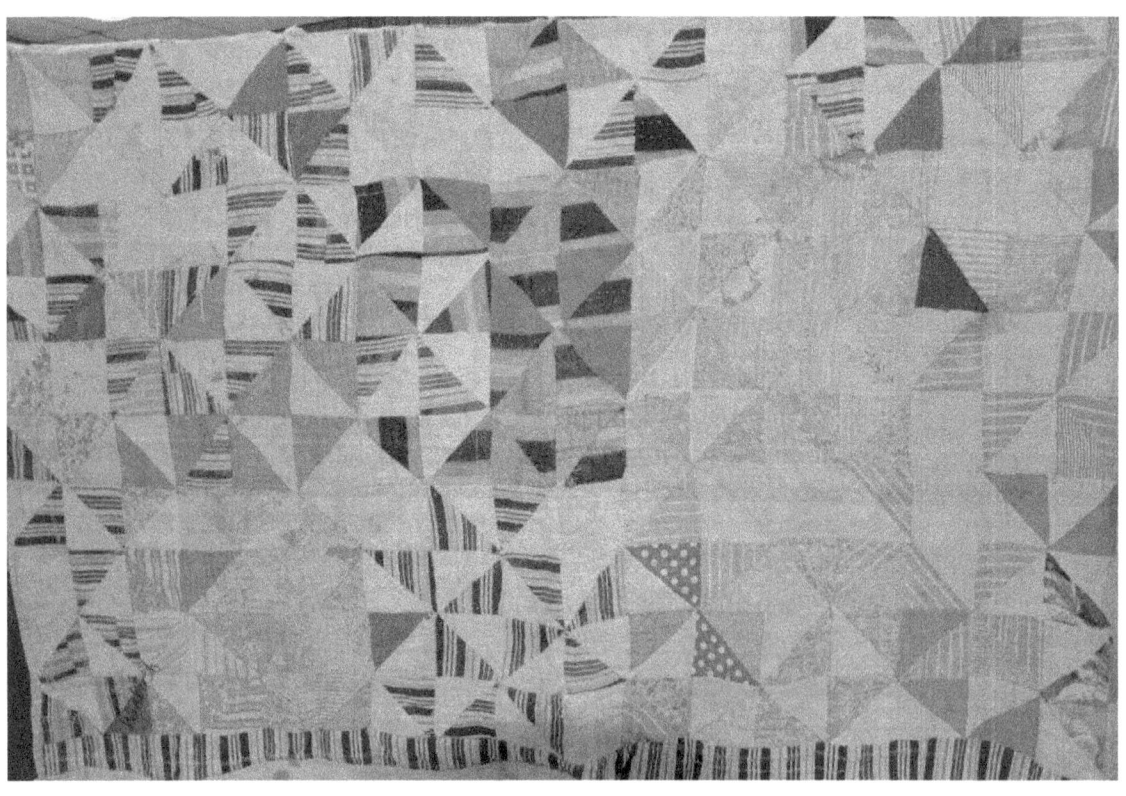

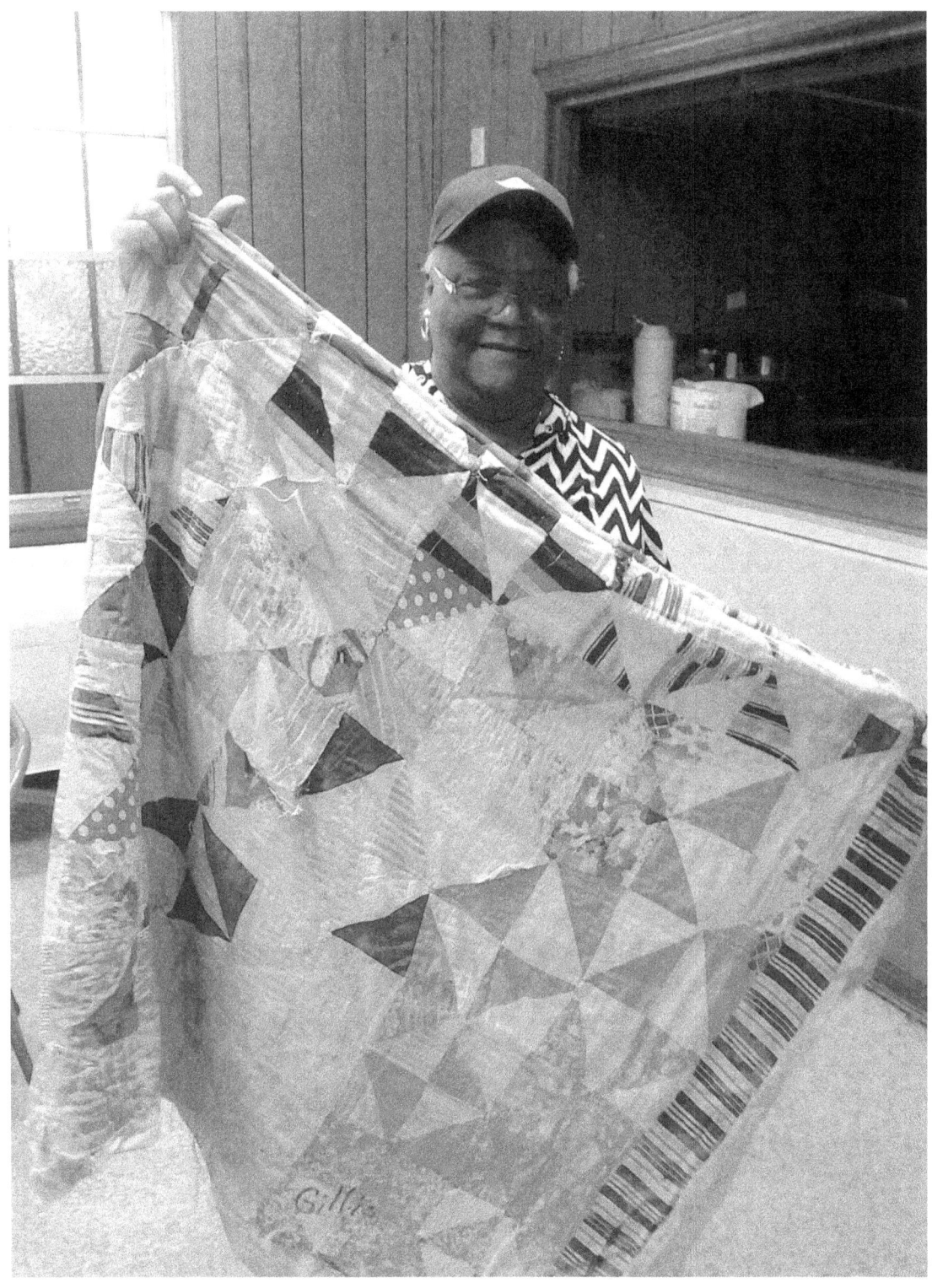

Elaine Winbush with her Pinwheels and Bow Tie pattern quilt

Sealey Hooker

Sealy Hooker's North Star pattern quilt

Sealey Hooker's Patchwork Block Quilt (Stripe made by Wilhelmina Brown)

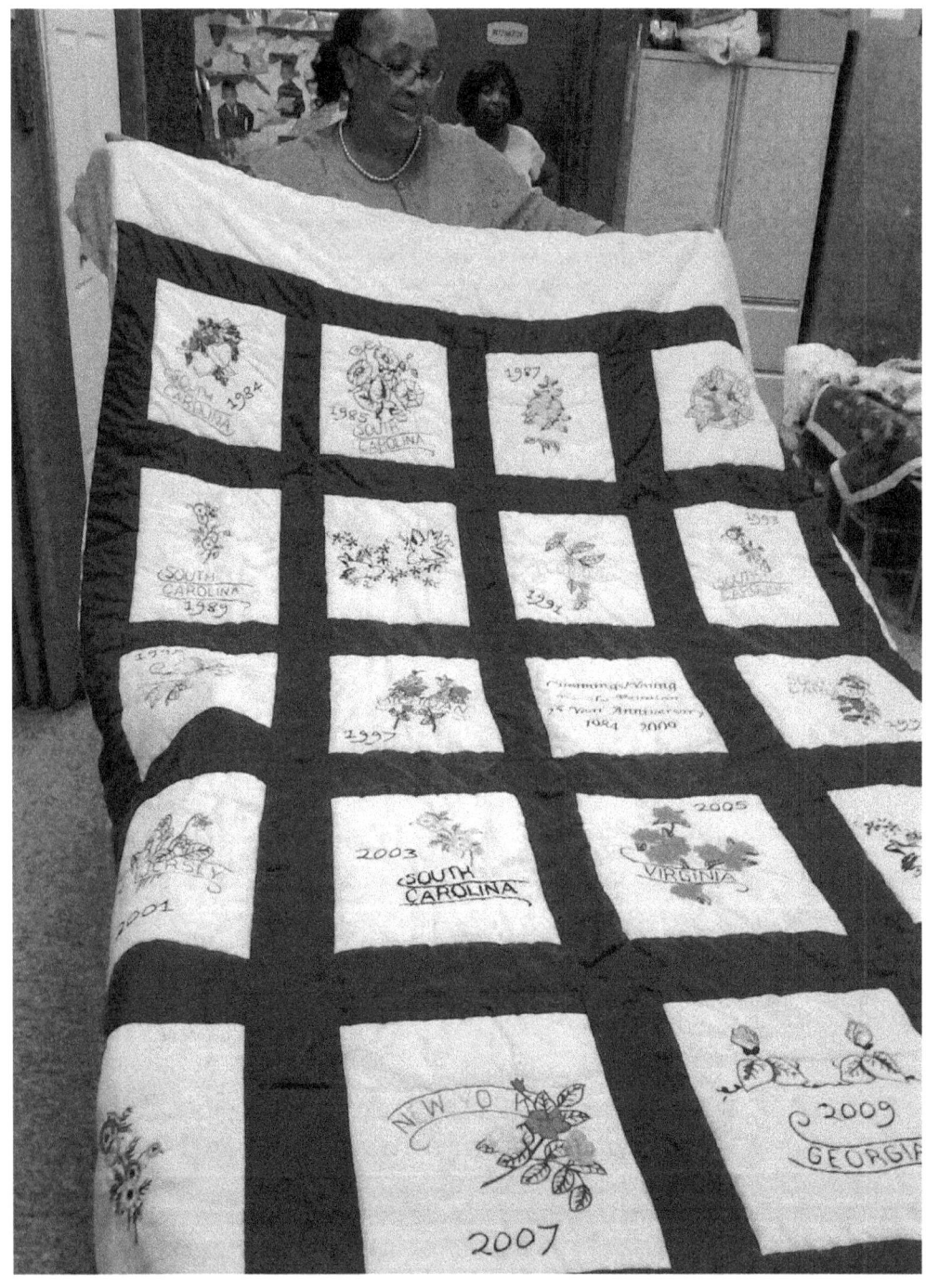

Sealey Hooker shows off her "Family Reunion Quilt" that was made by Gloria Brown

Mrs. Sealey Hooker's "All Over Plaid Quilt"

"This All Over Plaid Quilt is a favorite of the men folk in my family"

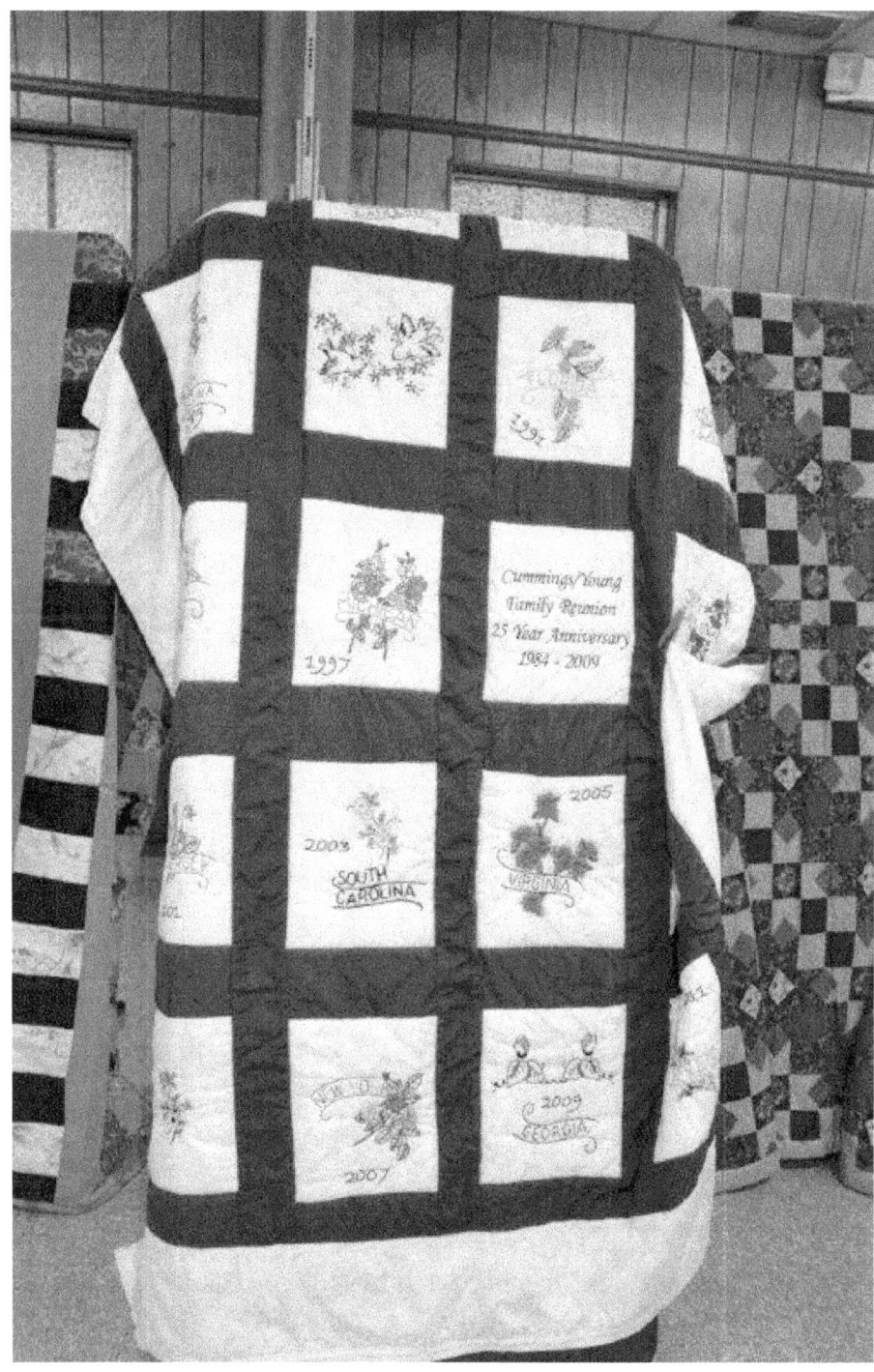

Mrs. Sealey Hooker Family Reunion Quilt (Made by Gloria Brown)

Four Patch Diamond Quilt by Dorothy Clark

Mrs. Dorothy Clark

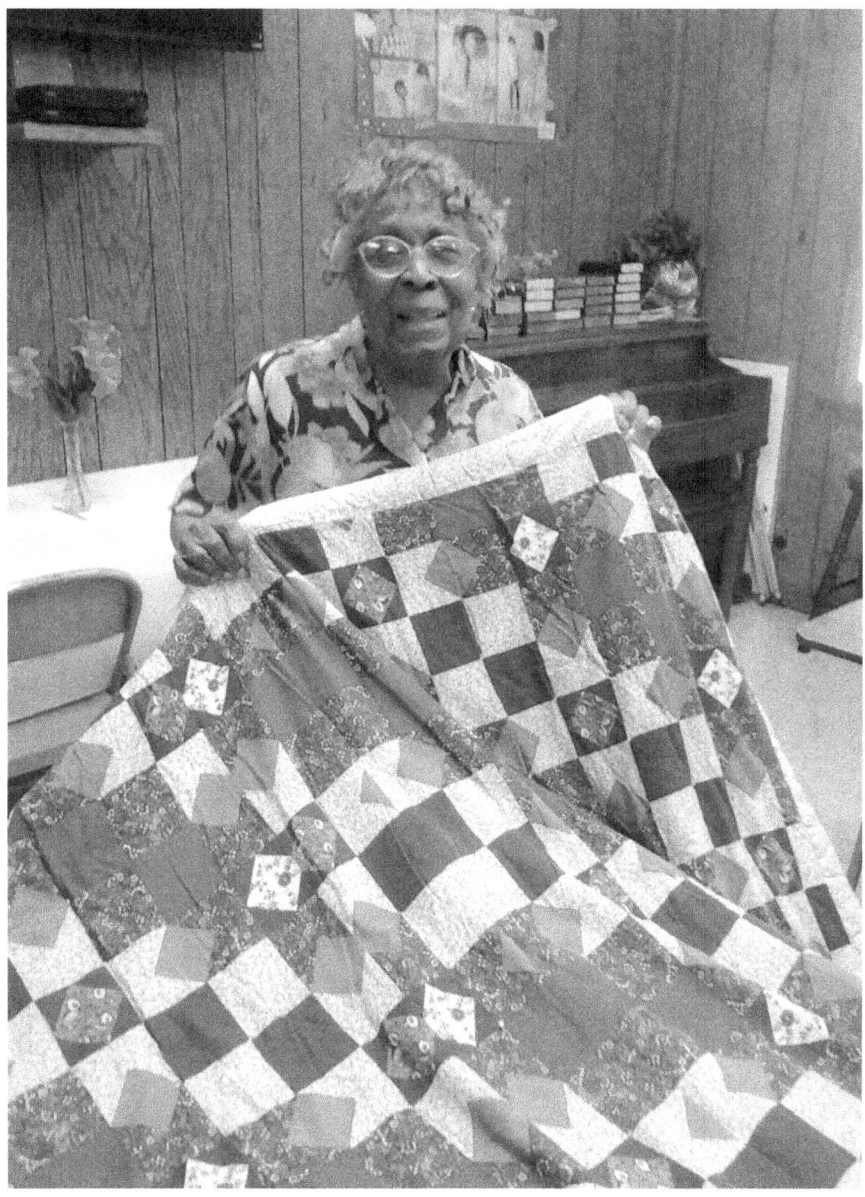

Mrs. Clark is very proud of the Senior Adult Ministry at Mt Zion Baptist Church. The Senior Adult Ministry has had over 100 members at one session. The Ministry is known for the Jingo game, the Bible form of bingo. Members enjoyed the game because it tested their Bible knowledge. Mrs. Clark is also very proud of the quilts made by the members. The quilts where often sold to church members. A good time is had by all who attend the Senior Adult Ministry, participating in arts and crafts, and games; however time does bring a change, and members pass away, but the spirit of joy remains. Mrs. Clark is a lifelong member of Mt Zion and is President of the Senior Adult Ministry. She is a Savannah native. She quilts, crochets, and is a doll maker.

Dorothy Clark's Crochet Work

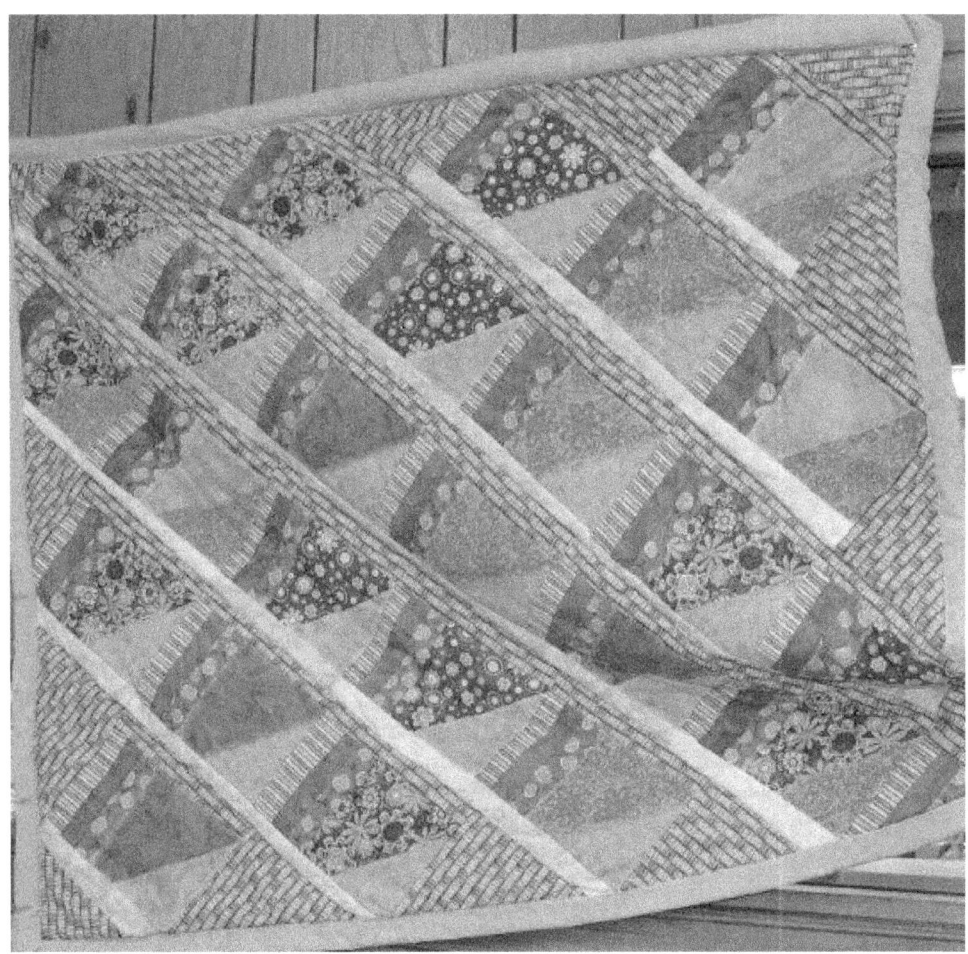

Mrs. Betty Williams (My first quilt) Patchwork

Betty Cohen Williams

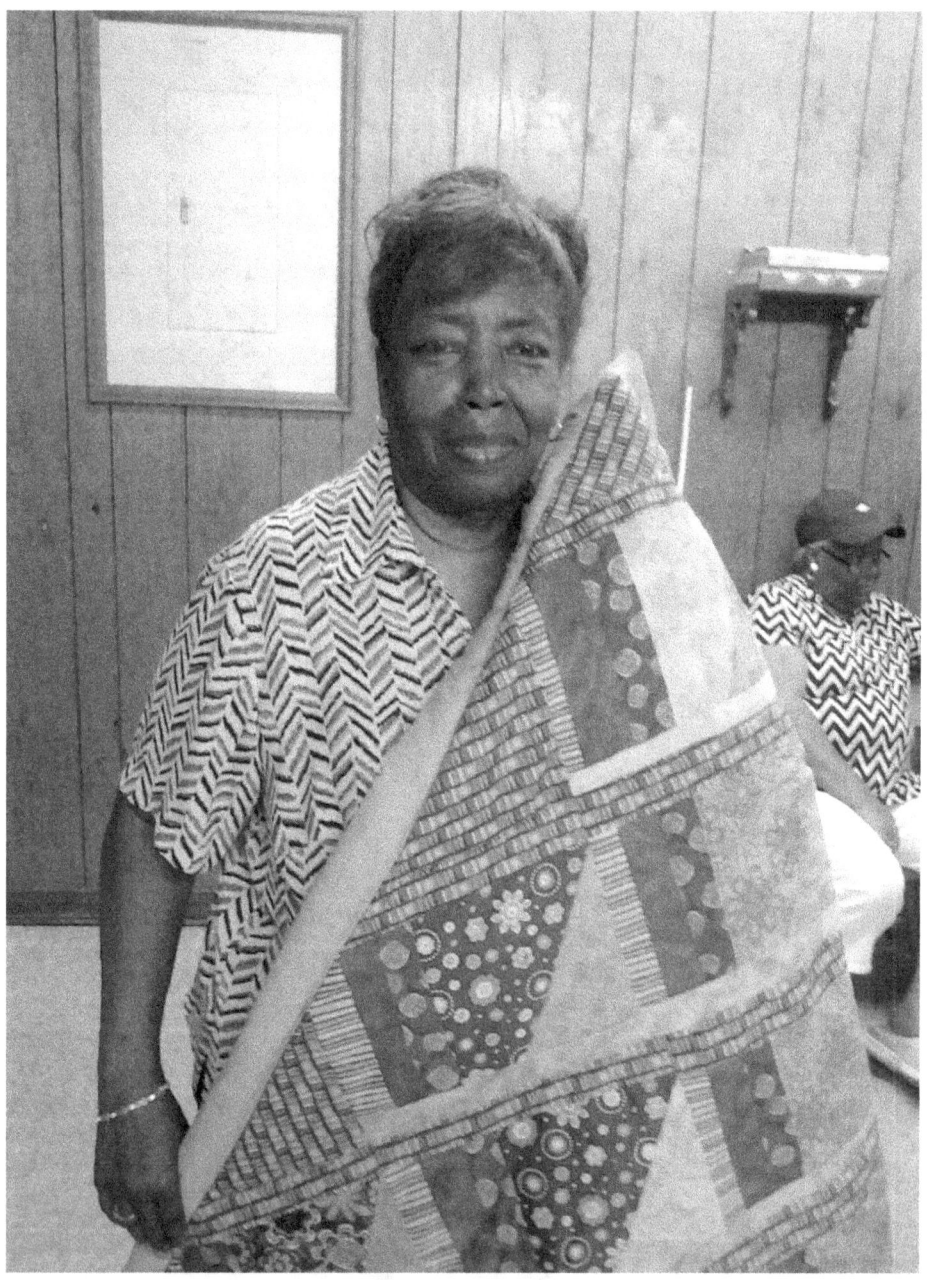

Savannah native and graduate of both Savannah State College and Armstrong State College where she earned her Masters' Degrees. Mrs. Williams taught Art in the Savannah Public Schools for 33 years. After retirement she continued to work with children gaining employment with the City of Savannah as Leisure Services Supervisor for 18 years. Mrs. Williams has been a member of Mt Zion Baptist Church since she was 12 years old and serves as the Sunday School Superintendent. She made her first quilt at Moses Jackson Golden Age Center.

Betty Williams' Wedding Ring Pattern Quilt

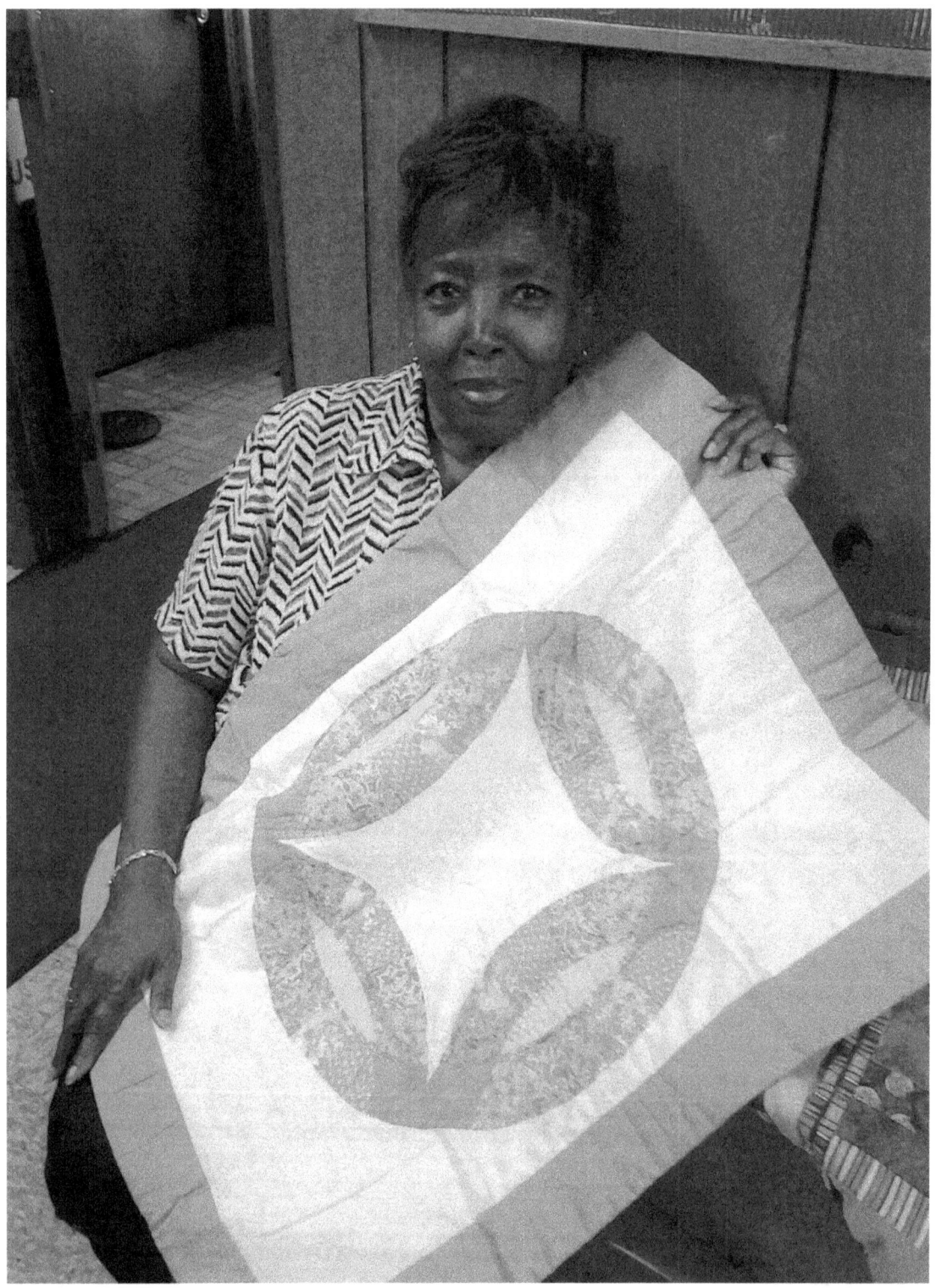

Mrs. Williams holds one of her favorite quilt creations

The Quilt Ladies of Mt Zion Baptist Church

L-R: Mrs. Clark, Mrs. Betty Williams, Mrs. Sealey Hooker, Mrs. Winbush

Mary Flournoy Golden Age Quilters

1101 W. 39th St., Savannah, GA

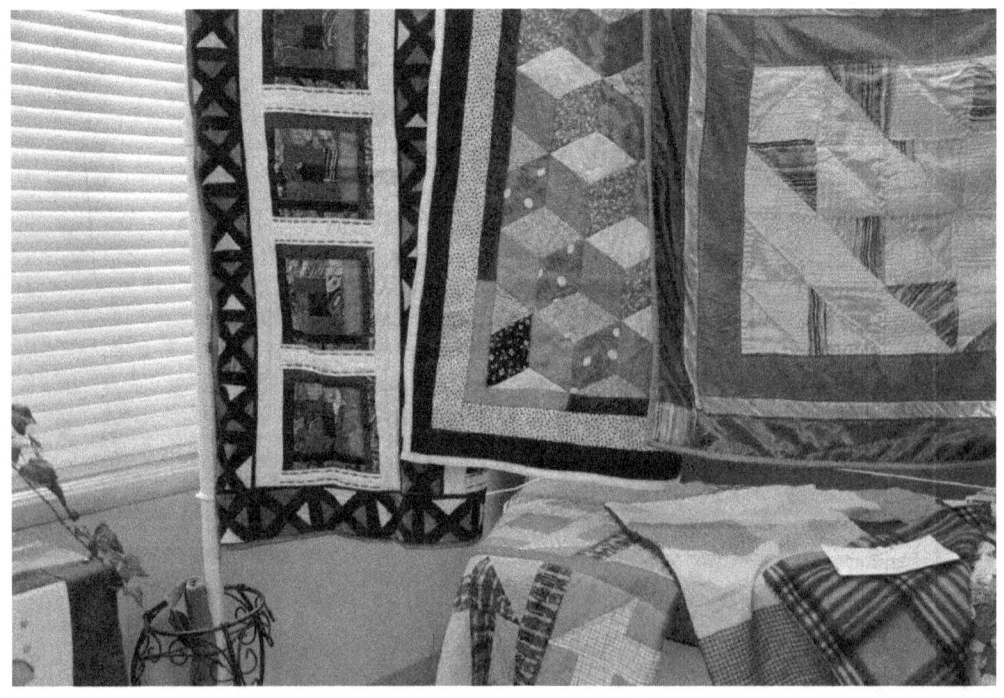

Patchwork quilts

Patchwork Quilts by Mattie Jones

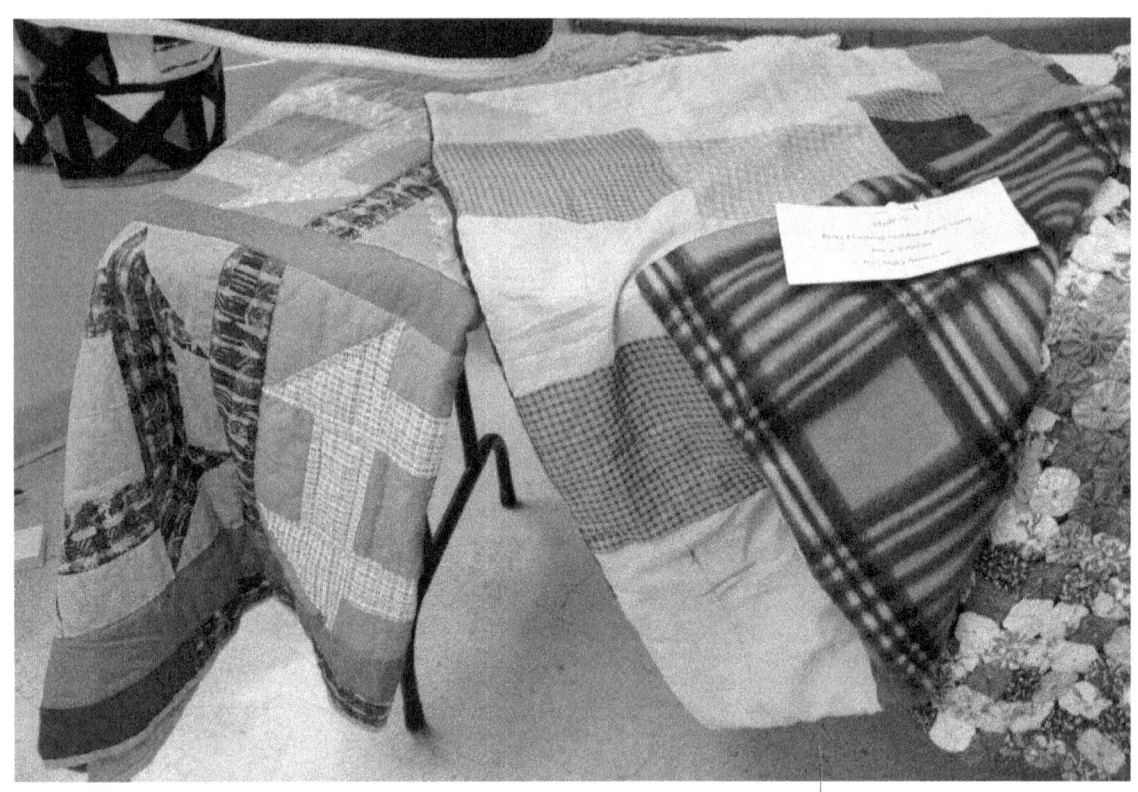

Rebecca Johnson Monkey Wrench (left)

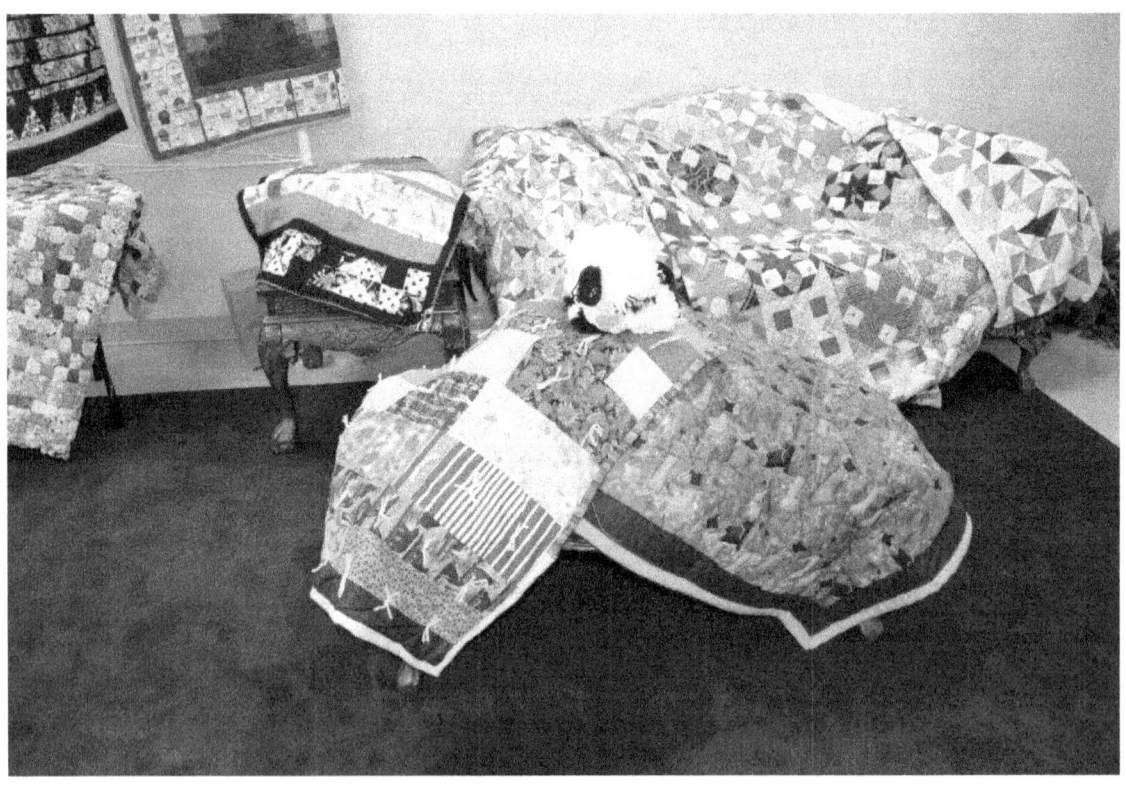

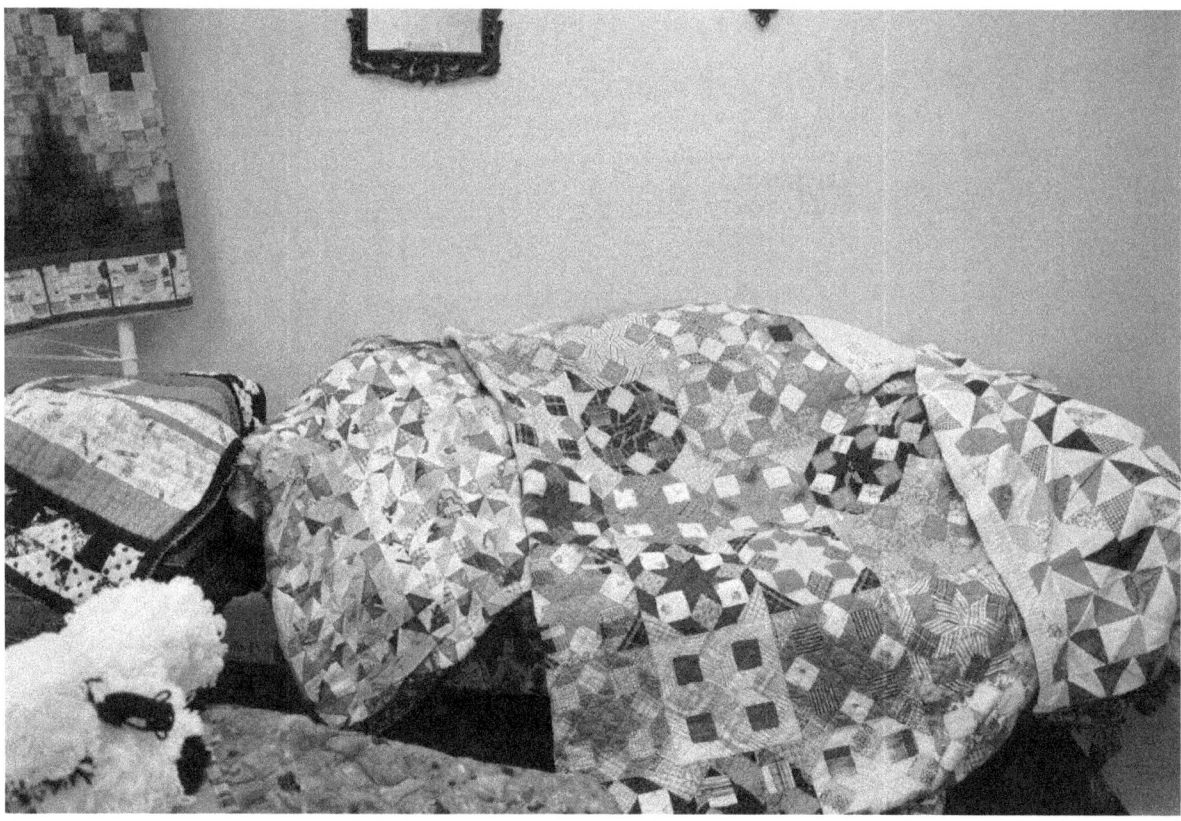

Pillows and Patchwork lap throw

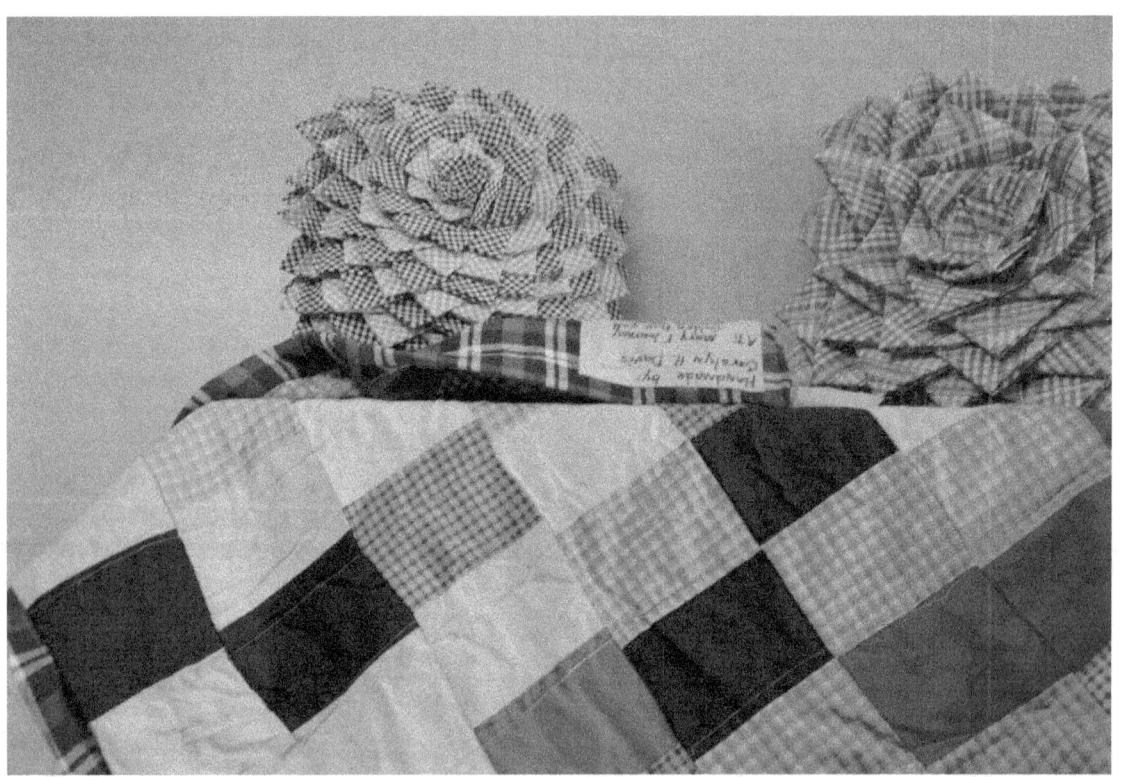

Patchwork lap throw made at Mary Flournoy

Patchwork quilt made by Rosa Thomas the mother of Mrs. Ora Gamble

Top made by Rosa Thomas mother of Mrs. Ora Gamble and quilted at the Mary Flournoy Golden Age Center

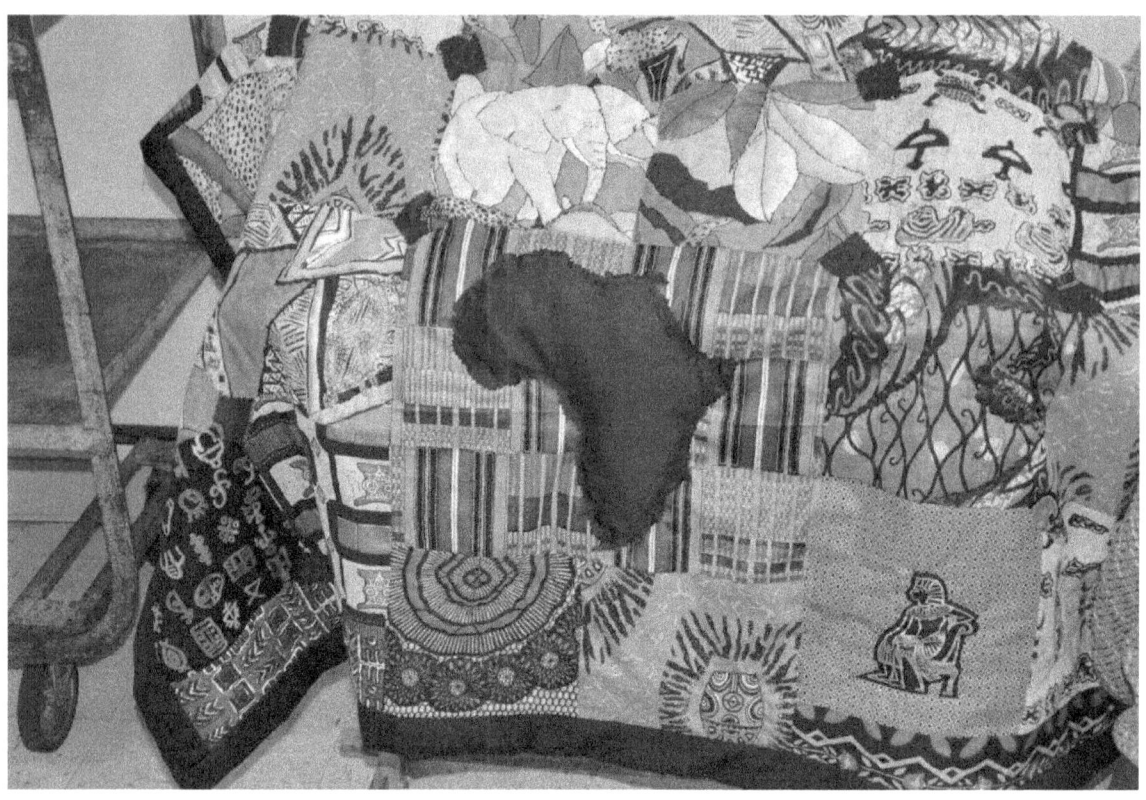

Jessie Stevenson Patchwork with Applique'

Dancing Ladies Quilt made by Rebecca Johnson

Something About Me Quilt

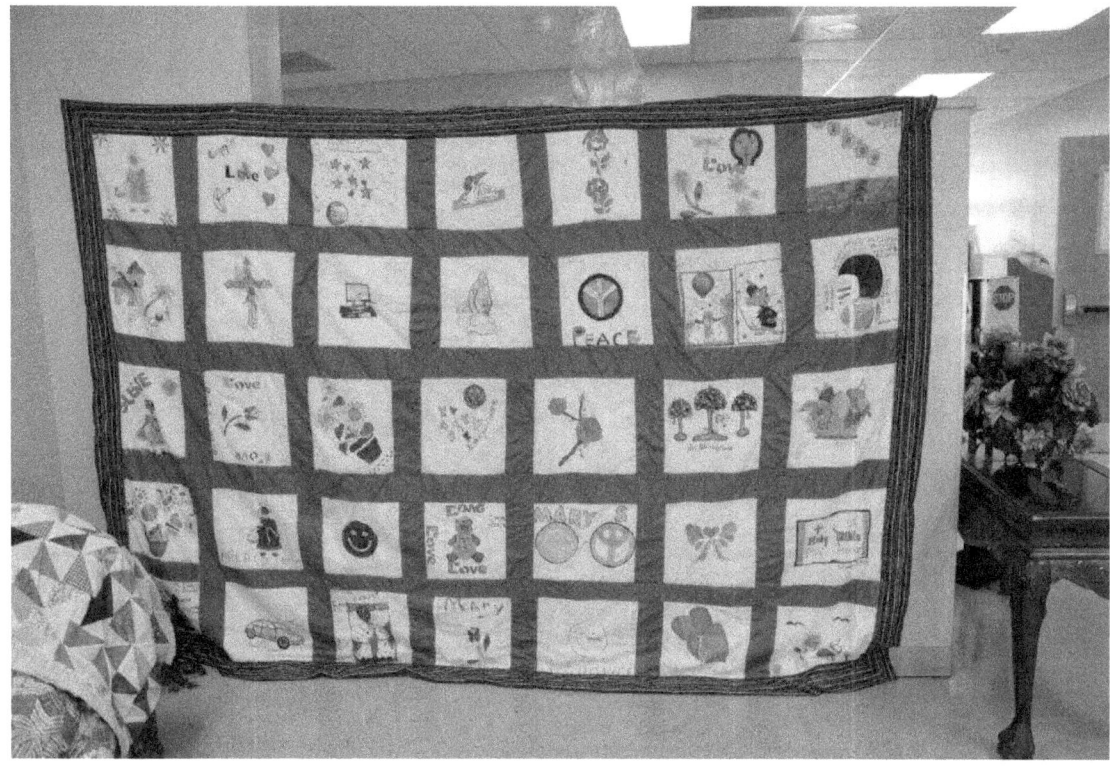

Seniors at Mary Flournoy Golden Age, and staff designed a quilt square which would display something unique about their personality. Paints, markers, and embroidery threads were used to produce the beautiful quilt. These quilt blocks share their love of flowers, families, their pets, and their favorite Bible verse.

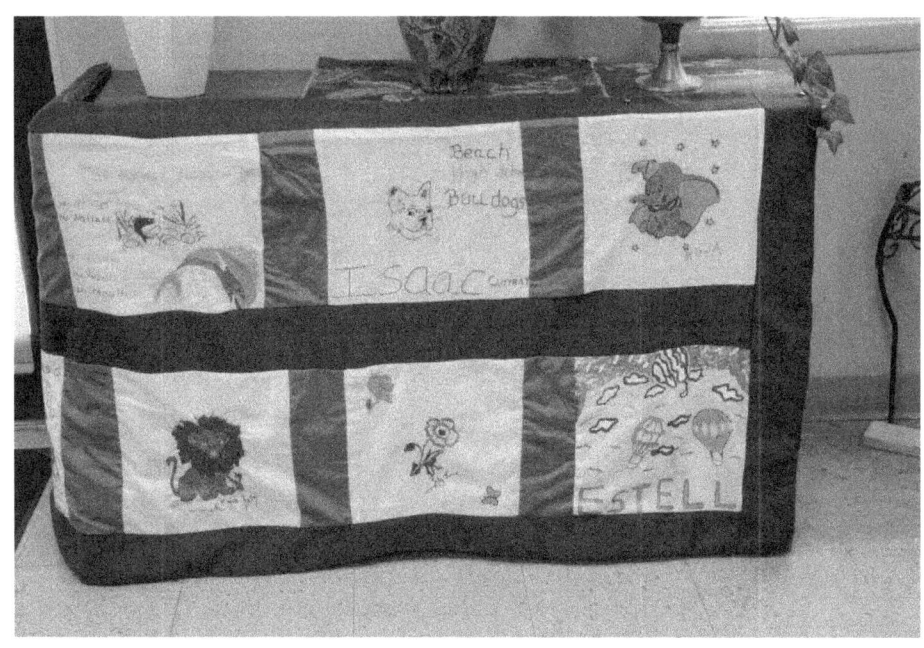

Tina Hicks at the quilt show at Mary Flournoy

Mrs. Ora Gamble

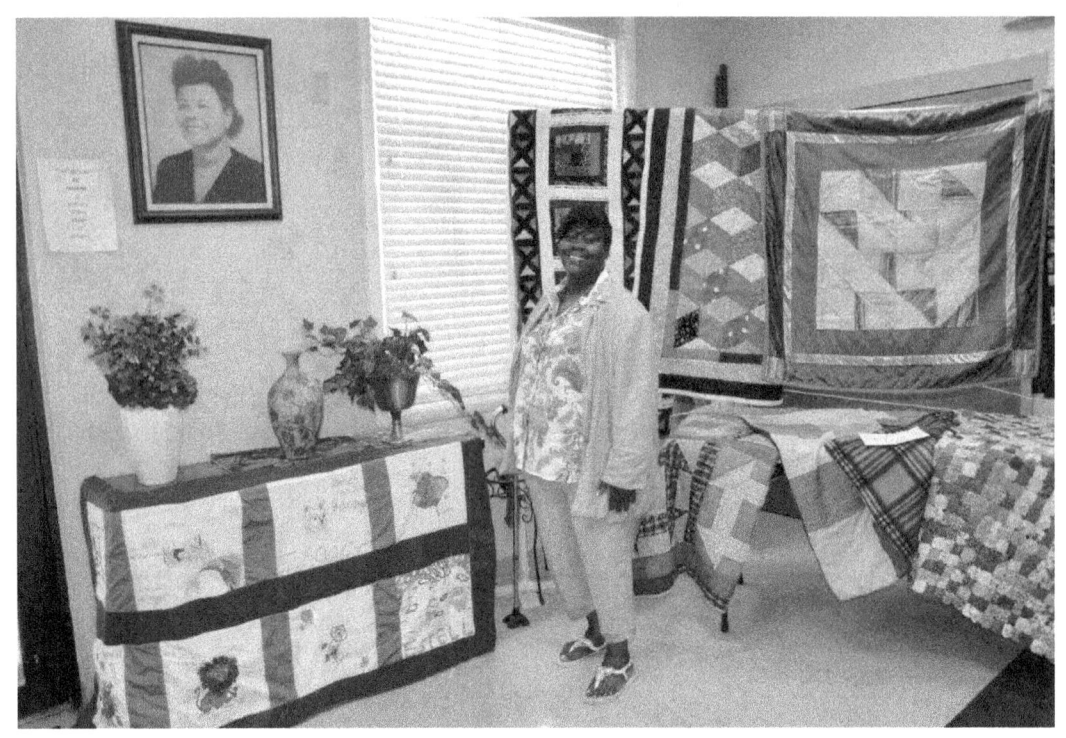

Deborah Anthony

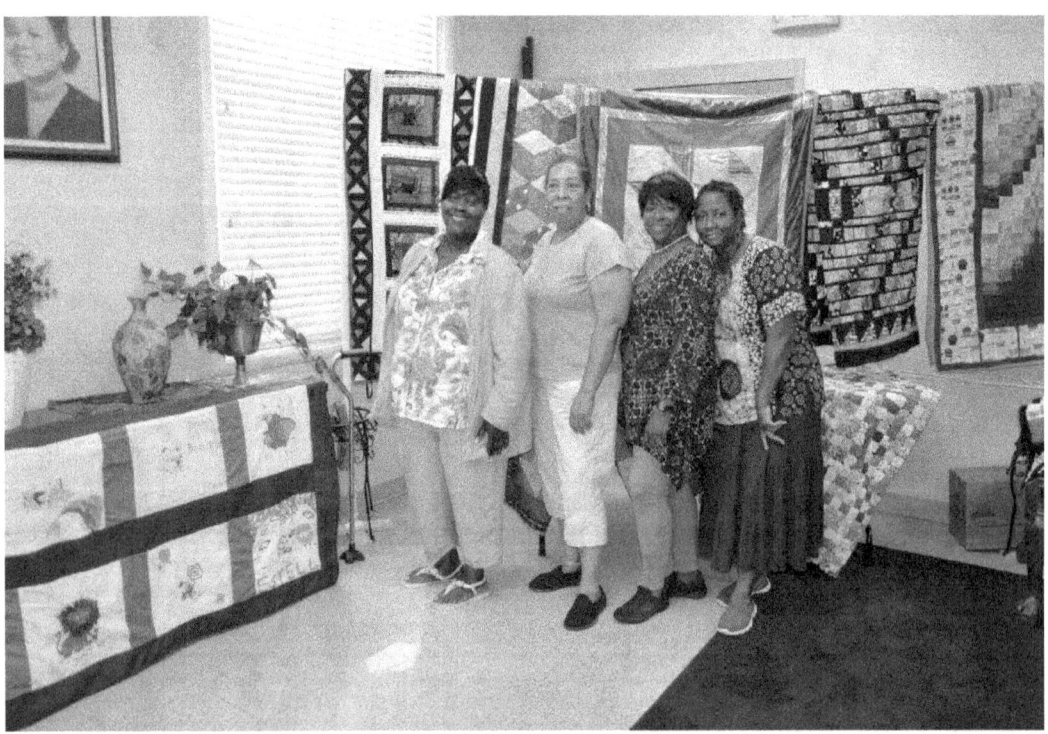

Deborah Anthony Charlene Smith, Christine Partlow, and Gloria Owuradu

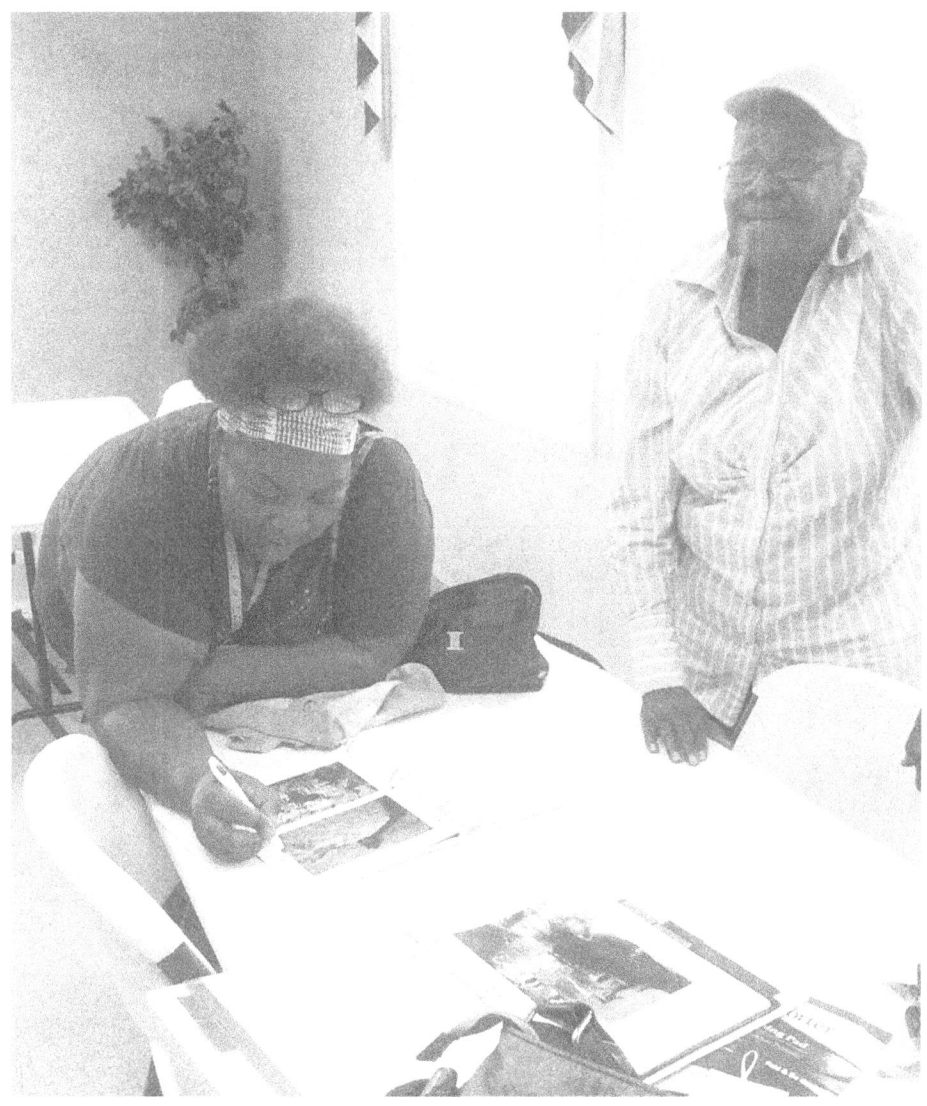

Tina Hicks and Mama Jessie Stevenson review exhibition workbooks

Meet the Something About Me Quilters

Gloria Owuradu

Working as a senior companion at the Center gives me an opportunity to assist with great projects such as the Something about Me Quilt.

Jessie Stevenson

Mrs. Stevenson's quilt "Road to Freedom" was made in memory of her sister Dorothy Durney. She used fabric from her sister's fabric stash. Mrs. Durney was a crafter who made beautiful dolls.

Linda Johnson encouraged the seniors to take on the Something About Me Quilt Project.

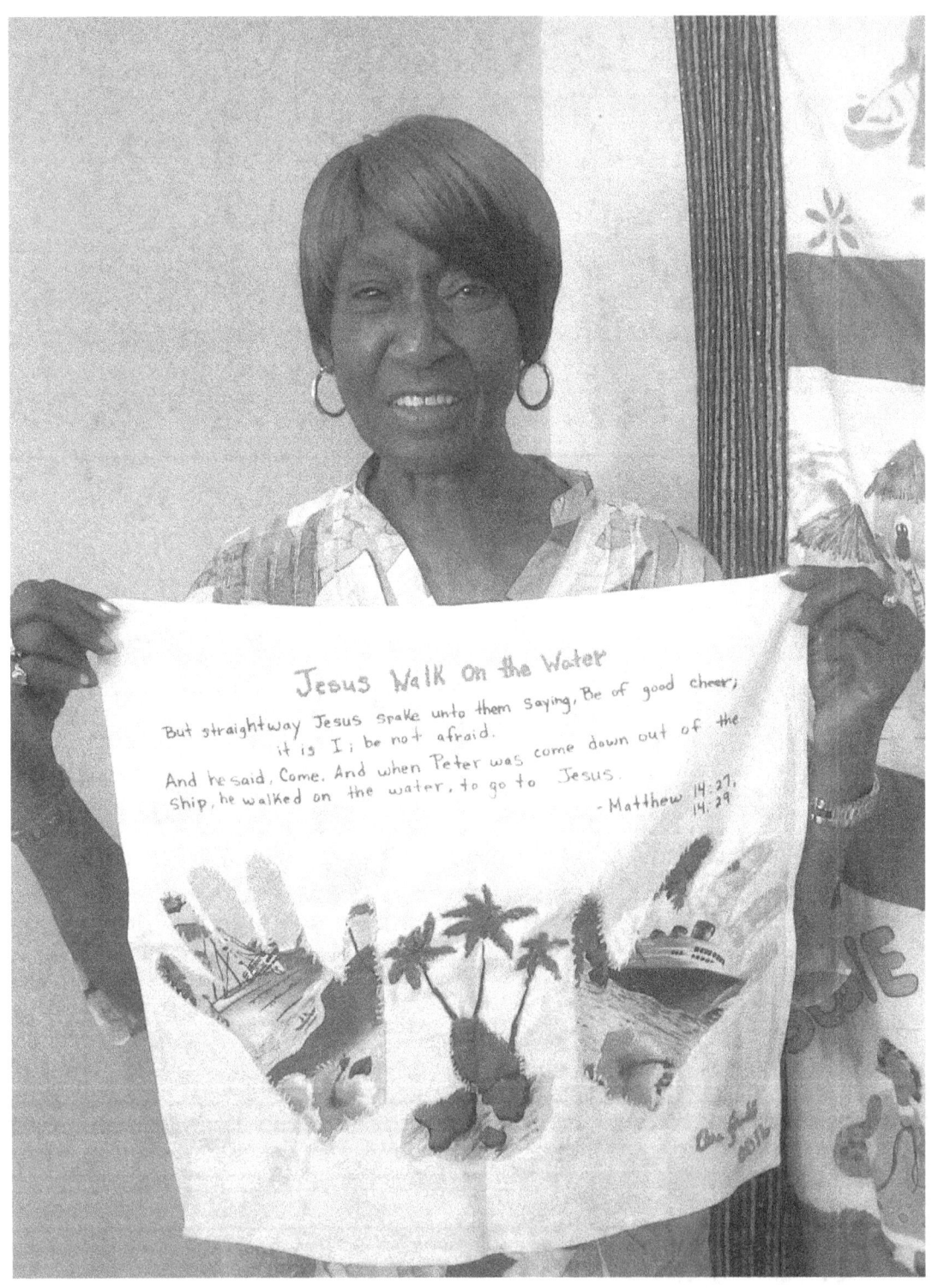

Mrs. Ora Gamble show her new quilt block about Christian hands and shares a scripture.

Ruby Brown was happy to bring a big smile to all who asked about her block on the Something About Me Quilt.

Ms. Ruby has a big hug for Tina Hicks

Mrs. Ruth Raulerson said it was fun to have people guess which one of the quilt blocks was hers.

Mary Champhers said that doing this kind of thing reminds her of her family and makes coming to the Center something she looks forward to doing every day.

Hope McKee and Tina Hicks enjoy a special moment.

AAMA Blacks in Museums Day of Recognition
Hue Man Research Institute for African Diaspora Museum Anthropology

Savannah State University Celebrates the Research of the Hue Man

Researching Black Museums and Communities

Savannah State University

3219 College St. Whiting Hall, Savannah, GA

Quilting the Blacks in Museums Family Reunion Exhibition

"Kiah Museum Day of Remembrance"
Quilt Exhibition Trail Highlights

1983 Blacks in Museums Development Specialist
Emma Jones Speaks
At Savannah State University

September 9, 2016
2:00-3:00 PM
Emma Jones

Emma Jones has been resilient when it comes to participating in Black history. As a young girl, she and her family crossed Edmund Pettus Bridge with fellow marchers. 1983 was the year she appeared in the AAMA Blacks in Museums Directory with her institution the Connecticut Afro American Historical Society. She continues to take part in various community cultural preservation labors. In 2009, Jones took part in Dixwell Community "Q" House preservation as a "Q" House veteran. The house collection told many stories of African American history and culture. She has retired from a career as an executive director in the Probate Court Service Center. Currently she spearheads efforts for justice over the unjust death of her son, Malik Jones, due to police brutality.

Emma Jones shared with students and faculty at Savannah State University her journey of activism with cultural arts administration at the Connecticut Afro American Museum in New Haven, her work with community organizing and most importantly her dedication to social justice for her son who was murdered by the police and inspired all who were in attendance.

Damion thanks Emma for her inspiring words and presents her with the official Hue-Man shirt

Emma Jones grew up in a family of quilters in Gees Bend, AL and was right at home with the "Piecing Together the Blacks in Museums Story".

(L-R) Jasmine McCray, Tori Becks, Mia Woodson, Dr. Richie Smalls Reed, Emma Jones, Morgan Brown, Keata Brown, and Damion Wynn

Quilting the Blacks in Museums Family Reunion Exhibition
"Kiah Museum Day of Remembrance"

Quilt Exhibition Trail Highlights

1983 Blacks in Museums Architect Richard Dozier Speaks
At Greater Gaines Chapel AME Church

September 9, 2016
3:30-4:30 PM
Richard K. Dozier

A former head of Tuskegee's Department of Architecture, Dr. Dozier is particularly interested in African American architecture and historic preservation. He has conducted pioneering research on Black architects and African American material culture and is a frequent exhibitor, lecturer, and consultant. He co-founded the country's first statewide African American preservation organization, the Alabama Black Heritage Council, and he was selected by the U.S. Department of the Interior to survey threatened structures at twelve historically black colleges.

L-R Natavis Harris, Jermecia Davis, Tina Hicks, and Dr. Richard Dozier at Beach Institute for the unveiling of the Kiah and Law Quilt made by Tina Hicks

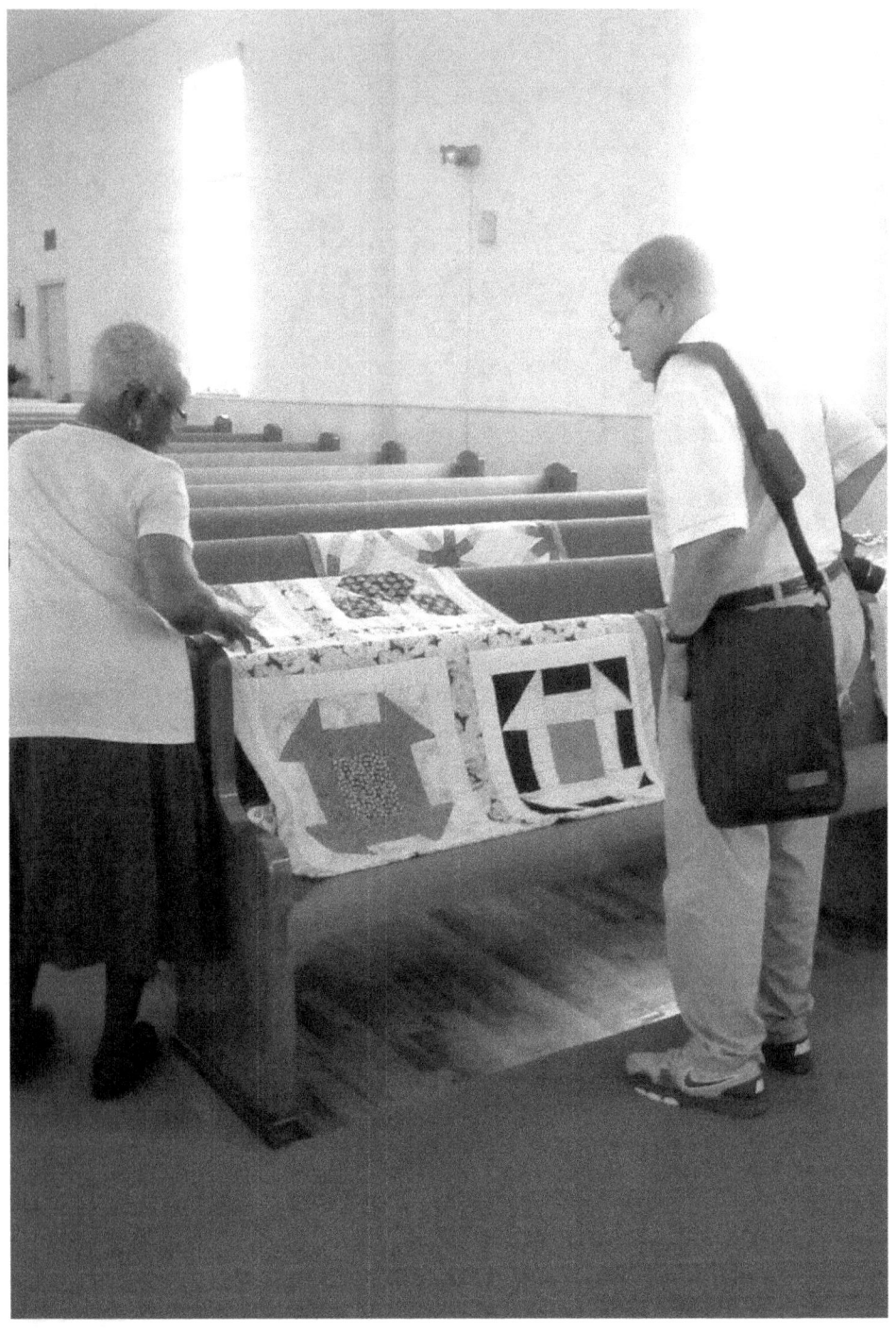

Sadie Williams talks about the Monkey Wrench quilt during Dr. Dozier's visit to St. James

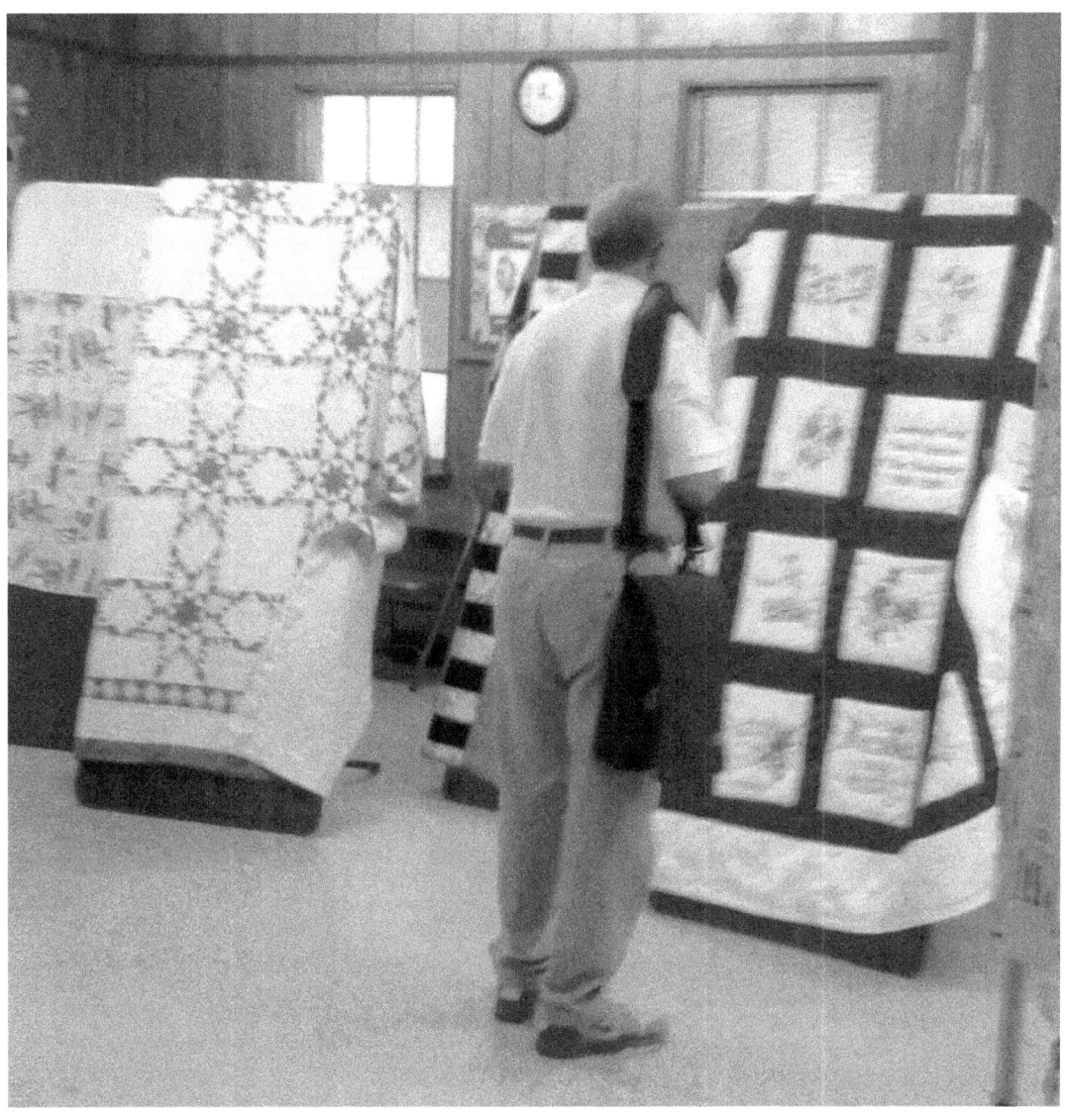

Dr. Dozier is enthralled with Sealey Hooker's Family Reunion quilt when he stopped by Mt. Zion Baptist Church as he travelled the quilt exhibition trail. He said the ladies did an excellent job for a one day display of so many fine pieces in the small space. He encouraged SSU student volunteer to take on a project with the CFSAADMC-Friends of the Kiah Museum to document and digitize the African American quilts and quilters at the historic churches in Savannah.

Dr. Dozier's stop at Savannah State University gave him a chance to peruse the student's research notebooks from the AAMA Blacks in Museums Project and take notes from speaker Emma Jones' presentation.

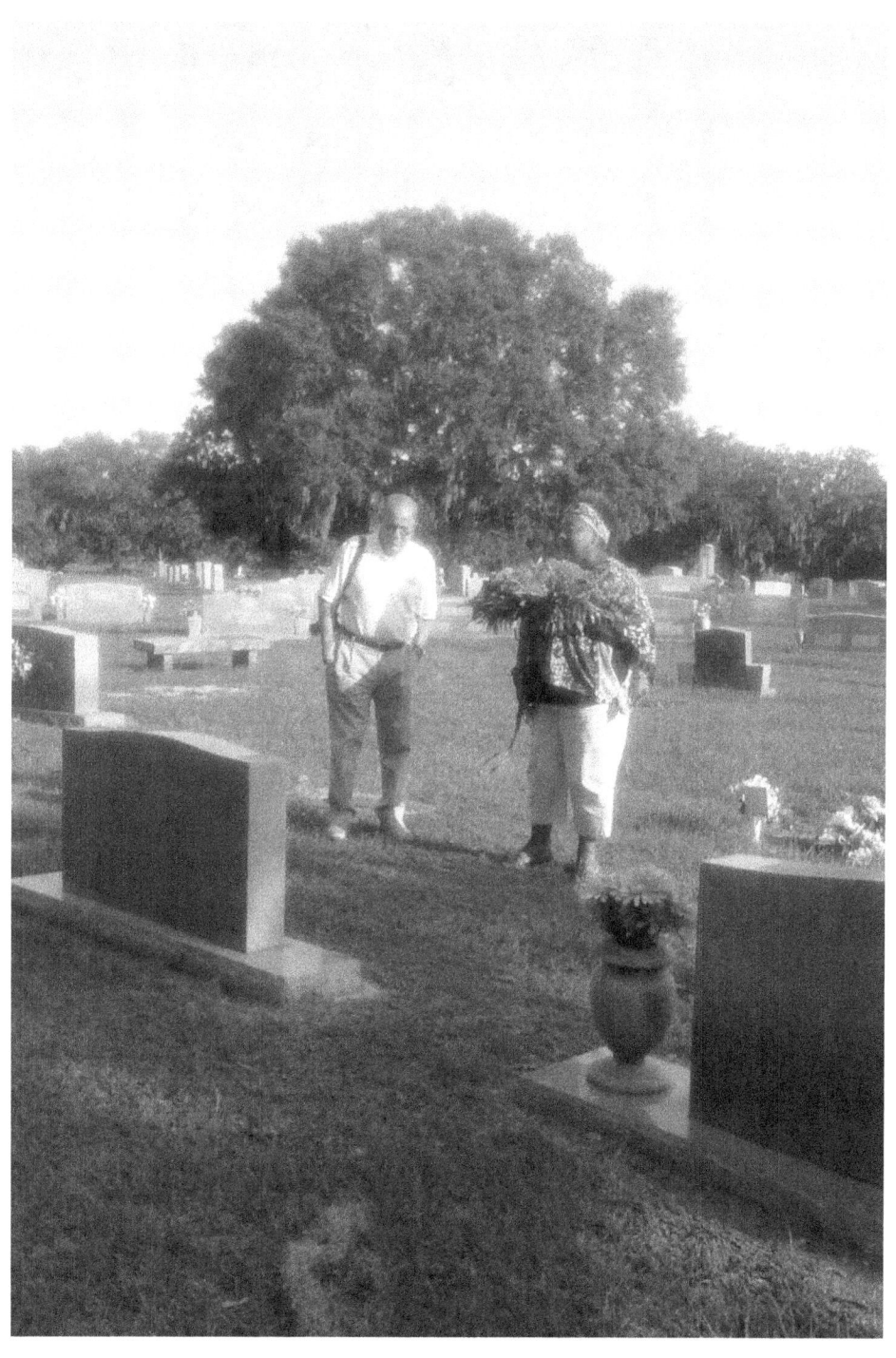

After Dr. Dozier's presentation at Greater Gaines Chapel AME Church he joined the caravan to Hillcrest Abby Cemetery to place a wreath at the graves of Dr. and Mrs. Calvin L. Kiah.

Margaret Santiago
Margaret Santiago Speaks to SSU Students

Mrs. Santiago was among those listed in the 1983 AAMA Blacks in Museums Directory and when she learned about the research project at SSU she wanted to come and meet the students and faculty who were doing this important work. Mrs. Santiago was one of the first African Americans to hold the position of Registrar with the Smithsonian National Museum of Natural History. She worked with so few Black anthropologists over the 30 years she was at the Smithsonian, she was thrilled to see that students at an HBCU were taking on this premier endeavor. She is retired and now lives in Puerto Rico and her travel plans did not permit her being a part of the September 9th quilt exhibition day because she was being honored at the opening of the new Smithsonian National Museum of African American History and Culture. However, she was not going back to Puerto Rico without thanking everyone for the work they were doing and sharing her story for them to record for the Blacks in Museums Project.

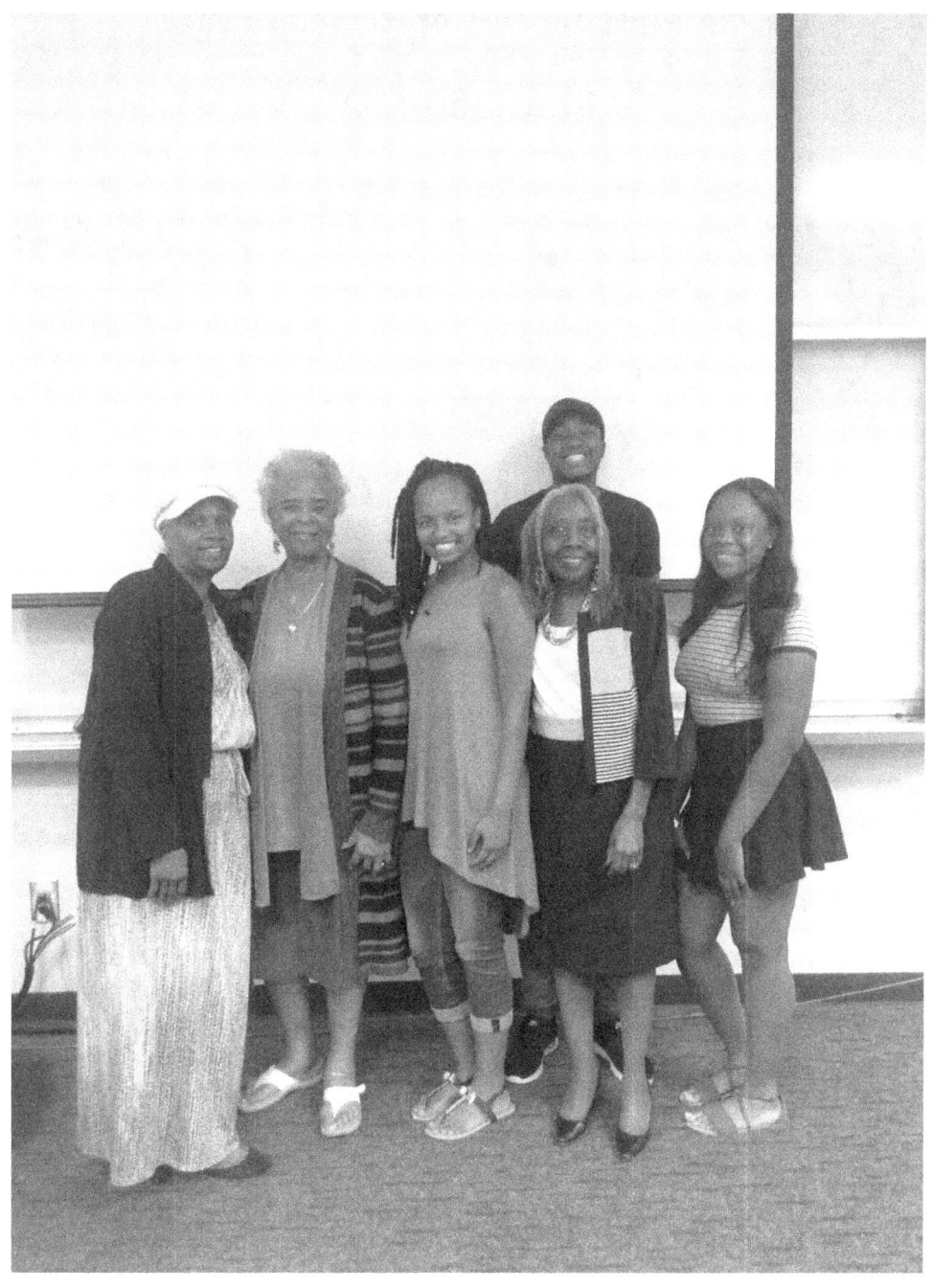

(L-R) Dr. Johnson-Simon, Margaret Santiago, Donnielle Montgomery, Dr. Richie Smalls Reed, Jeremiah Jackson, and Tatyana Kitchen.

Kiah Museum Day of Remembrance
Beach Institute

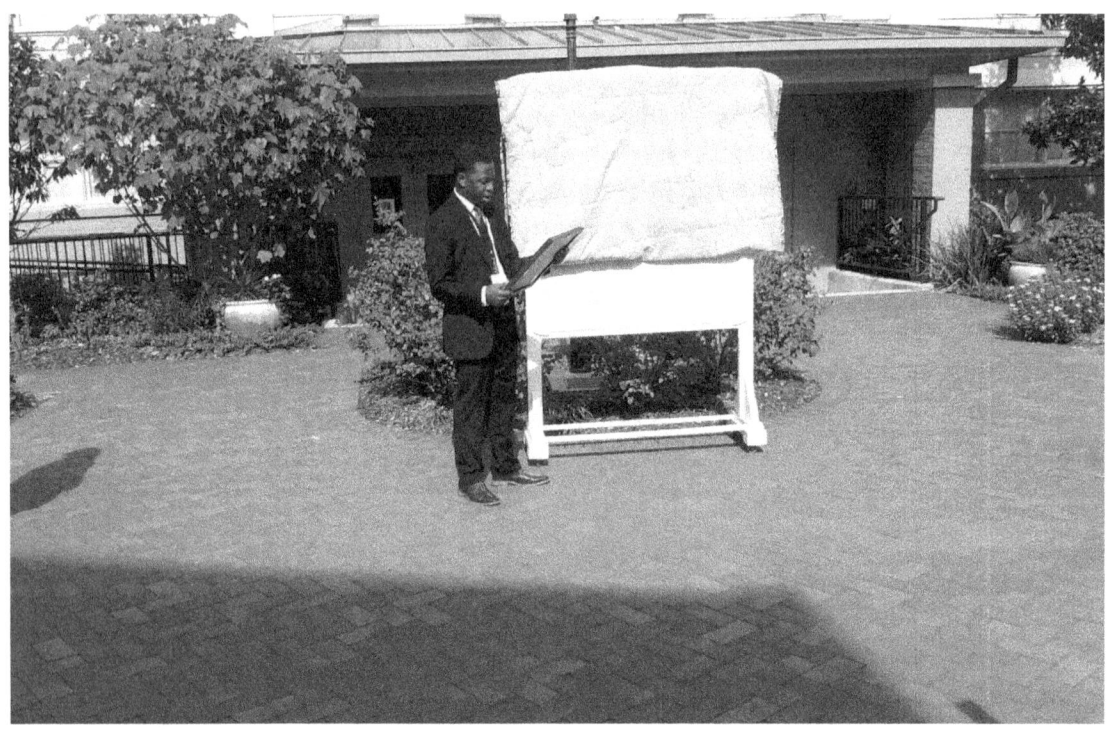

Reading of the proclamation by Natavis Harris SSU graduate student

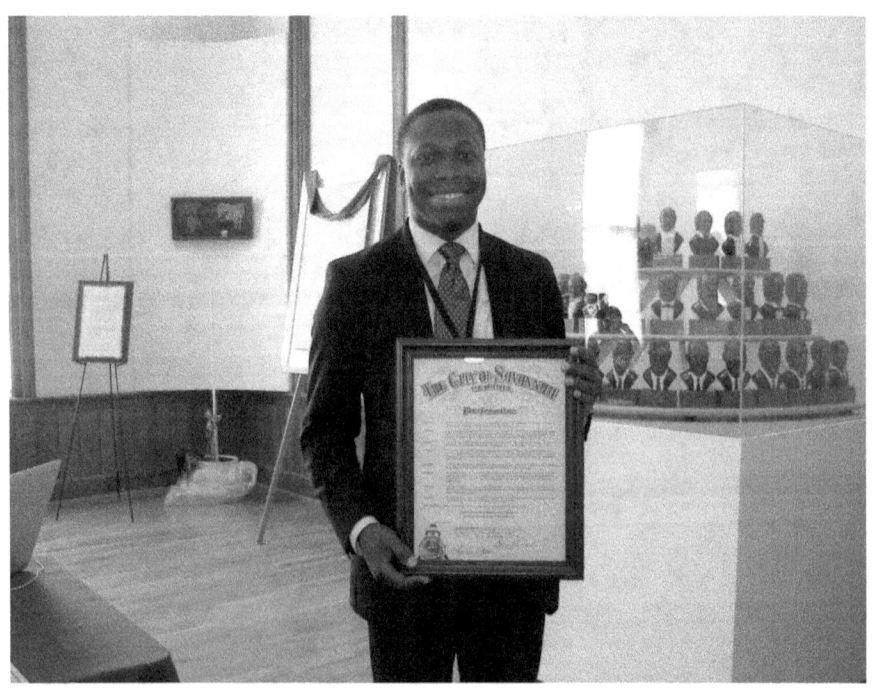

SSU student and Hue Man Research Institute secretary Jermecia Davis and Hudson Hill quilt curator Tina Hicks unveil the Kiah and Law Quilt

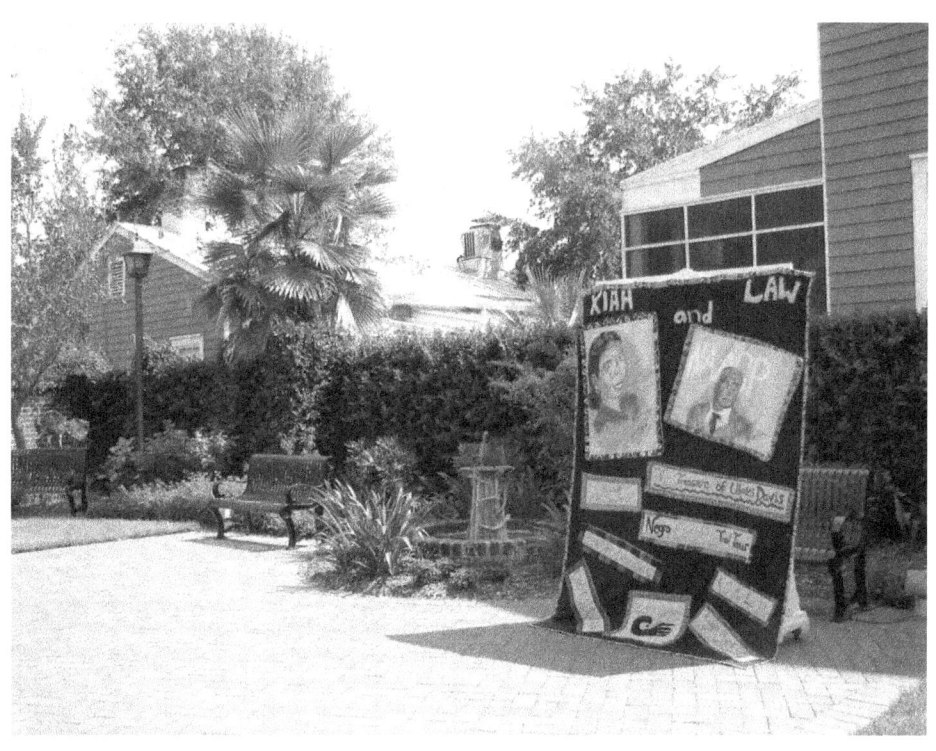

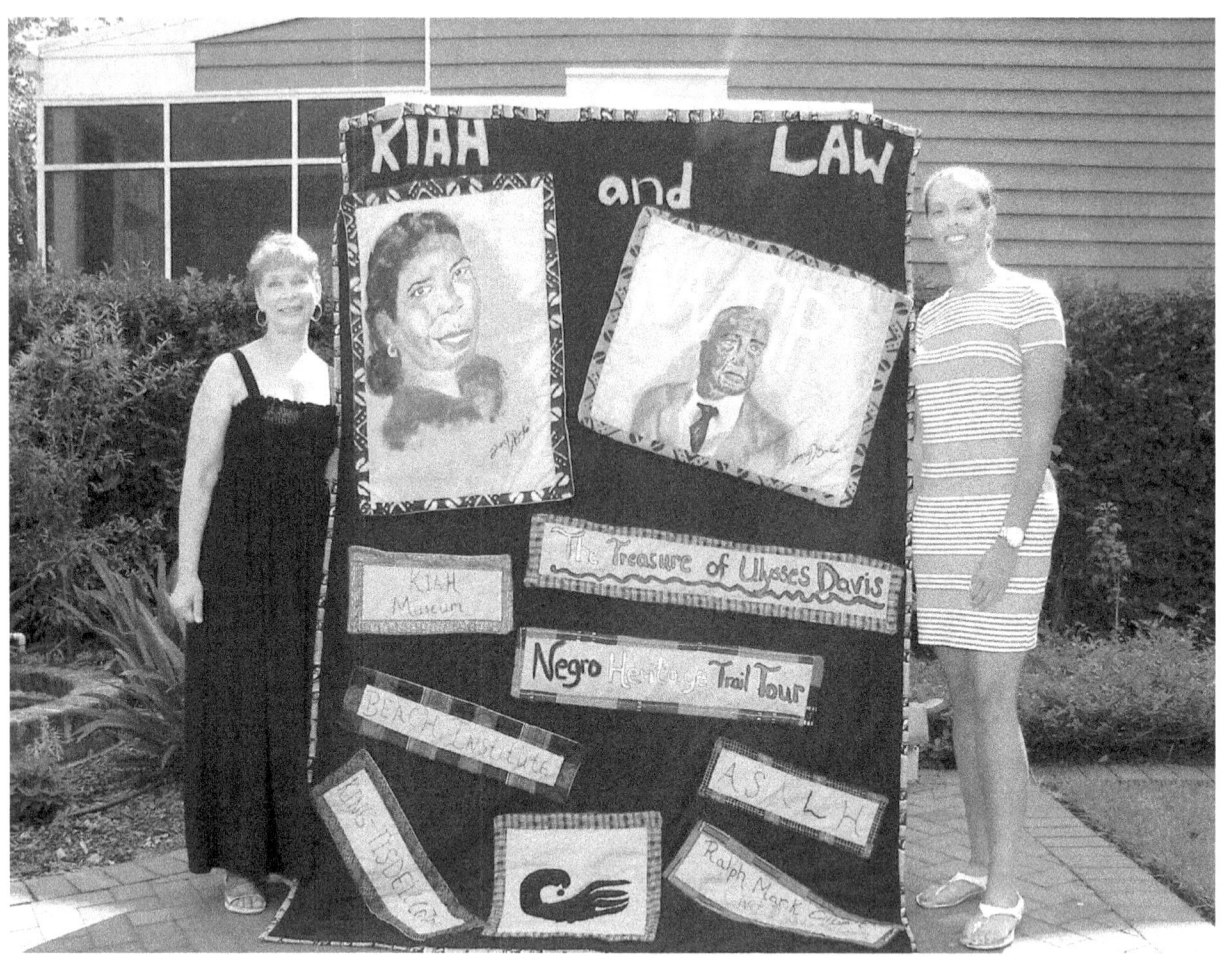

Members of the Kiah family traveled from Atlanta to be part of the special event. Pictured above is Lyndsey Kiah (right) and her mother (left) Mrs. Gregory Kiah, with the Kiah and Law Quilt designed by Tina Hicks. Images of Mrs. Kiah and Mr. Law were created by SSU student and Hue-Man founding member, Tori Becks. Lyndsey is the daughter of Gregory Kiah the nephew of Dr. Calvin L. Kiah. The Kiah family members contributed oral histories and photos for the Kiah Museum Day of Remembrance.

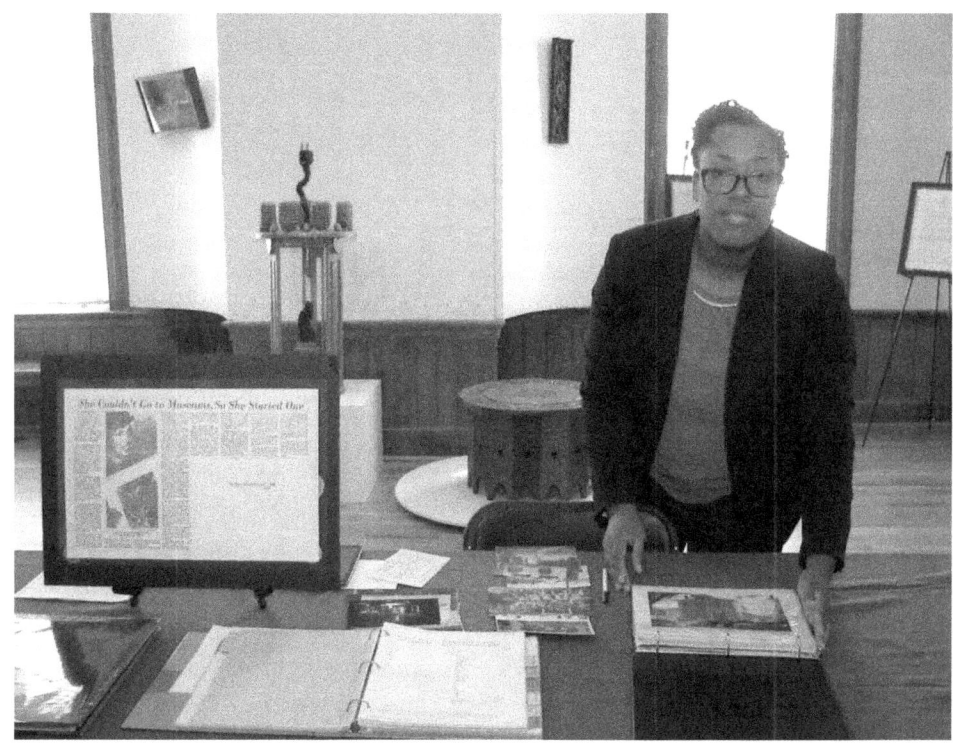

Sauda Mitchell Friends of the Kiah Museum collections and archival management prepares the area for those interested in sharing Kiah and Law stories.

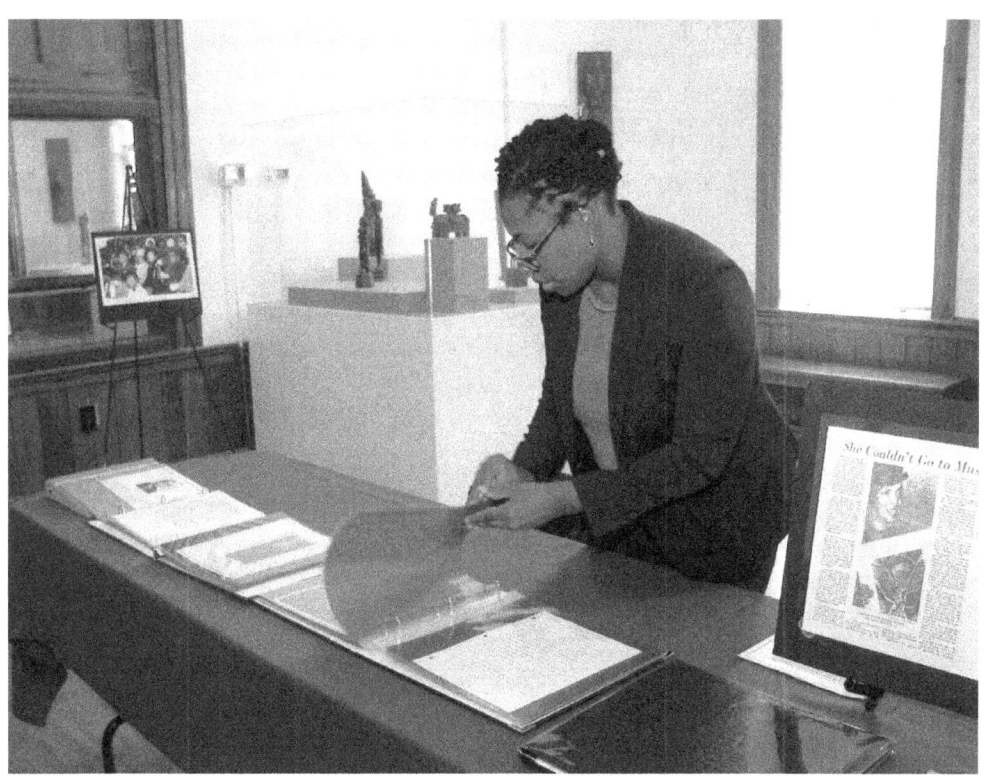

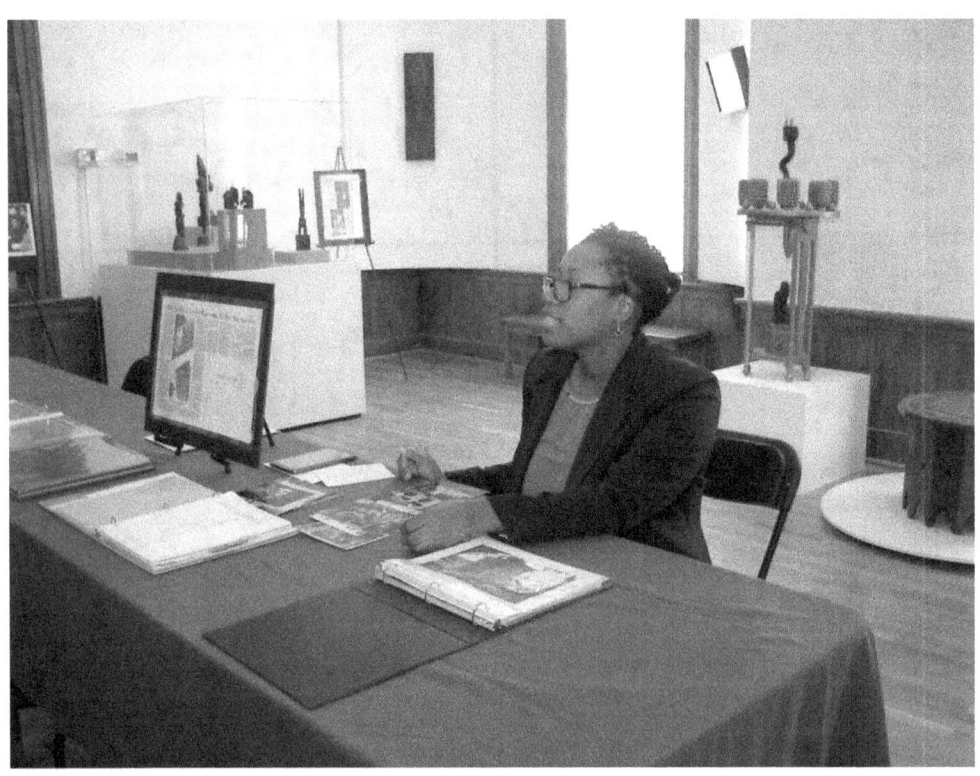

Sauda arranges photos of the Kiah Museum donated by the Kiah family members. She also took time to share the Kiah Museum notebooks with visitors. She was set up in the Ulysses Davis Gallery at the Beach Institute. Both Mrs. Virginia Kiah and W. W. Law were responsible for launching the artwork of this local artist.

Kai Walker and Quilting Kiah Stories

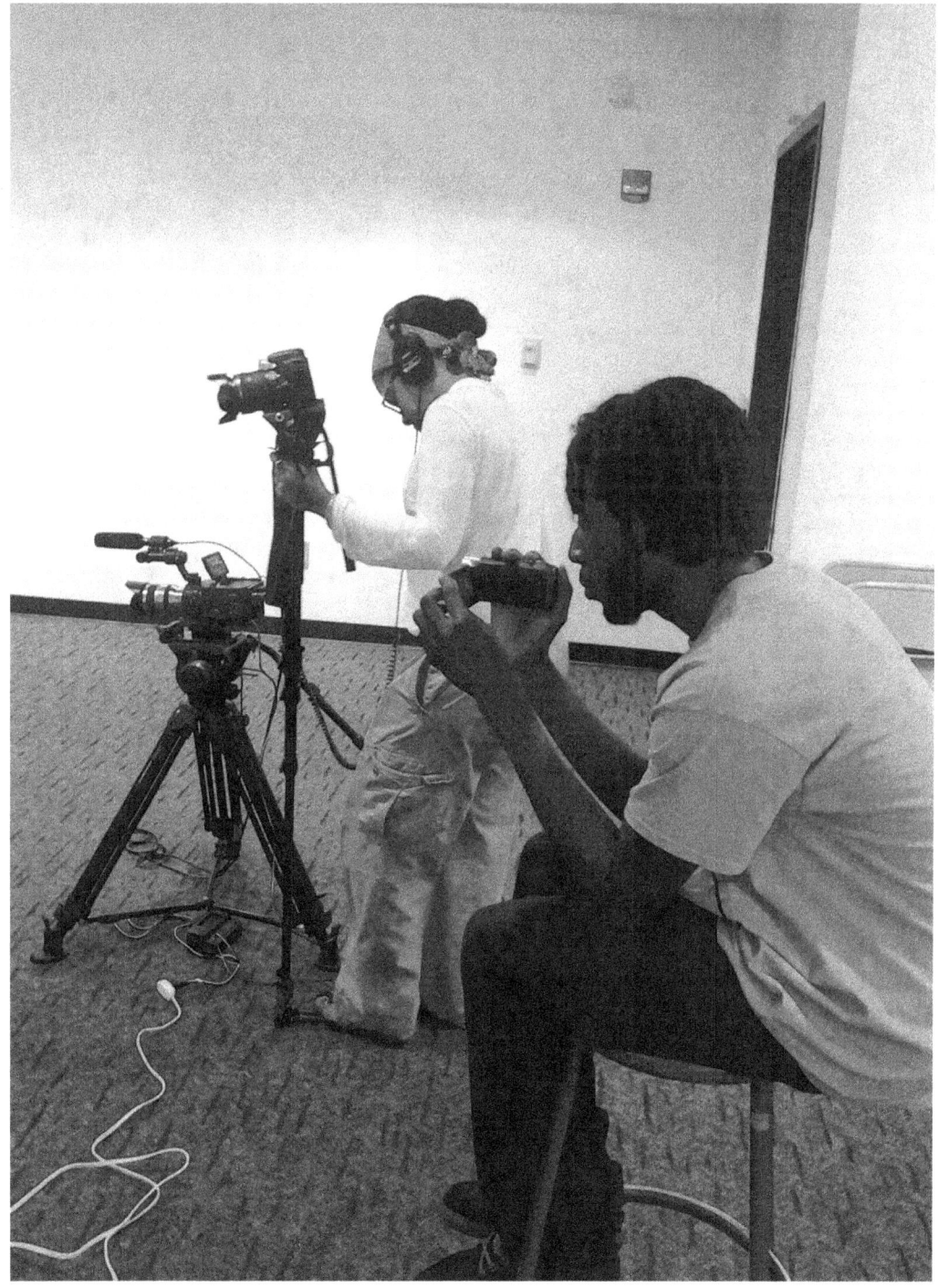

Kai Walker at work with Hue-Man president Damion Wynn as they prepare for Quilting Kiah Stories Oral History and Documentary.

(L-R) Edy Gresham, Tina Hicks, Mary Scott, Gloria McKind, Patricia Howard, Patricia Beaton, and Sadie Williams. Quilters share their stories of Savannah, Cuyler Brownville, Dr. Calvin L. Kiah, Mrs. Virginia Jackson Kiah and the Kiah House Museum during their interview with Edy Gresham.

Kiah family members join other attendees for the Kiah Museum documentary preview at the Beach Institute that professor Kai Walker has placed on Youtube. Because the video was amateur footage of a personal tour of the museum given by Mrs. Virginia Kiah for a few of her family members it was a precious jewel received by the CFSAADMC Friends of the Kiah Museum who are dealing with a building that is closed and deteriorating, no inventory or destination of original contents, deceased founders, and handful of residents who remember details about it all. The work of Professor Walker with editing the rare footage will help with the ongoing research of this museum. Family members commented that they had forgotten so much about the museum and it was a precious treat to see Aunt Virginia again.

Juneteenth
Getting the Word Out About the Show at 38th Street Wells Park

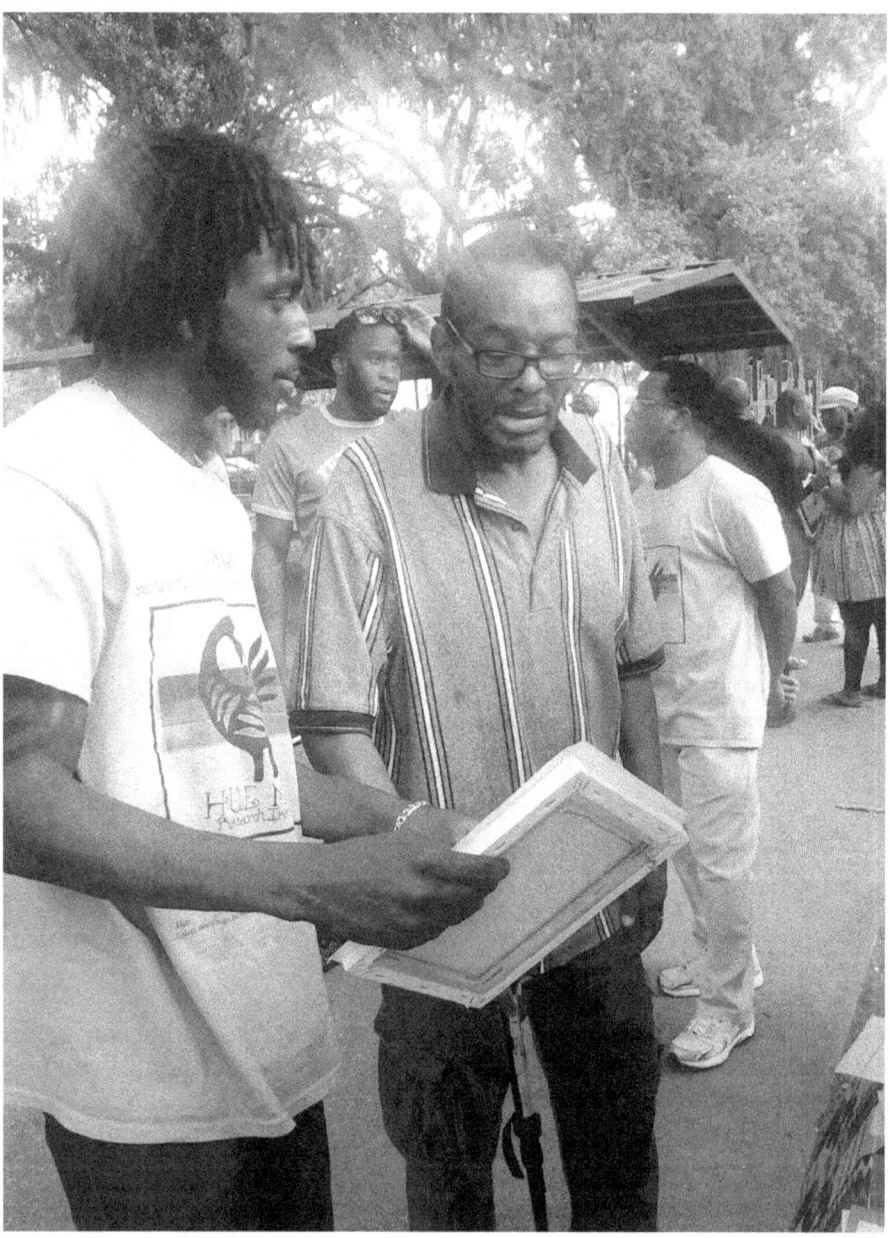

Damion Wynn and Terrance Grasty asks Festival goers about their Kiah Museum memories

Damion Wynn President Hue Man Research Institute

These young ladies wanted to use their creative skills to paint quilt blocks for a community quilt about saving the Kiah Museum.

After learning about the Kiah Museum located several blocks away from Well's Park where the Juneteenth Festival was being held the ladies returned to make more painted quilt blocks.

This mother helps her daughter with her quilt block "Let's Save the Kiah Museum".

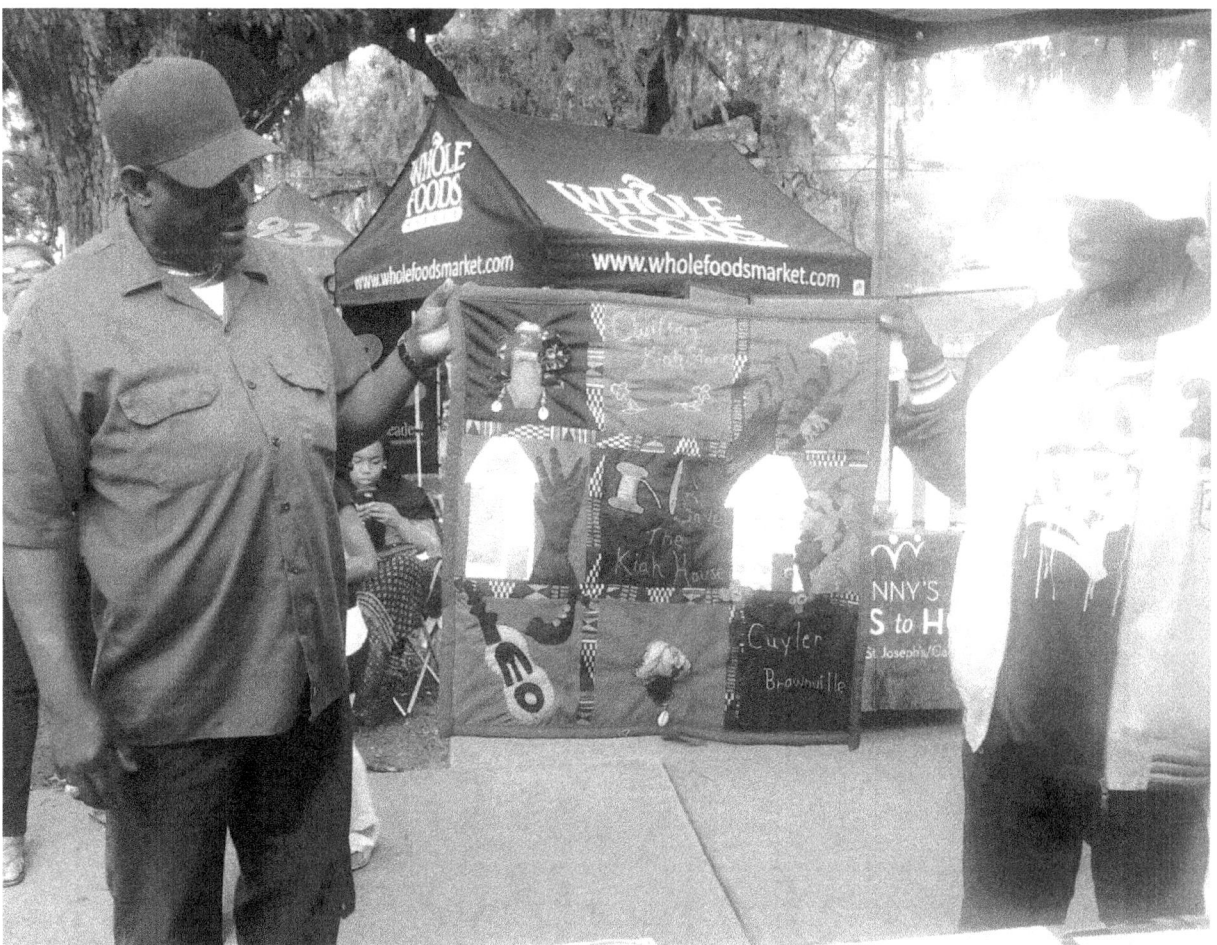

Two gentlemen attending the Juneteenth Festival stopped by the booth and shared their stories about growing up in Cuyler Brownville and the Kiah Museum being a place they will always remember for being a safe and beautiful place that kids were always welcome to come in and see the wonderful things on exhibit. They liked talking to the bird who would talk back to them. They remembered how kind the couple was to all the children and told them they could come back anytime they wanted to. They never asked for any money so they would go often. They were never turned away. They said they were sad about what was happening to the building and offered to help in any way they could including with repairs.

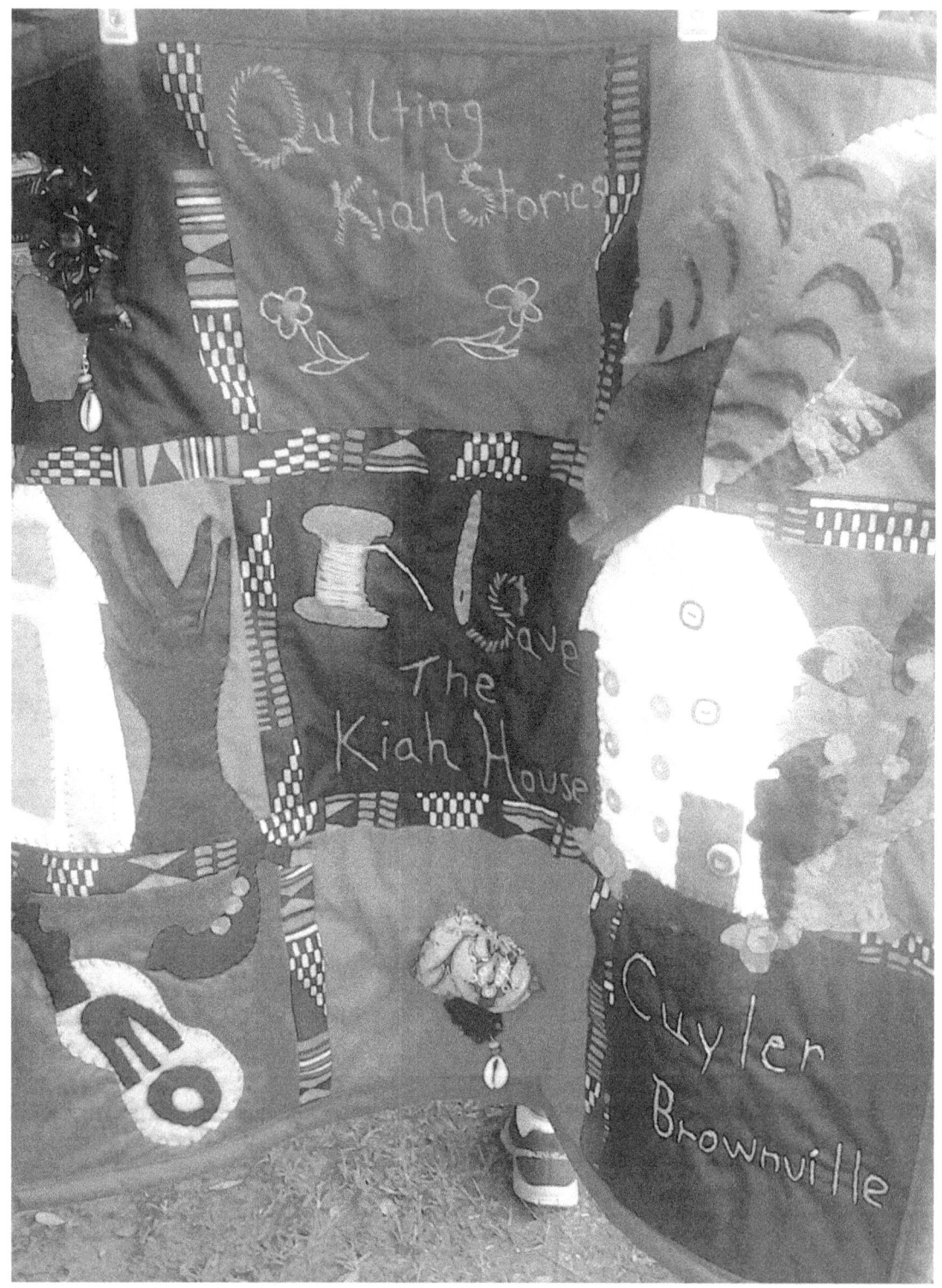

Quilting Kiah Stories quilt created by Tina Hicks

Tina Hicks--Hudson Hill Golden Age "Quilters for the Kiah Museum"

Tina Hicks helps one of the youngest festival goers to come to our booth work on his quilt block.

Carver Village Kids Quilting to Save the Kiah Museum

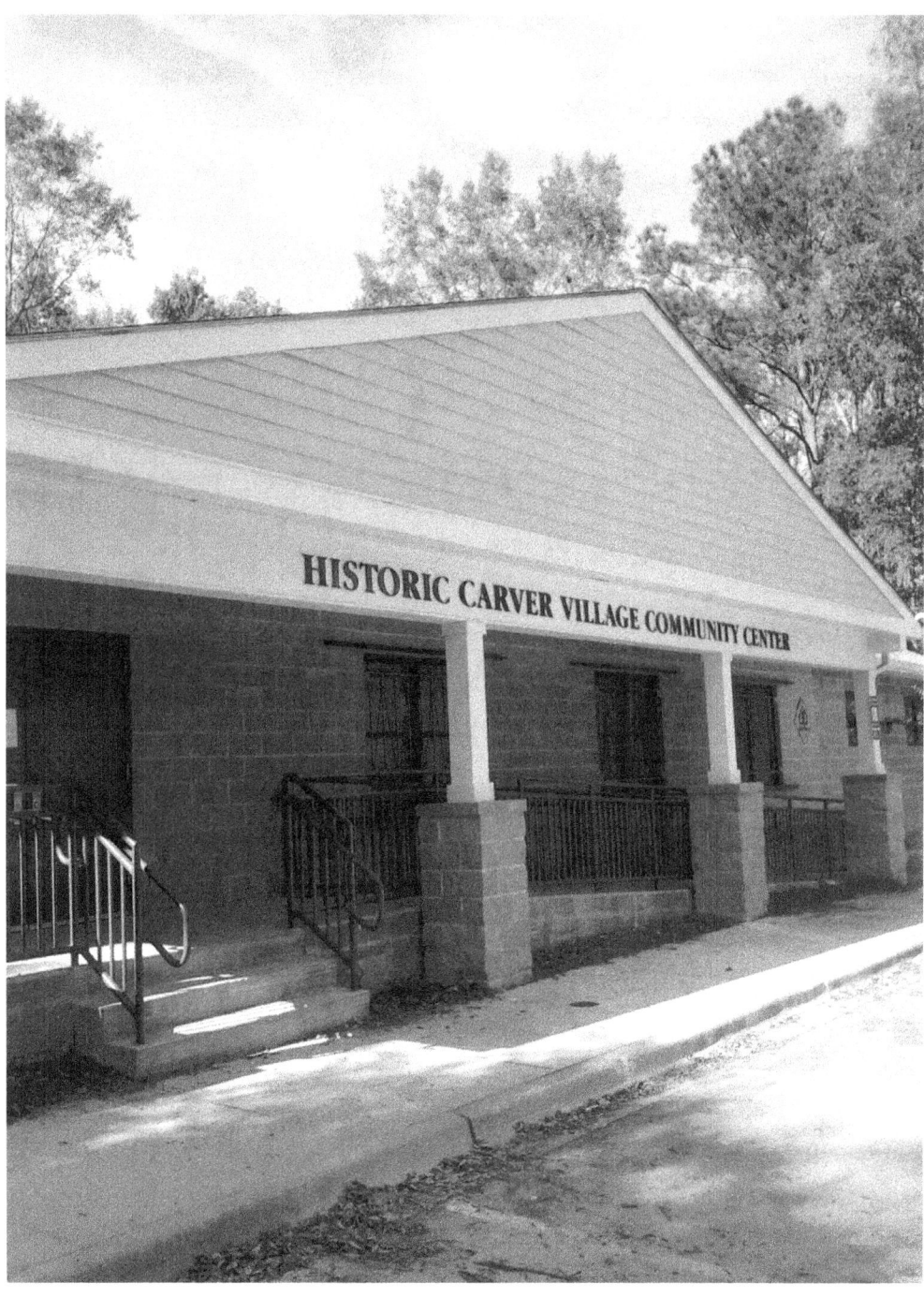

Carver Village Community Center
925 Collat Ave., Savannah, GA

Coach Lee Miller

Coach Miller is a Savannah native, who grew up in East Savannah. Coach Miller is a graduate of Savannah High School and he attended Savannah State University. In 2003 he graduated from Savannah Technical College with a certification in Electrical Maintenance and Construction.
At 18years old he became a volunteer basketball coach at Delaware Community Center.
The past 11years Coach Miller has been coaching for the City of Savannah and Leisure Services Supervisor at Carver Village Community Center.

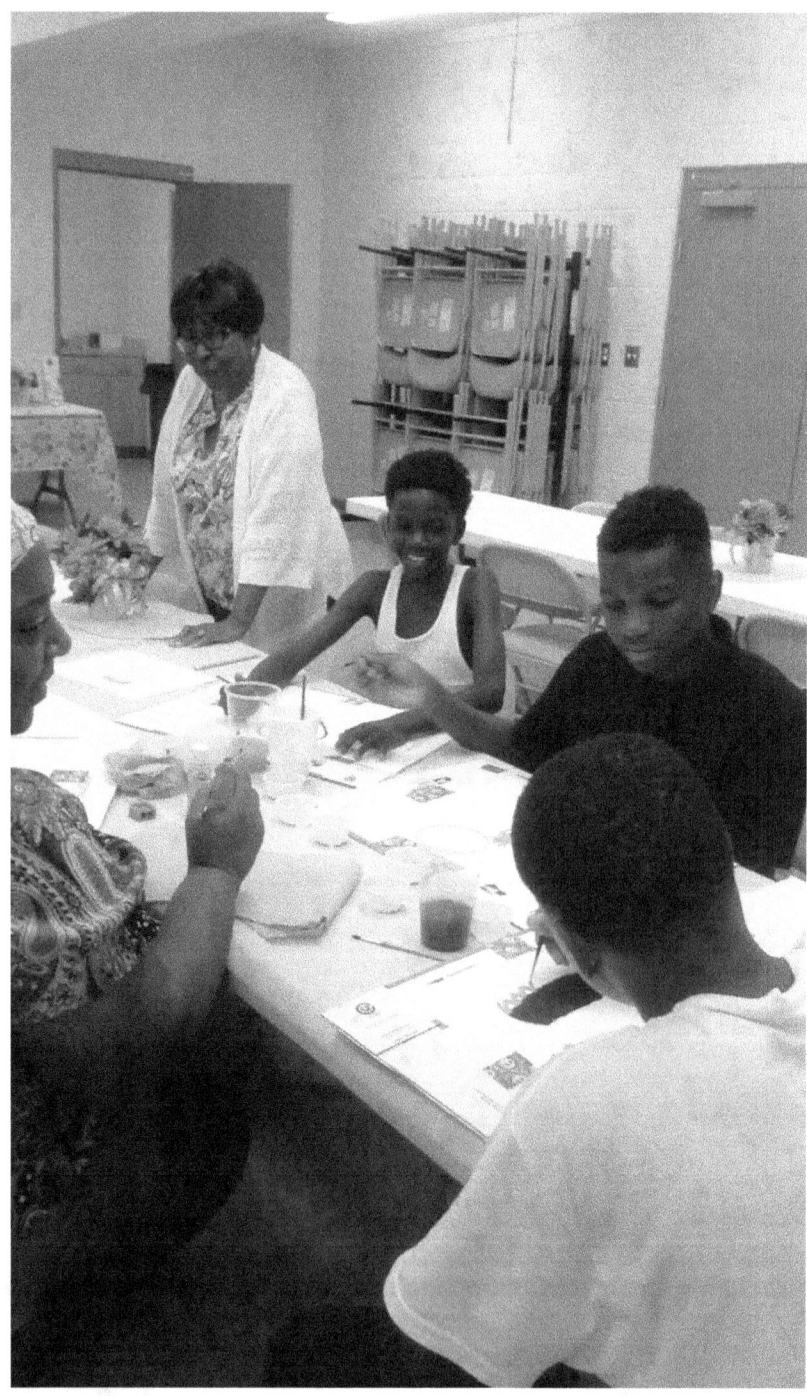

Tina Hicks and Patricia Beaton assistances the young men with their quilt blocks for the community quilt. The ladies tell them about the history of the Kiah Museum. They also let them know that a group called the Friends of the Kiah Museum has started to work to save the building from further destruction.

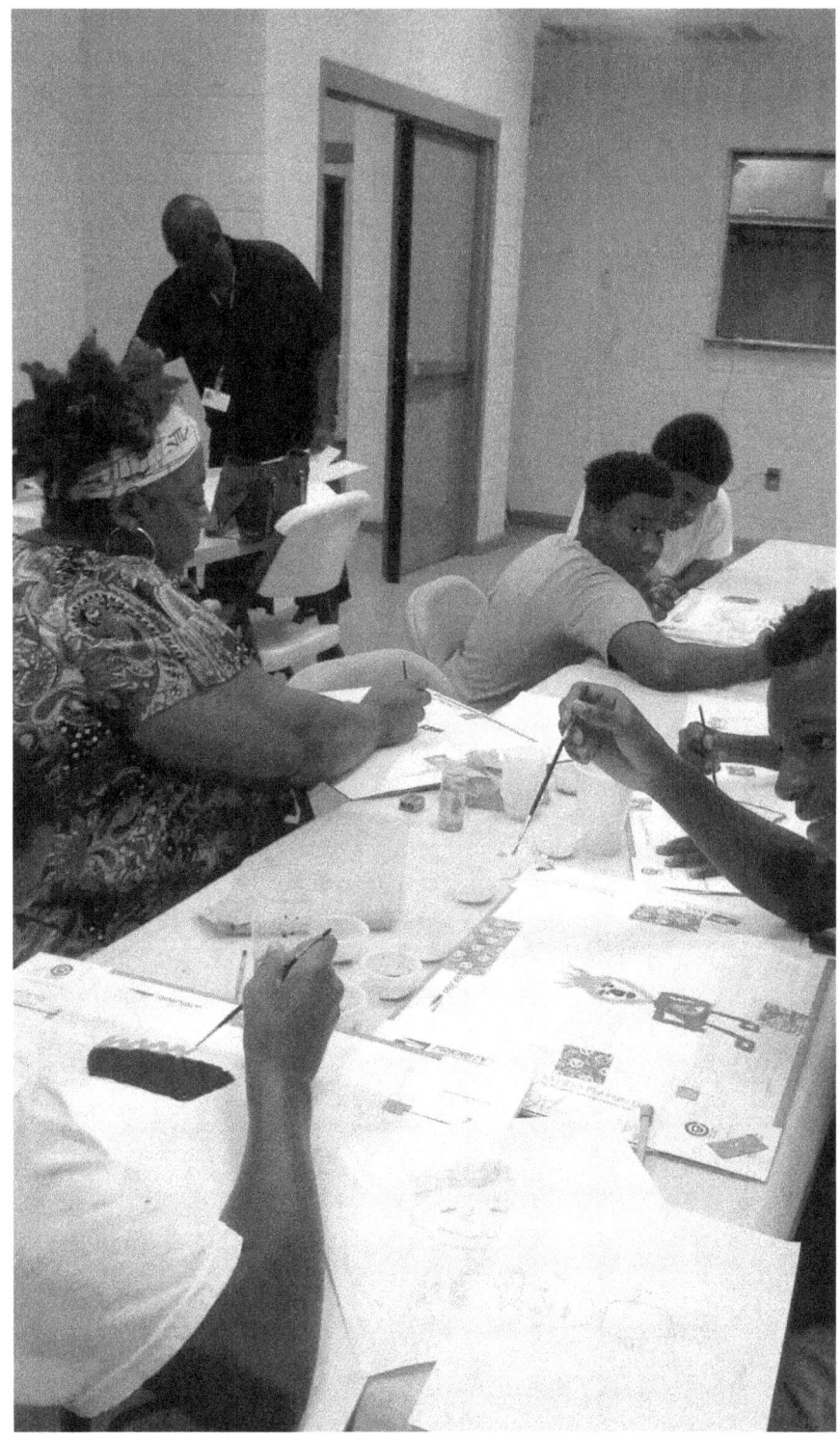

Tina Hicks help with supplies as the young men work on their designs that will go on the quilt blocks.

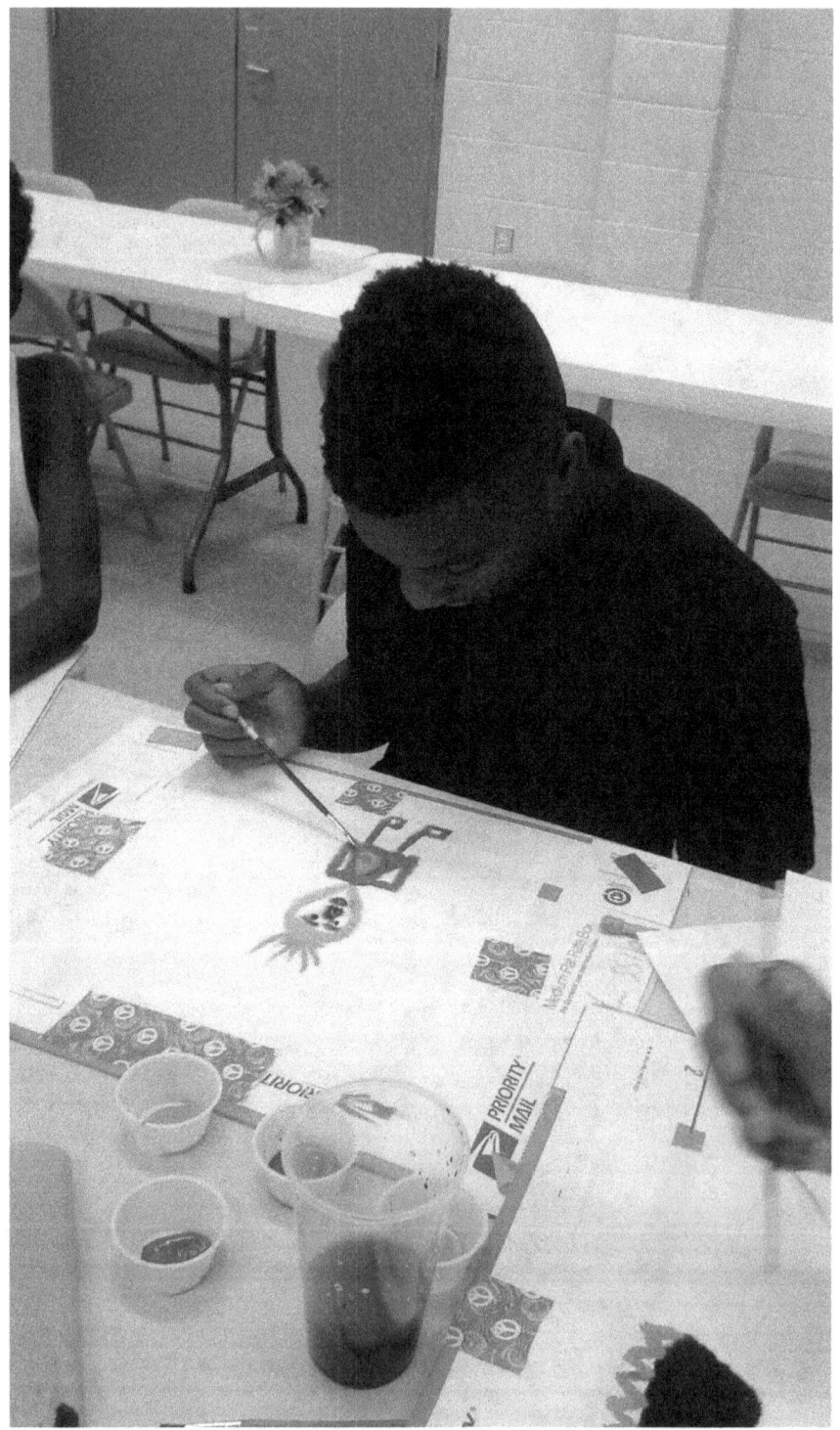

One young man says that he would rather be outside playing ball but this is important too. He asked the other young men who were outside playing football to come in and join them because these ladies are trying to help somebody.

This young lady said she didn't want to do the same community quilt as the young men. When she learned about a quilt being designed to honor W. W. Law and Mrs. Virginia Kiah and the work they did together she said that's the one she wanted to work on.

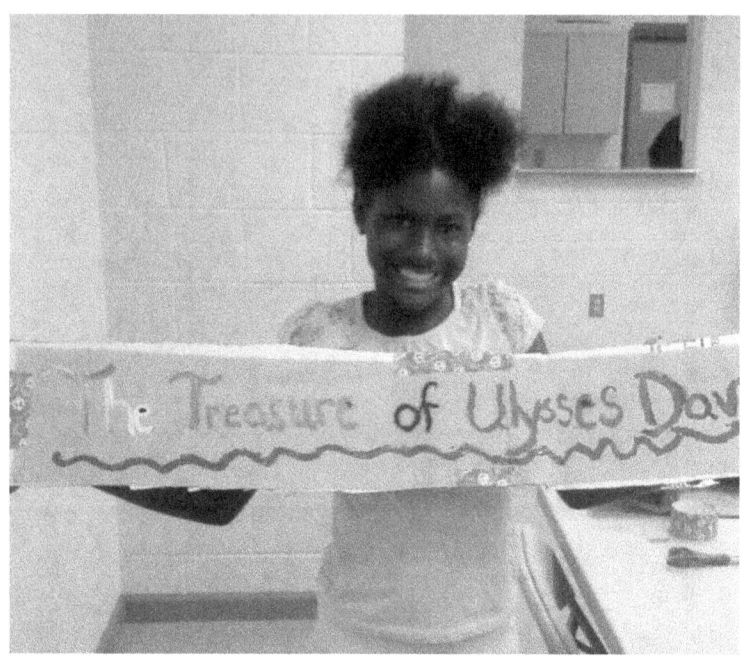

Some of the Hudson Hill ladies are making their strips for the Kiah and Law Quilt using their embroidery skills but this young lady said she wasn't interested in that either. She did a fabulous job of painting her strips for the quilt.

It's time for the young men to show off their painted quilt blocks too.

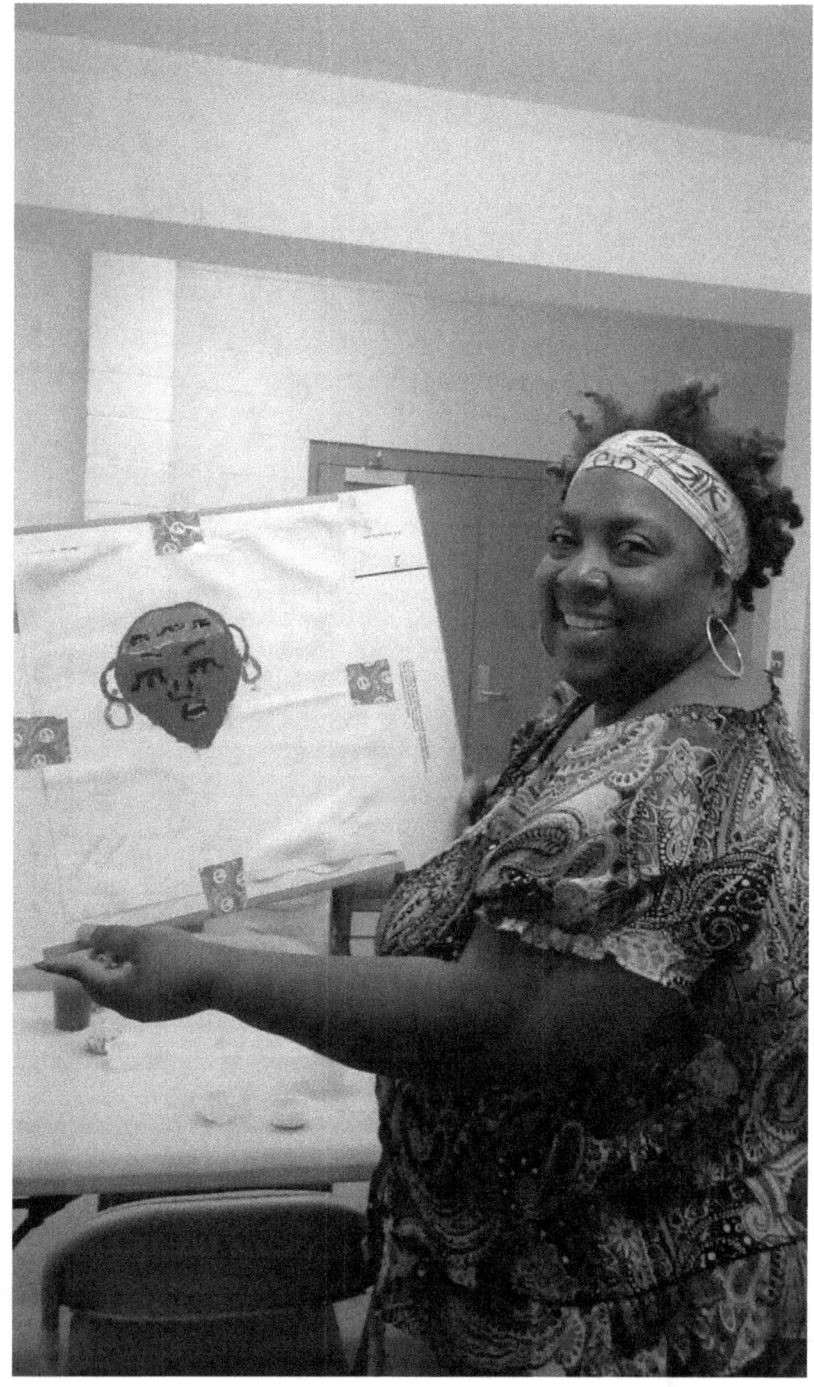

Tina Hicks proudly displays one of the painted quilt blocks that a young man painted of her

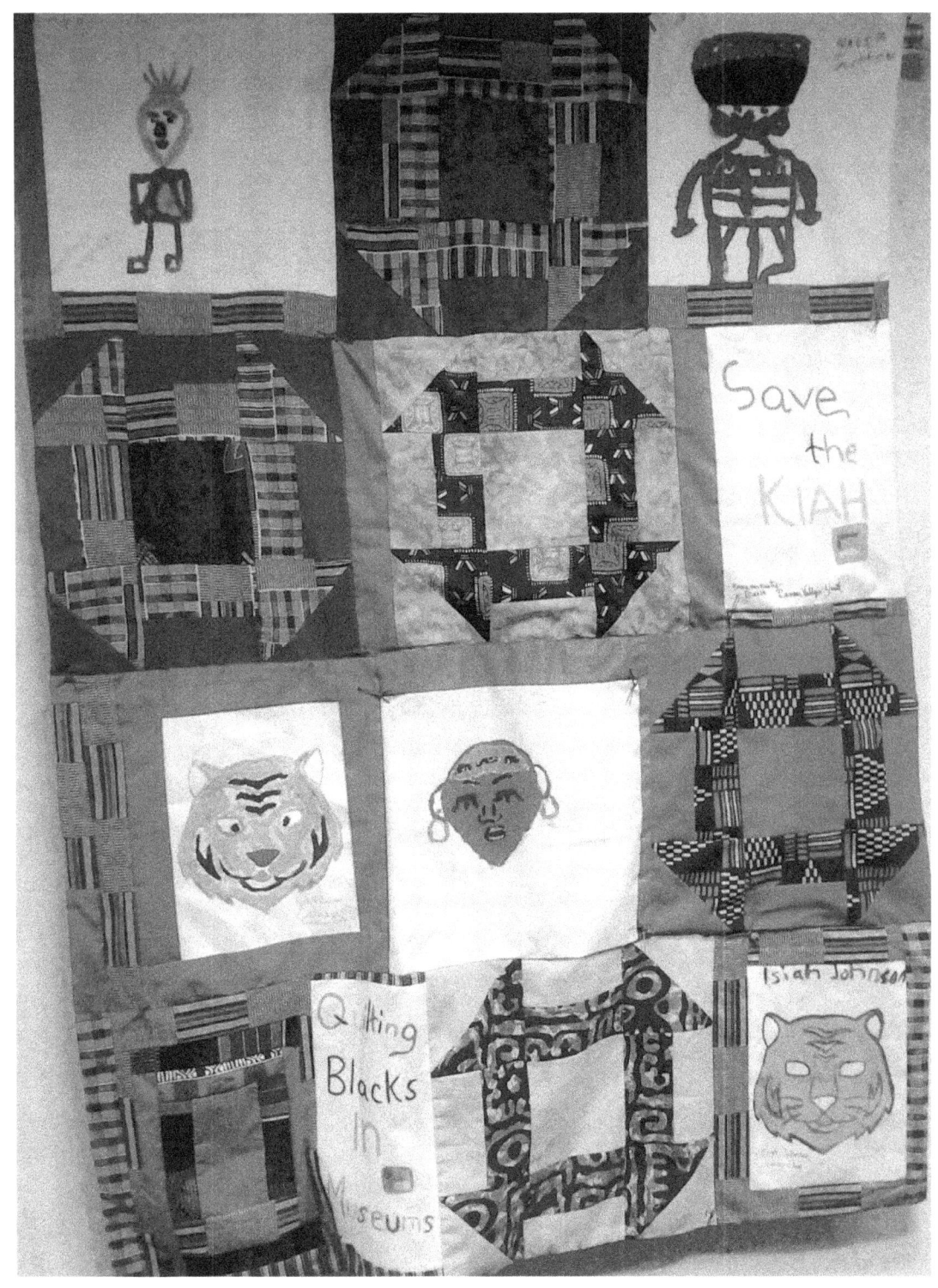

The finished Carver Village Kids Community Quilt was displayed at the Bull Street Library

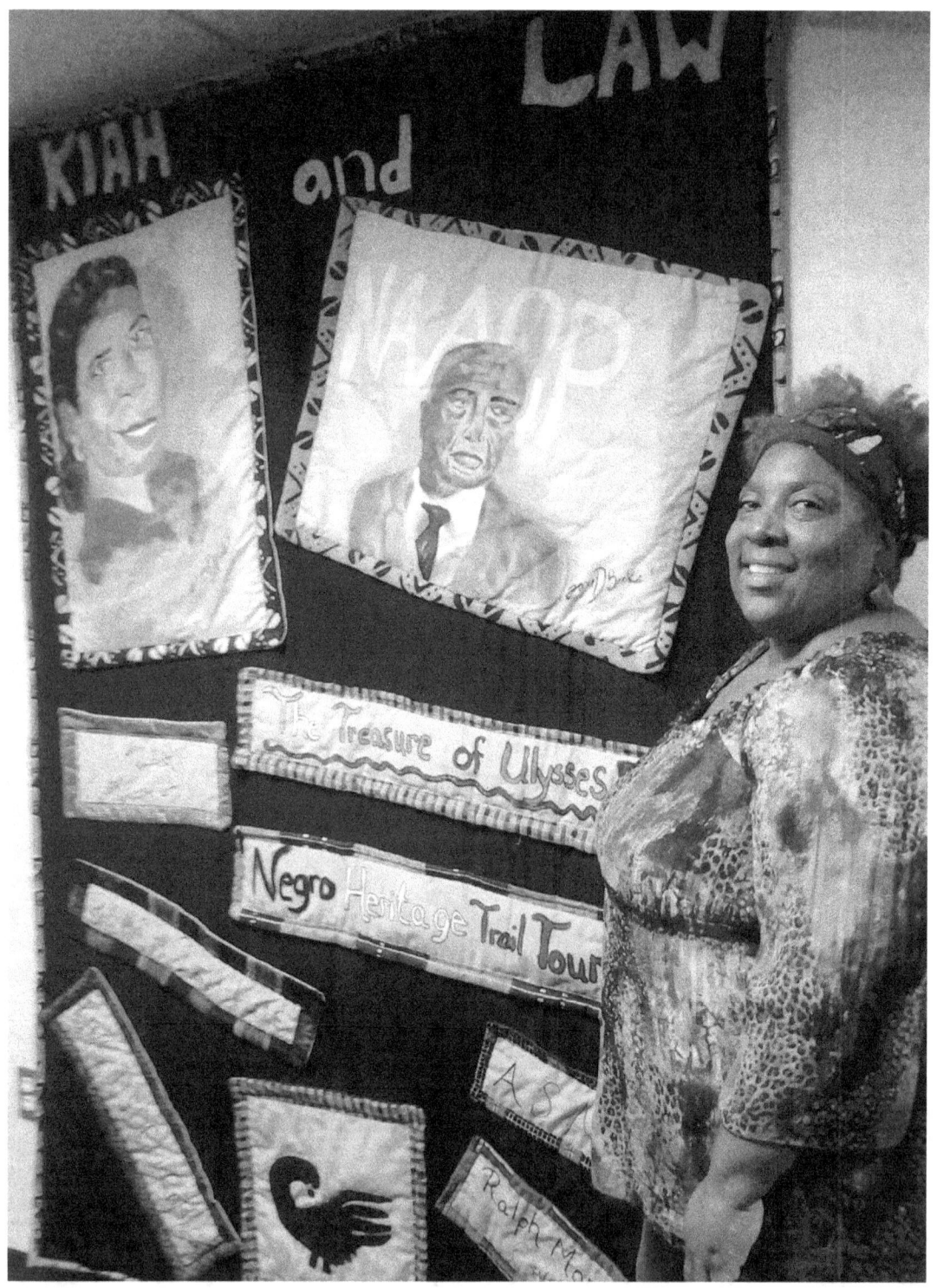

Tina Hicks stands with the finished Kiah and Law Quilt at the Bull Street Library

Asbury United Methodist Church

1201 Abercorn Street, Savannah, GA

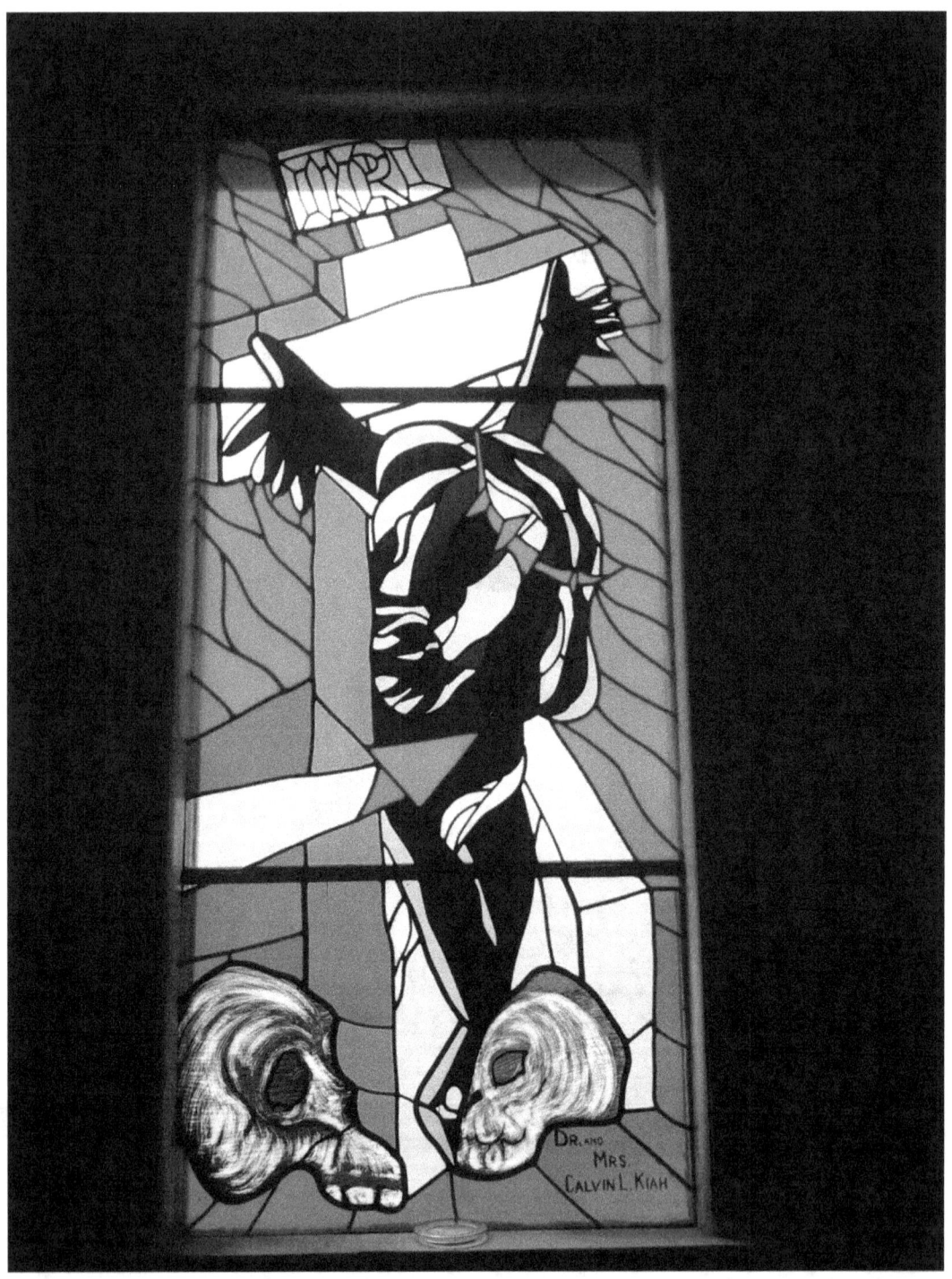

The beautiful stained glass window donated by the Kiah's served as a backdrop for those who came to tell their Kiah stories.

Mr. Vincent Hamilton

"I am a prior student of Mrs. Virginia Kiah. She taught me in elementary school. I knew her when I was in the 4th and 5th grade and she taught me art. She taught me how to bake and make things out of clay. She was a very stern task master. But she was a very classy lady. She taught us a lot of cultural things and things about etiquette that we didn't get in our own community at the time. There's so much I could tell but that's all I will share right now."

Mrs. Henrietta Taylor

I never had the opportunity to take a class with either Dr. Kiah or his wife. I knew about the museum that they had at their house and I always remember how gracious they were and I was proud to be a member of their church family. I just started learning to quilt and I made my first quilt recently and I will continue to work on the quilts of Asbury so we can have a larger exhibition at this site next year.

Mrs. Mildred Harris Hall

I am a former student of Dr. Calvin L. Kiah. You know there are those who come into our lives for a season and those who come into our lives for a reason. Dr. Kiah was one of those persons who came into my life during the season when I was a student at Savannah State College (1960-1964). Dr. Kiah touched my life in so many ways as an instructor. First of all he was a God fearing man. He did not give us the answers but he was that kind of instructor that questioned and invigorated our minds and in most cases our souls. As a result of being a student of Dr. Kiah many years ago I still think of him lovingly. I realize that it was him for whom I got by first job. One day I was in his class and I had just graduated and didn't have a job and he said "What are you doing back in here?" My major at that time was in secondary education grades $7^{th} - 12^{th}$ and one of my earlier high school teachers, who was a principal, said if I had some elementary courses he could hire me. So I went back for summer school. I ended up in Dr. Kiah's class and he said "Did you graduate last week?" and I said "I did but I need certification. I need 10 more hours to get into Elementary Education". And one day after class he told me that he needed to see me. I waited and Dr. Kiah said, "Miss Harris do you have a job? Let me ask you another question "Do you want a job?" and I said "Yes of course I want a job". So he told me to go down to Sol Johnson Elementary and told me just whom to speak to. And, that was my first job. He was so loving and kind and I've tried to model that with my students. From him I learned that failure is not an answer. So do not take it for an answer. And, for that reason Dr. Calvin Kiah is one of those I will always remember lovingly and thankfully for touching my life in such an awesome way. Thanks for the opportunity.

Live Oak Bull Street Library

2002 Bull Street, Savannah, GA

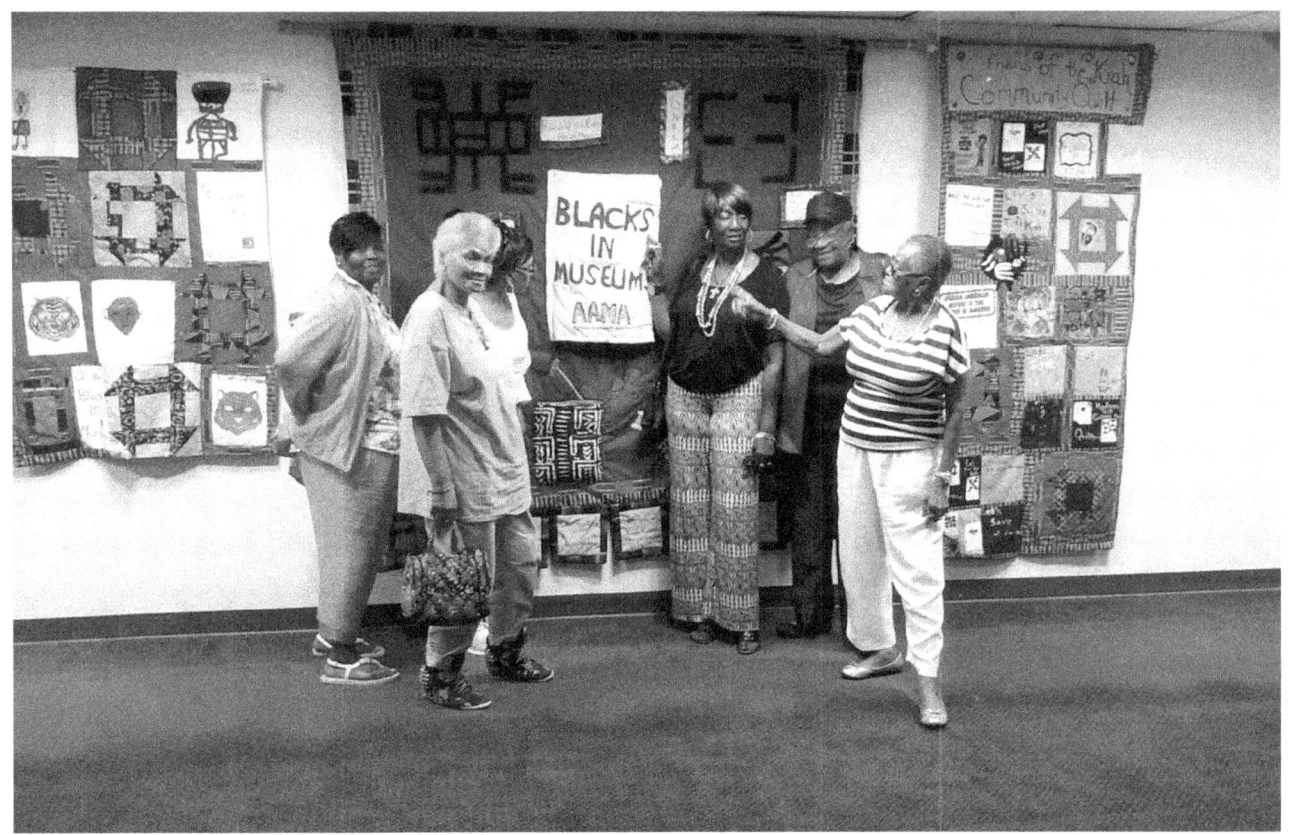

Quilting the 1983 Blacks in Museum Reunion

The Blacks in Museums Directory was the idea for creation for the lead Quilt. Creating a large closed directory in 3D in its original color with large lettering on the cover would draw attention to the importance of the directory. Along with the replica of the directory the quilt would display a tribute to the six founding pioneers of AAMA by creating mini quilts with names hand embroidered. The mini quilt design would also represent the CFSAADMC also their logo would be created in 3D. The ideas of the pouring of libation came from a conversation between Dr. Deborah Johnson- Simon and Dr. Richard K. Dozier about so many who have passed away since the publication of the directory. The Hudson Hill Quilters are represented by the appliqué technique of the sewing machine with a mini quilt being sewn and hand sewing displayed by appliqué form of a hand with needle and thread. The conception of the quilt began with many hours of mental conversations about direction, technique, and materials. The quilt was produced from a variety of recycled fabrics such as clothing, pillow cases and bed linen. Trial and error played a big role in creating the directory on the quilt. A large closed replica of the directory in 3D form is the focal point of the main design for the lead quilt

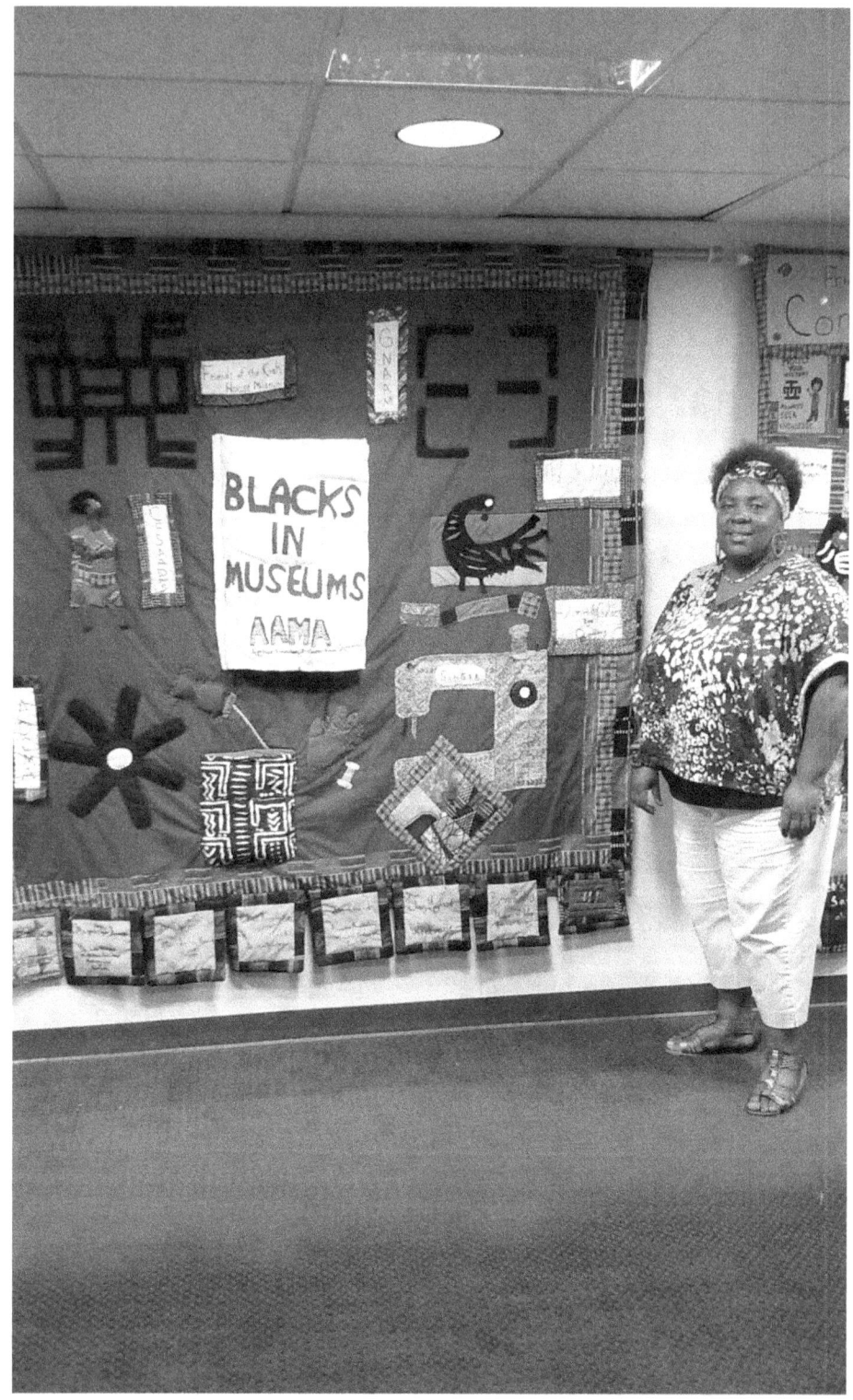

Tina Hicks with the Blacks in Museums Quilt

Six Who Led the Way for African American Museums Networking

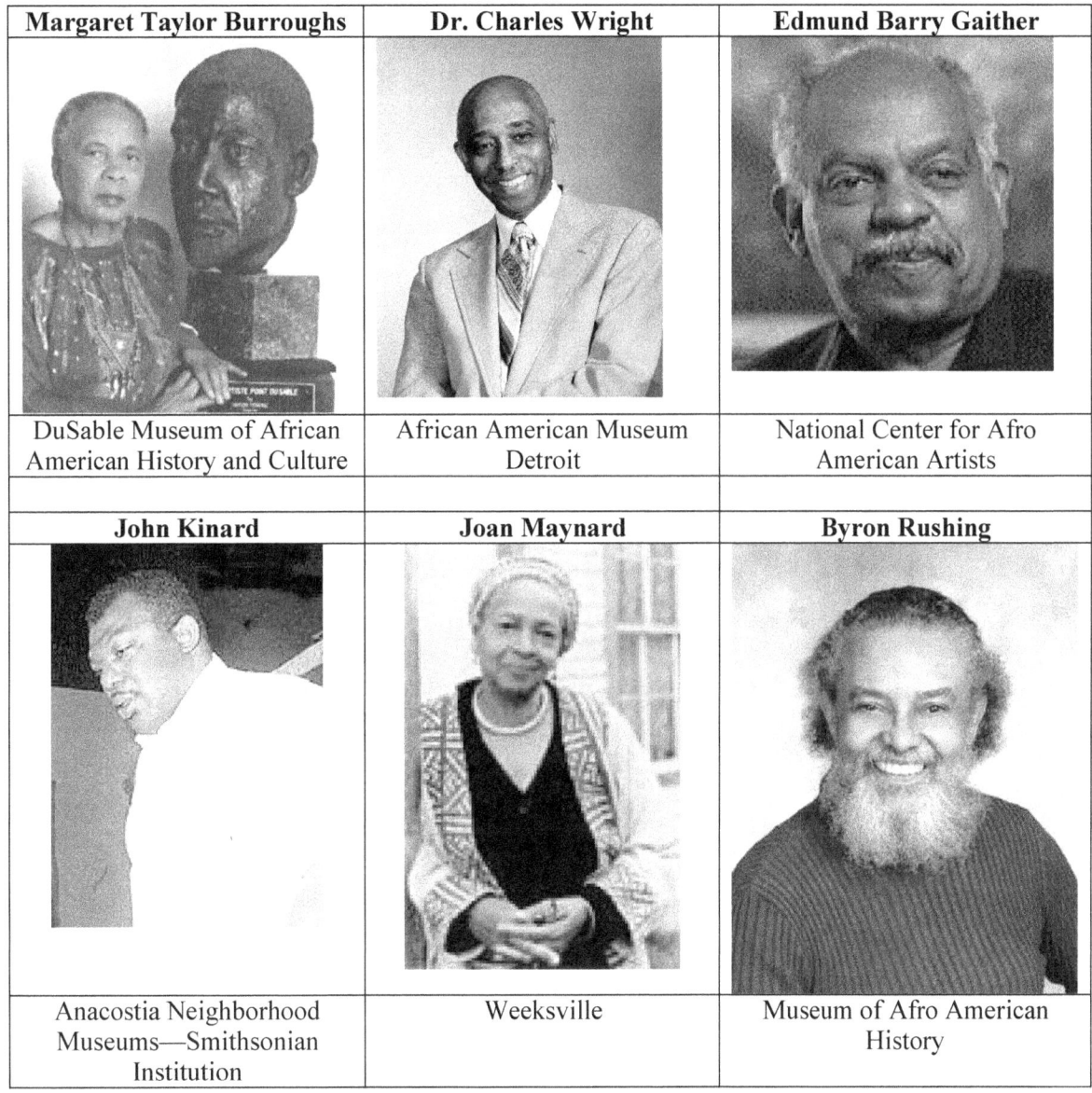

In the late 1960s, Dr. Margaret Burroughs, founder of the DuSable Museum in Chicago, and Dr. Charles H. Wright of the Museum of African American History in Detroit, initiated a series of conferences for Black museums. The National Association of Museums and Cultural Organizations and the Black Museums Conference, the first informal Black museum association, evolved from these conferences. In 1978, a consortium of six Black museums, with funding from the National Museum Act (administered by the Smithsonian Institution), presented a series of conferences at participating institutions. The conferences provided the opportunity for an ad hoc committee to lay the groundwork for yet another organization. Under the chairmanship of E. Barry Gaither, the committee prepared by-laws, which were ratified in Detroit in February of 1978. The new organization adopted the name "African American Museums Association" (AAMA), and elected its first governing council. AAMA's first office was at the Museum of the National Center for Afro-American Artists in Boston, Massachusetts.

Source: **http://www.blackmuseums.org/missionandhistory**

CFSAADMC Symbols and Meanings

Friends of the Kiah Museum (Kiah)	Georgia Network of African American Museum (GNAAM)
 NEA ONNIM NO SUA A, OHU "He who does not know can know from learning" Adinkra symbol of knowledge, life-long education and continued quest for knowledge	**WOFORO DUA PA A** "when you climb a good tree" symbol of support, cooperation and encouragement "Woforo dua pa a, na yepia wo" meaning "When you climb a good tree, you are given a push". More metaphorically, it means that when you work for a good cause, you will get support. Source: Cloth As Metaphor by G.F. Kojo Arthur
Research Institute for African Diaspora Museum Studies (The Center)	**African Diaspora Children's Museum of Anthropology (ADCMA)**
HYE WON HYE "that which does not burn" symbol of imperishability and endurance	**ANANSE NTONTAN** "spider's web" symbol of wisdom, creativity and the complexities of life Ananse, the spider, is a well-known character in African folktales.

The Kiah Museum Day of Remembrance
About the Kiah's

Dr. Calvin L. Kiah
(1910-1994)

Calvin Lycurgus Kiah was a native of Princess Ann, MD. He graduated from Morgan State College in 1932 and received his master's degree and doctorate in education from Columbia University in New York. He served as Dean of Savannah State College and was Vice President for Academic Affairs for Georgia State University in Atlanta, He was a World War II Veteran and a member of Asbury United Methodist Church. Dr. Kiah was 83 years old at the time of his death.

Source: Savannah Morning News, Monday, August 8, 1994

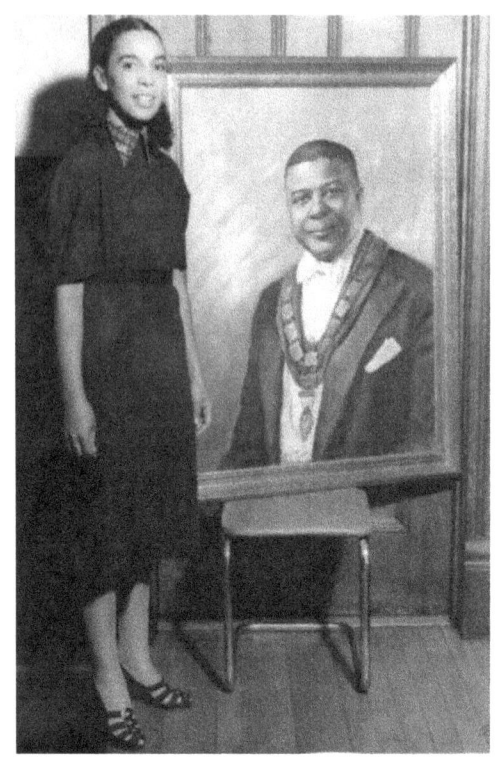

Virginia Jackson Kiah
(1911-2001)

Notable artist and former Savannah College of Art and Design Board of Trustees member, Virginia Jackson Kiah was born June 3, 1911, and discovered a passion for art at an very early age. Growing up in Baltimore, MD., she attended Frederick Douglass High School. After overcoming racial obstacles, Kiah earned a B.A. from the Philadelphia Museum School of Art in 1931 and an MA from Columbia University in 1950. She studied at the University of Pennsylvania and the Art Students League of New York where her teachers included portraitists Robert Brackman and Vincent Drummond. In 1950, Kiah came to Savannah with her husband, Calvin Lycurgus Kiah, and taught at Beach High School until 1963.

While teaching high school in Maryland and Savannah, Kiah continued to develop her skills as an artist and dedicated herself to sharing them with others. She remained committed to Civil Rights and showed remarkable leadership as the promotional and membership secretary of the Baltimore branch of the NAACP during the 1930s, following the lead of her mother Lillie May Carroll Jackson, known as the "Mother of the Civil Rights Movement" and the former president of the Baltimore branch of the NAACP.

Source: CFSAADMC, We're Cookin it up Again: Cookbook and Workbook; 2012, Johnson-Simon, Baker & Miles.

About the Kiah Museum
Kiah Museum - A Museum for the Masses

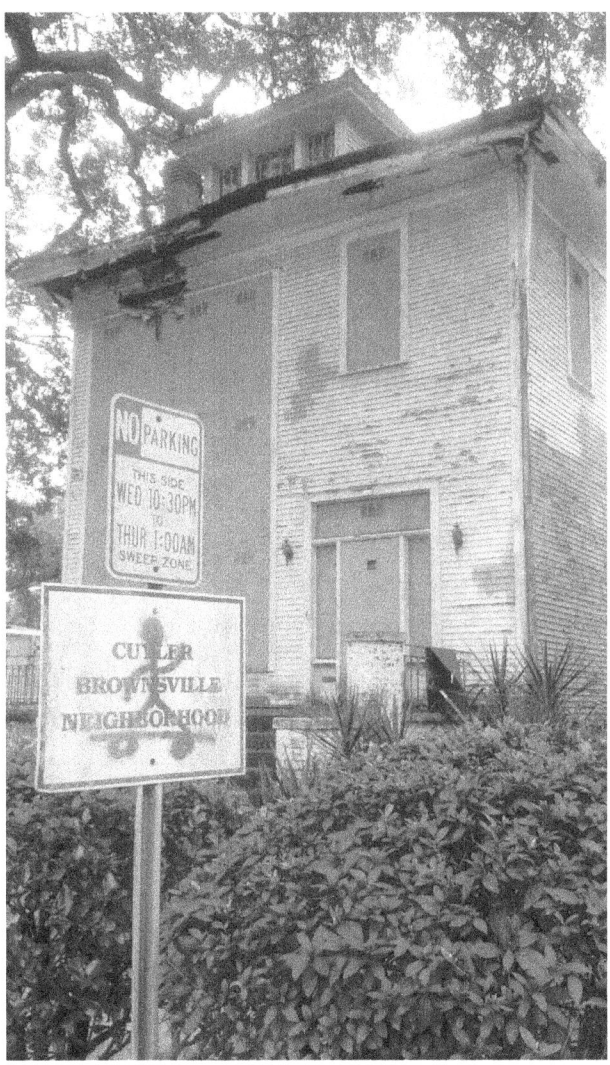

The Kiah's and their vision for the museum is best described in this excerpt from the 1974 Archives Notes Vol 2 Issue 2 Article 8 by David B. Gracy II of Georgia State University.

"Mrs. Calvin L. Kiah takes a back seat to no one in her pursuit of useful knowledge. She is the founder and director of the fifteen-year-old Kiah Museum of Savannah—a Museum for the Masses--that displays exhibits ranging from rare objects of furniture and silver from the eighteenth and nineteenth centuries, to aeons-old fossils, to sculpture and paintings. Mrs. Kiah describes the Museum as a "mini, mini Smithsonian Institute," for she collects in every field she can. Among the holdings of particular interest to SGA members are printed items of Afro-Americana from the Harmon Foundation and an extensive correspondence concerning the care of museum materials and the filing and preserving of paintings. In the Marie Dressler Collection, the Kiah Museum holds a number of photographs of the actress and her colleagues, and other personal affects.

Mrs. Kiah has been particularly concerned about the preservation of paper and canvass, since her museum holds both paper records and paintings. Some of the information she has obtained, she graciously shared with the last issue of GEORGIA ARCHIVE. Mrs. Kiah invites correspondence and visits to the Museum (admission free), 505 West 36th Street, Savannah 31401."

Georgia Archive, Vol. 2 [1974], Iss. 2, Art. 8
http://digitalcommons.kennesaw.edu/georgia_archive/vol2/iss2/8

About Cuyler Brownville

One of the oldest African-American neighborhoods in Savannah, Cuyler-Brownsville is significant for its early grid pattern of streets designed shortly after the Civil War. The district also holds excellent examples of single and multiple family residences, attached row houses detached commercial buildings and community landmark buildings.

Cuyler Brownsville, in fact comprises two old districts—the Cuyler School District to its north and the Brownsville district to its south—was settled from the last decades of the nineteenth century. The Cuyler-Brownsville neighborhoods were inhabited by some of Savannah's wealthiest Black families until well into the twentieth century.

This part of the city, along with neighboring areas such as the blocks around Cann Park, were actively promoted as ideal residence locations for African Americans' aspiring to the suburban lifestyle that became increasingly popular from the late nineteenth century onward.

By the midcentury, however, as restrictions previously imposed by whites upon where Savannah's Black residents could live began to be lifted, many of Cuyler Brownsville's wealthier inhabitants began to move out of the old district into previously segregated parts of the city.

Unfortunately, this movement of many old residents precipitated the decline of the area, hit too by the economic problems that have beset Savannah during much of the twentieth century. Crime and drug problems rose and many began to perceive this historic neighborhood as unsafe.

Though some parts of the neighborhood still struggle with crime and other special problems, many people, some of whom have lived in Cuyler Brownsville for decades, are actively working towards the improvement of their neighborhood.

Source: http://www.historicsavannahparks.com/savannah-history/cuyler-brownsville-historic-district.html

EOA Supports the Kiah Museum Day of Remembrance
Cuyler Street School, 618 Anderson Street, Savannah, GA

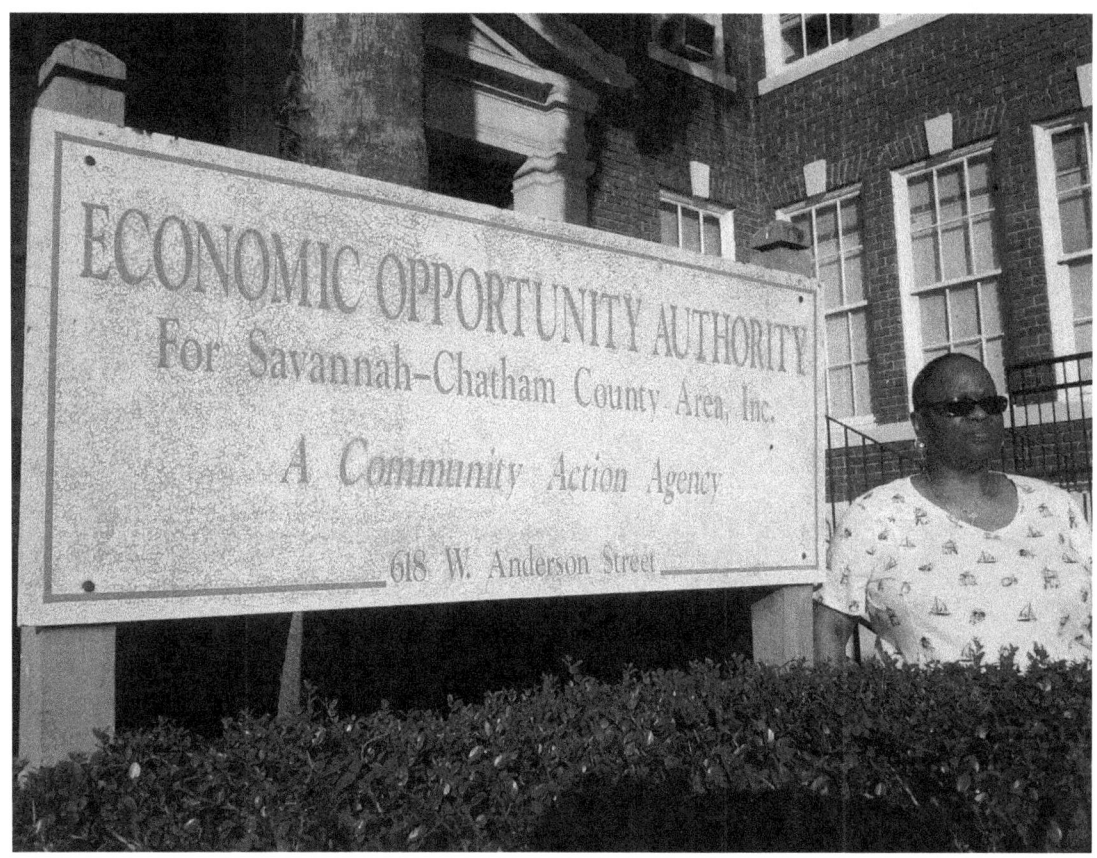

About the EOA

The Economic Opportunity Authority for Savannah-Chatham County, Inc. (EOA) is a private non-profit agency created by joint resolution of the City of Savannah, Chatham County Commission and the Board of Public Education in 1964. The Authority was incorporated on January 6, 1965. The Community Action Program (CAP) provides a variety of programs and services to assist low to moderate income residents of Savannah and Chatham County.

The agency received funding from the U.S. Department of Health and Human Services, the State department of Human Services, the U.S. Department of Agriculture, the City of Savannah, the Chatham County Commission, the Georgia Housing Finance Authority, the Corporation for National and Community Services, the United Way, private foundations, and charitable organizations.

EOA programs include: Head Start/Early Head Start, Weatherization, Foster Grandparent, Retired and Senior Volunteer program, Energy Assistance, Homeless Services, Housing Services, Crisis Intervention, Employment, Job Development and Training Computer Learning lab, and many more.

Source: http://www.eoasga.org/about-us/

Mrs. Patricia Howard

Mrs. Howard welcomed the opportunity to share her quilts and those of her Hudson Hill Golden Age Girls with the folks at the Cuyler Street School on the special day set aside for Savannah to remember Mrs. Virginia Kiah and the Kiah Museum. Mrs. Kiah taught art at the Cuyler Street School now home of the EOA.

"Mrs. Kiah was my teacher at Sophronia Tompkins High School in the 10th grade arts class. One thing I remember about Mrs. Kiah is that she was very vocal and strong when it came to her passion for us to learn about art. She felt that all students need to learn something about art. She was a smart woman and a caring woman"

"I will always remember one class that she was teaching us how to mold clay. She was demonstrating the technique for us and the clay was molding perfectly in her hands. Then we were to do it. Well it must have been something about our body heat because none of us was able to get that clay to mold in our hands like Mrs. Kiah did. The more we tried it just melted into a big mess. We thought it was so funny and we started to laugh at our meager efforts to mold the clay and she started to laugh about it too. We learned a lot about art from her that most of us still remember today."

Tina Hicks shared her Kiah Kids quilts at EOA's Cuyler Street School

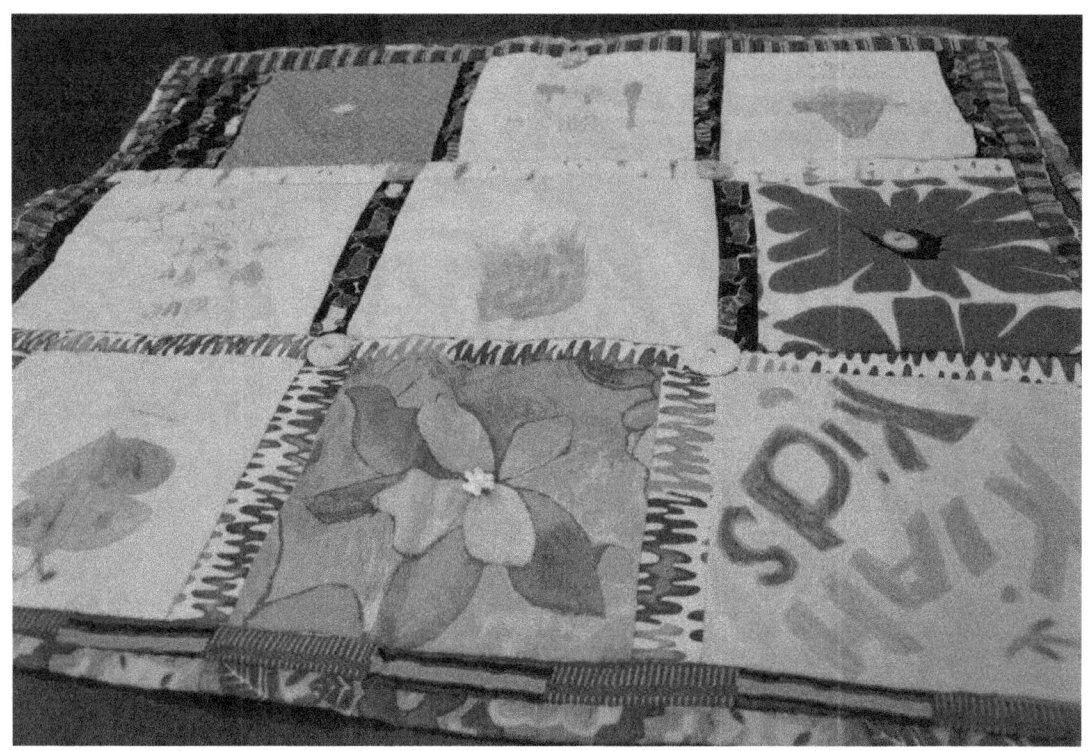

Kiah Kids Quilt by Tina Hicks

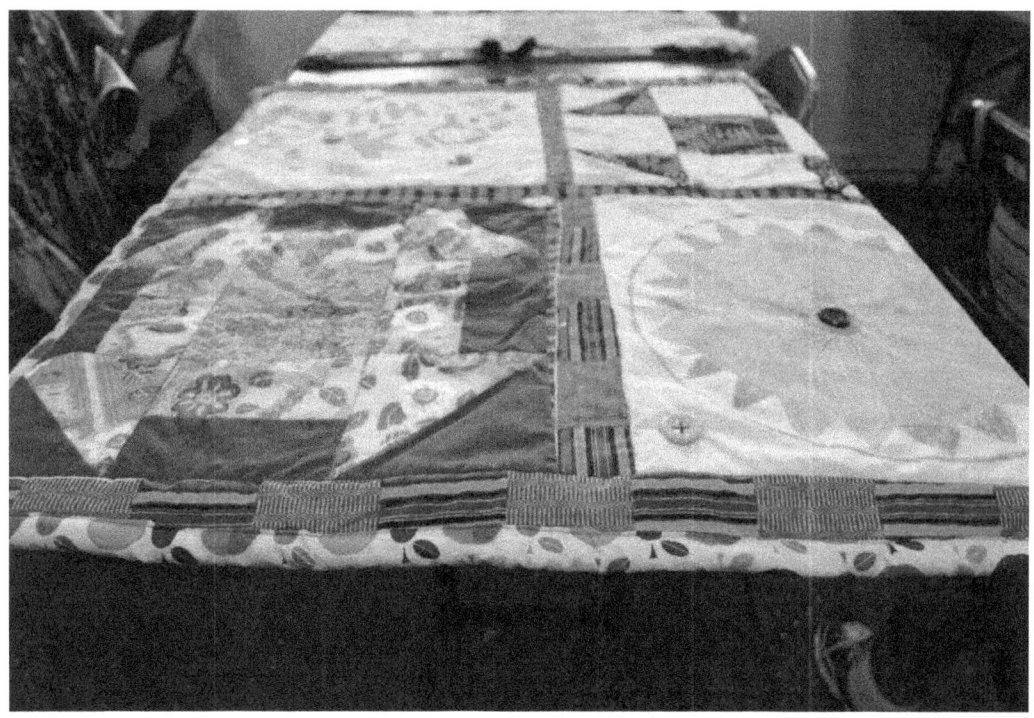

Kiah Kids Quilt II with Underground Railroad Quilt Symbols by Tina Hicks

Tina Hicks and Patricia Howard participated in the creation of the Beloved Community Quilt

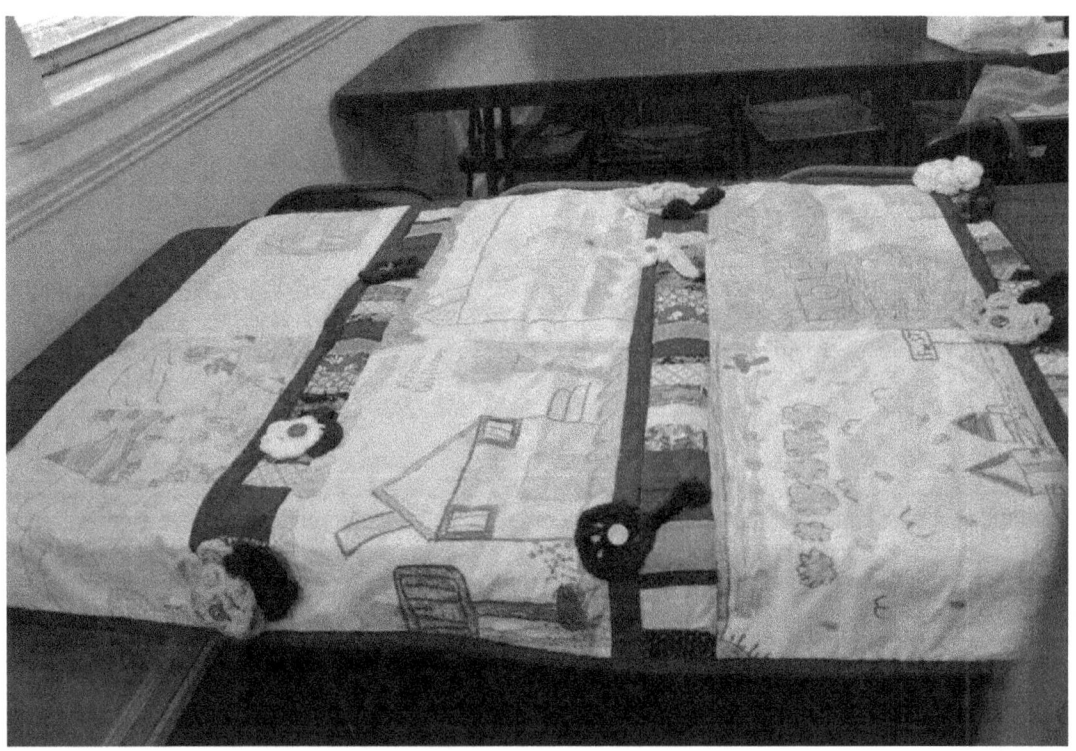

Beloved Community Quilt

About the Cuyler Street School

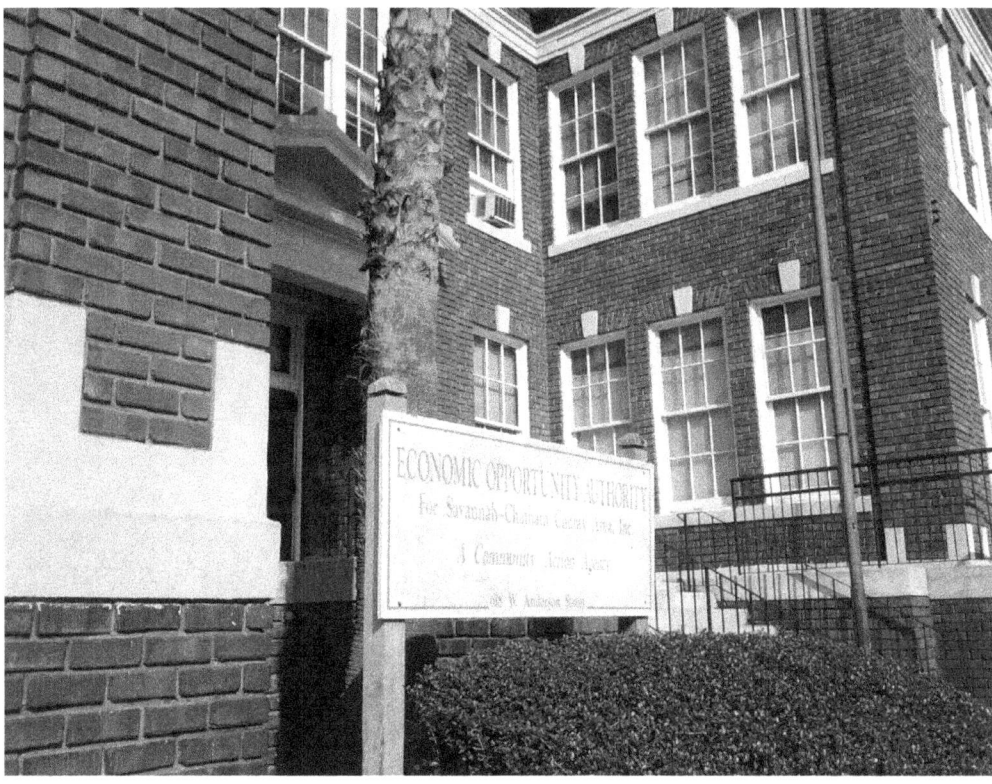

Soon after the end of the Civil War, Freedmen's Associations and northern religious societies established several schools in Savannah to educate African American children. Under pressure for African American citizens, the Chatham County Board of Education first opened two schools for African American children in 1872; however, those were set up in existing buildings. The Board did not construct a school building specifically for African American children until 1914. This was the Cuyler Street School located at the corner of Cuyler and Anderson streets. Cuyler Street School served elementary, junior high and senior high school students at various periods through its 62 years of service as a public school. It was the only African American high school in Savannah from the late 1920s to 1950. Cuyler Street School was closed in 1975 and today functions as the Economic Opportunity Authority.

John Finney and Kiah Stories

Mr. John Finney is the Director at the Economic Opportunity Authority (EOA) but he also attended the Cuyler Street School when he was growing up in Savannah. While attending the school he also remembers many stories about Mrs. Virginia Kiah and the Kiah Museum because he was one of her students. When he heard that Mrs. Kiah's nephew was coming to Savannah and wanted to see the Kiah House and Museum, Finney agreed to give a tour of the school too.

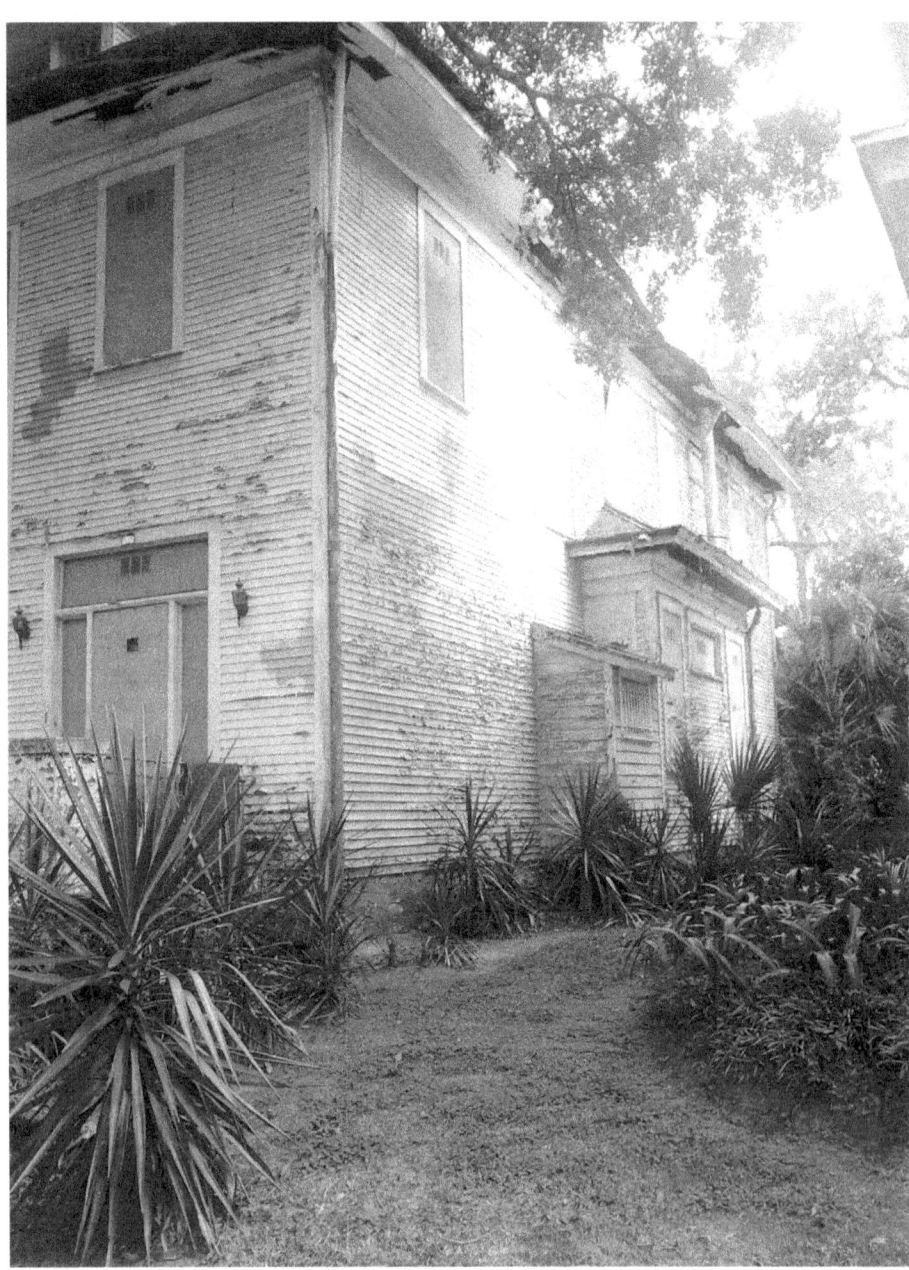

Home and Museum of Dr. Calvin L. Kiah and Mrs. Virginia Jackson Kiah
505 W. 36th Street, Savannah, GA

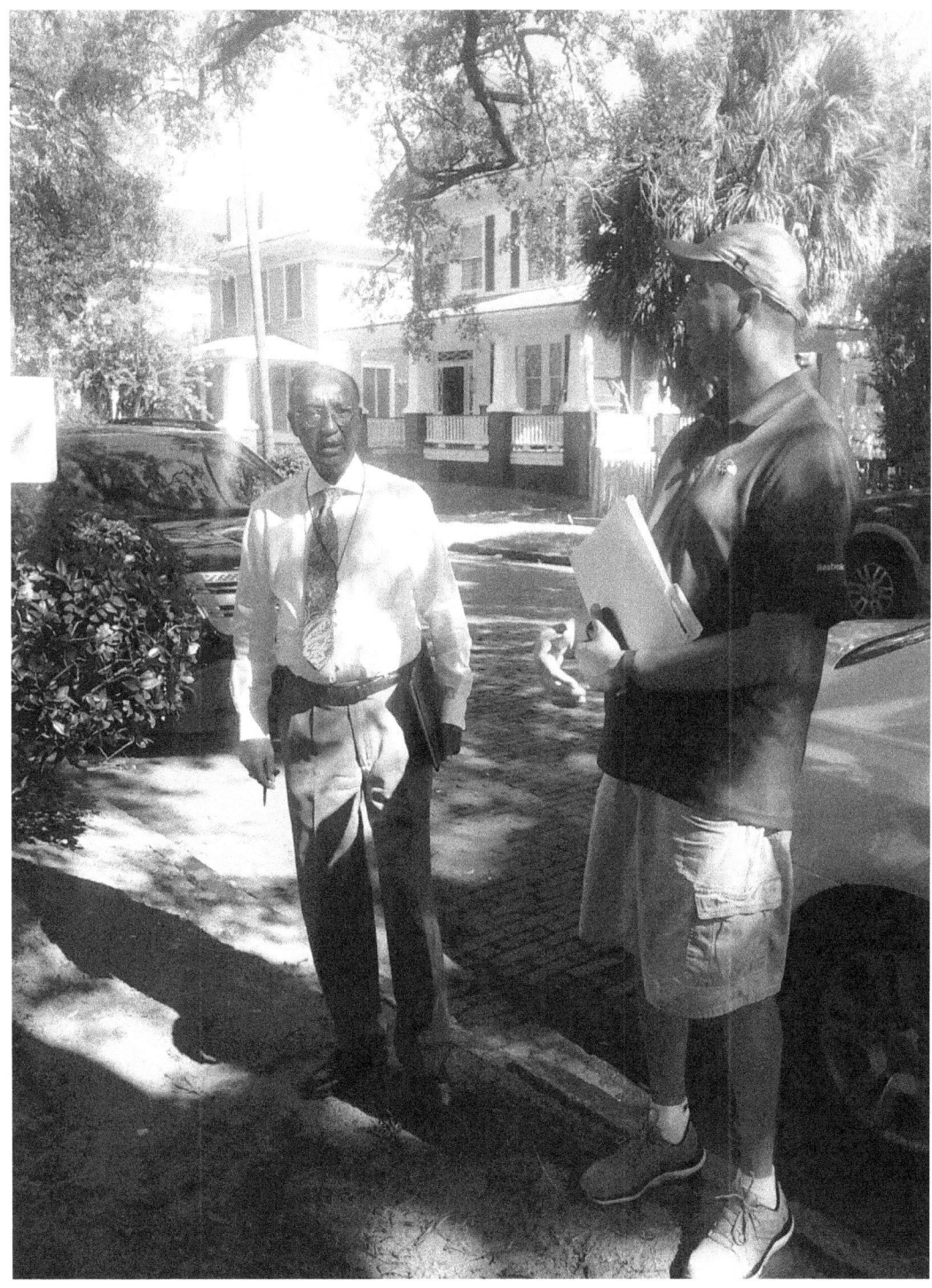

John Finney (left) meets Keiffer Mitchell Jr. nephew of Mrs. Kiah

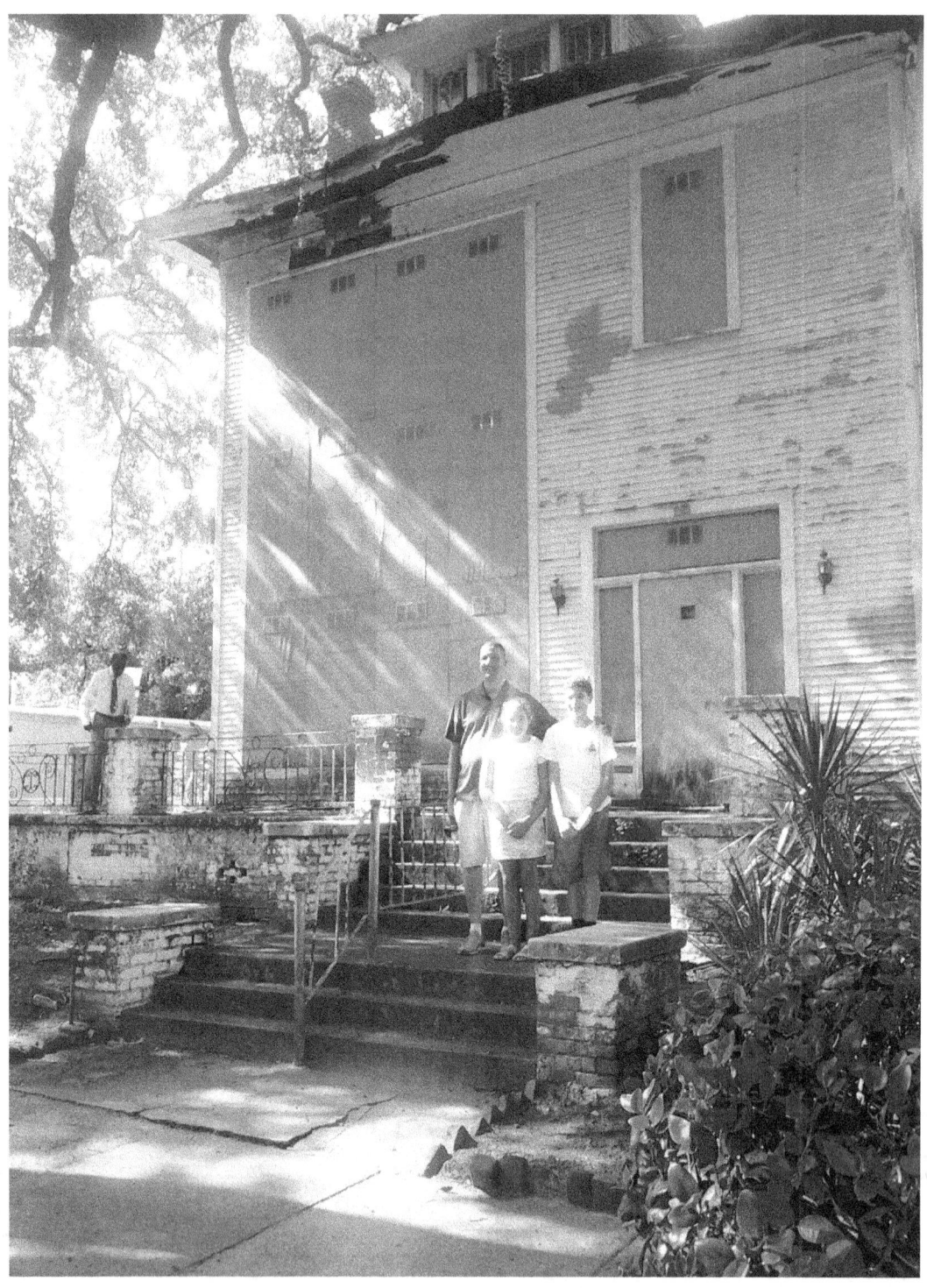

Keiffer Mitchell with son and daughter on the steps of the Kiah House.

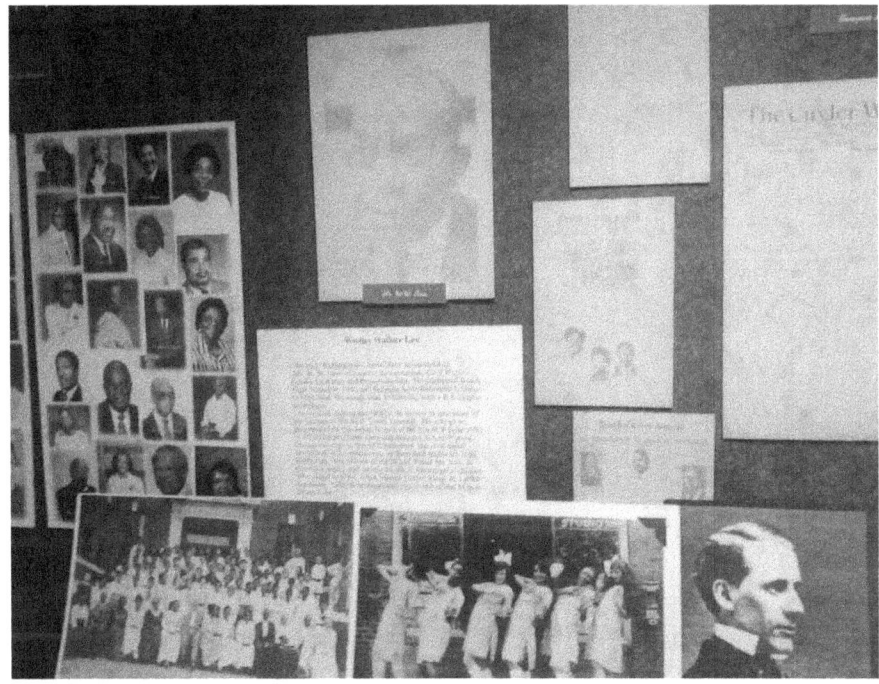

John Finney has been the archivist of the Cuyler Street School and put together a pictorial history on the first floor or the building. The large photo in the center is W. W. Law.

Finney tells the family about the challenges to save the building and the work toward historic designation

Mrs. Nicole Mitchell listens as Finney shares stories of his experience as a student in the art class while showing them the room that Mrs. Kiah taught students at the Cuyler Street School.

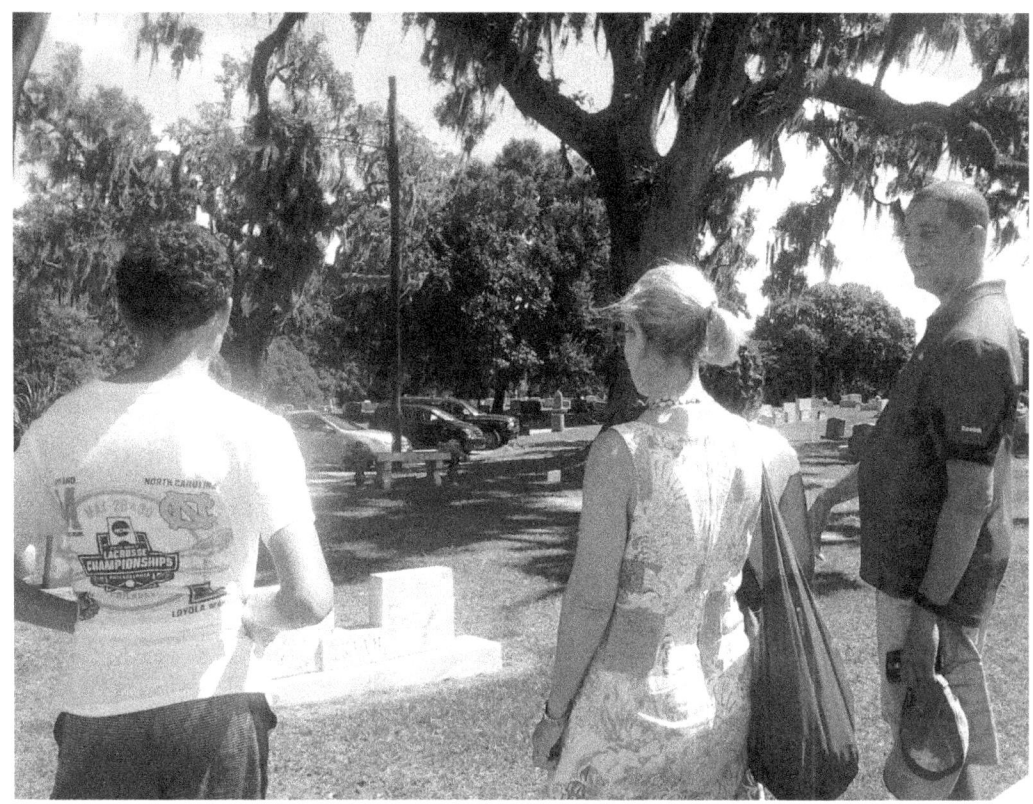

The family concluded their Savannah visit at the Hillcrest Abby Cemetery where the Kiah's are buried. He shares the story with his son that his uncle always told him that this was the most important piece of real estate that a man could own.

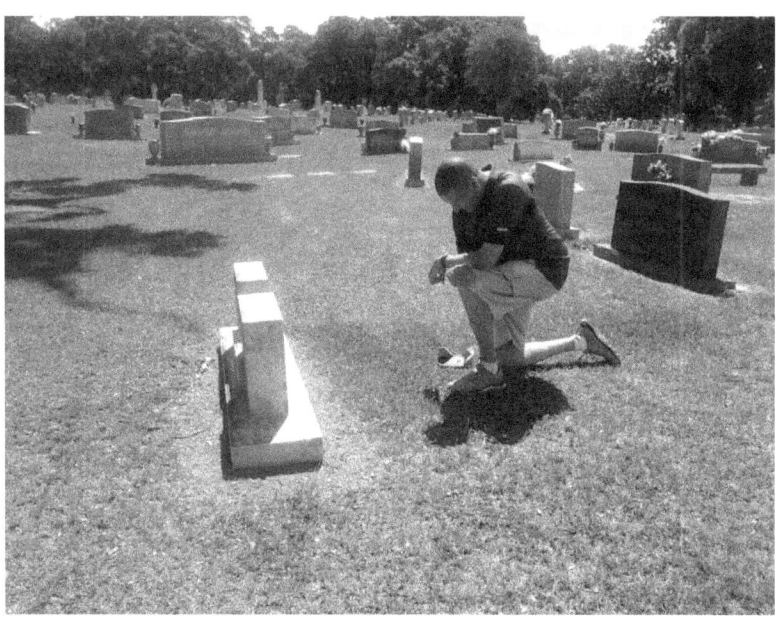

A moment needed to say good-bye

Hillcrest Abby Wreath Ceremony
Gravesite Ceremony Remembering the Kiah Museum Founders

Hillcrest Abby East Cemetery
Wheaton St, Savannah, GA

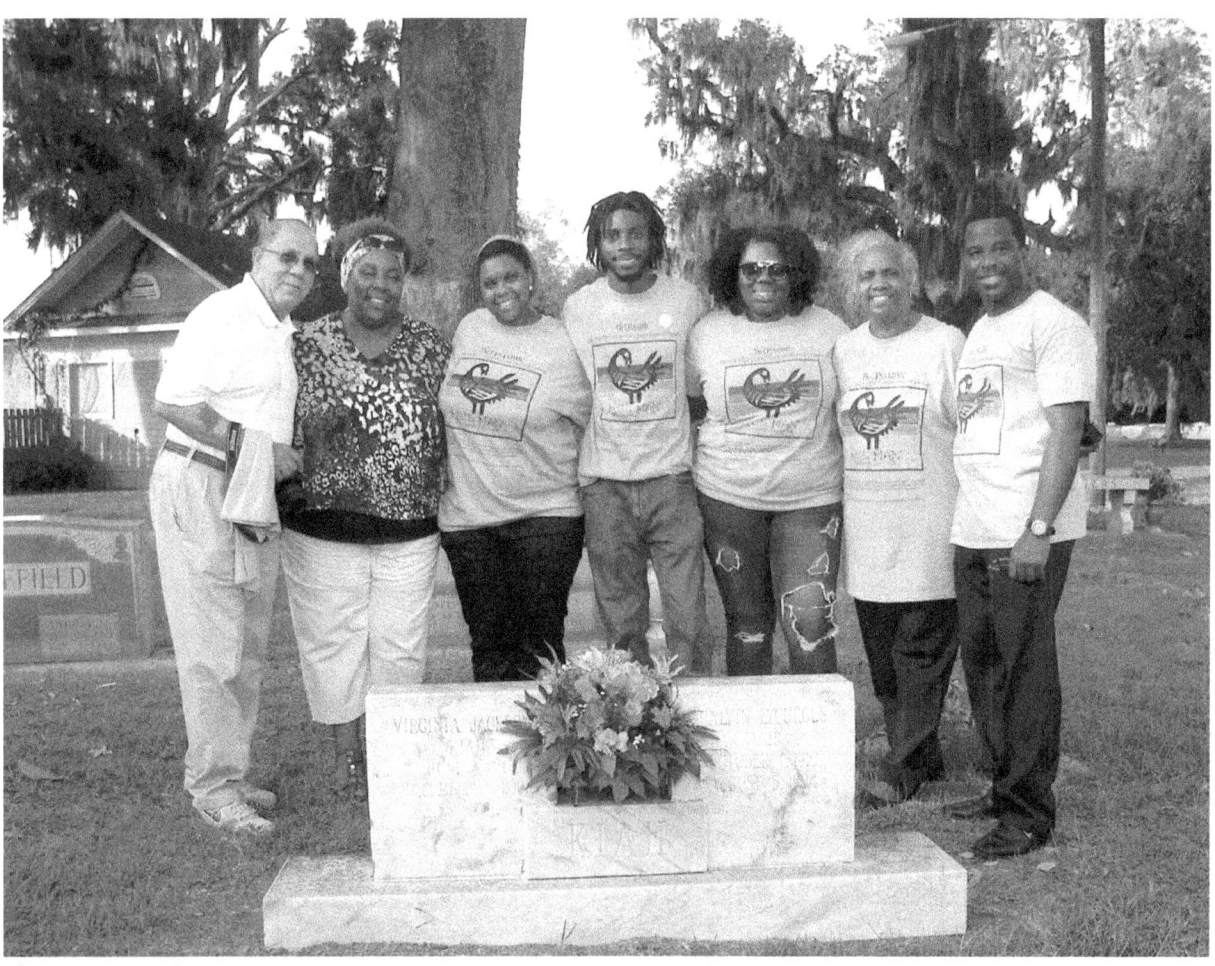

Hue-Man Team gathers for wreath lying with Dr. Richard Dozier and Tina Hicks

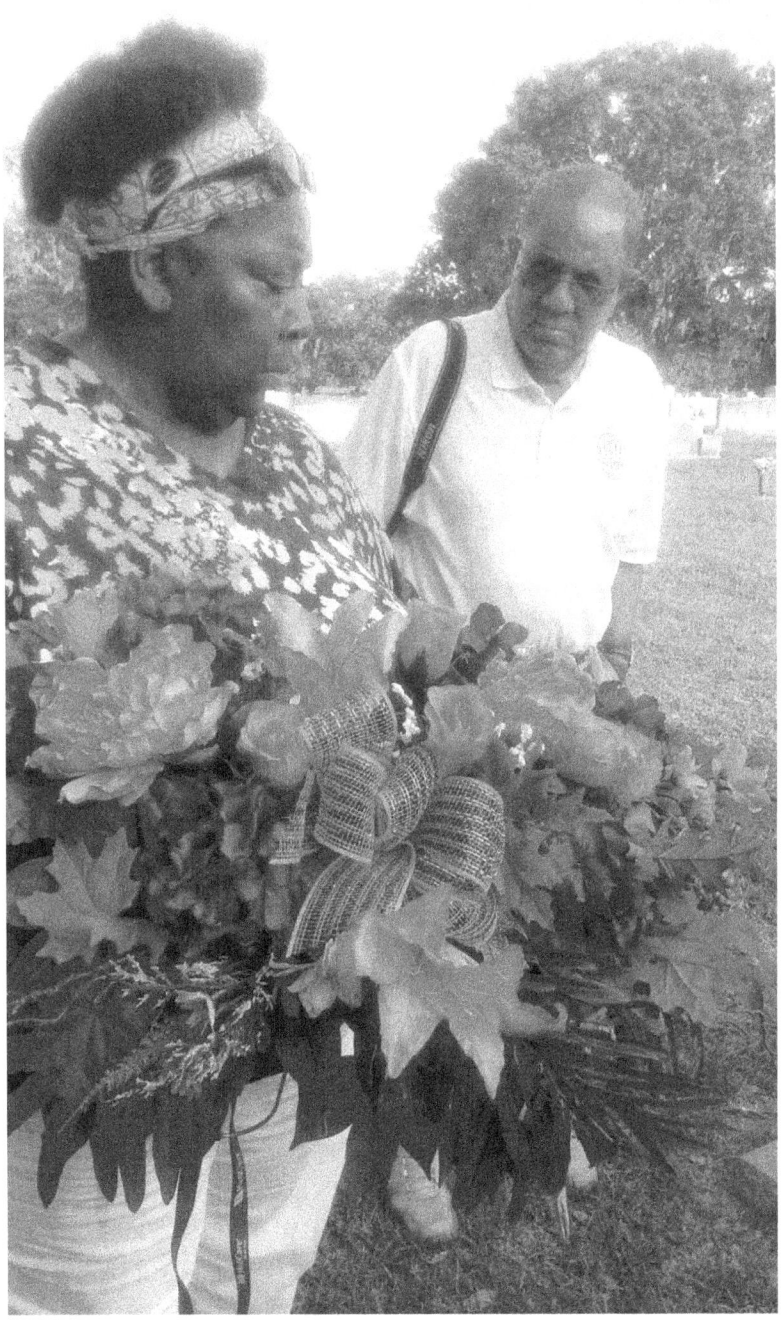

Tina Hicks and Dr. Richard Dozier

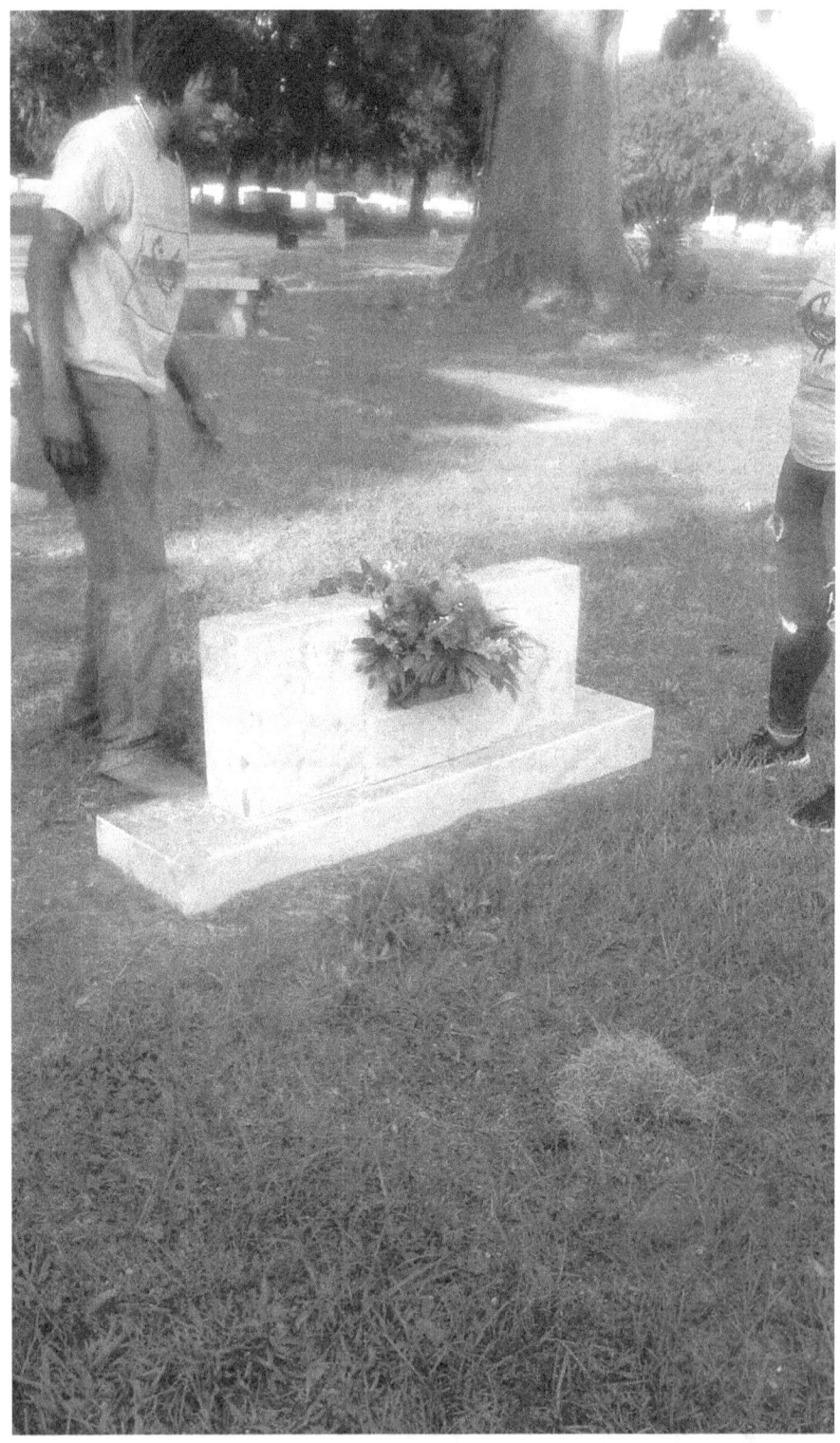

Damion takes a few moments to make sure that the wreath is placed securely

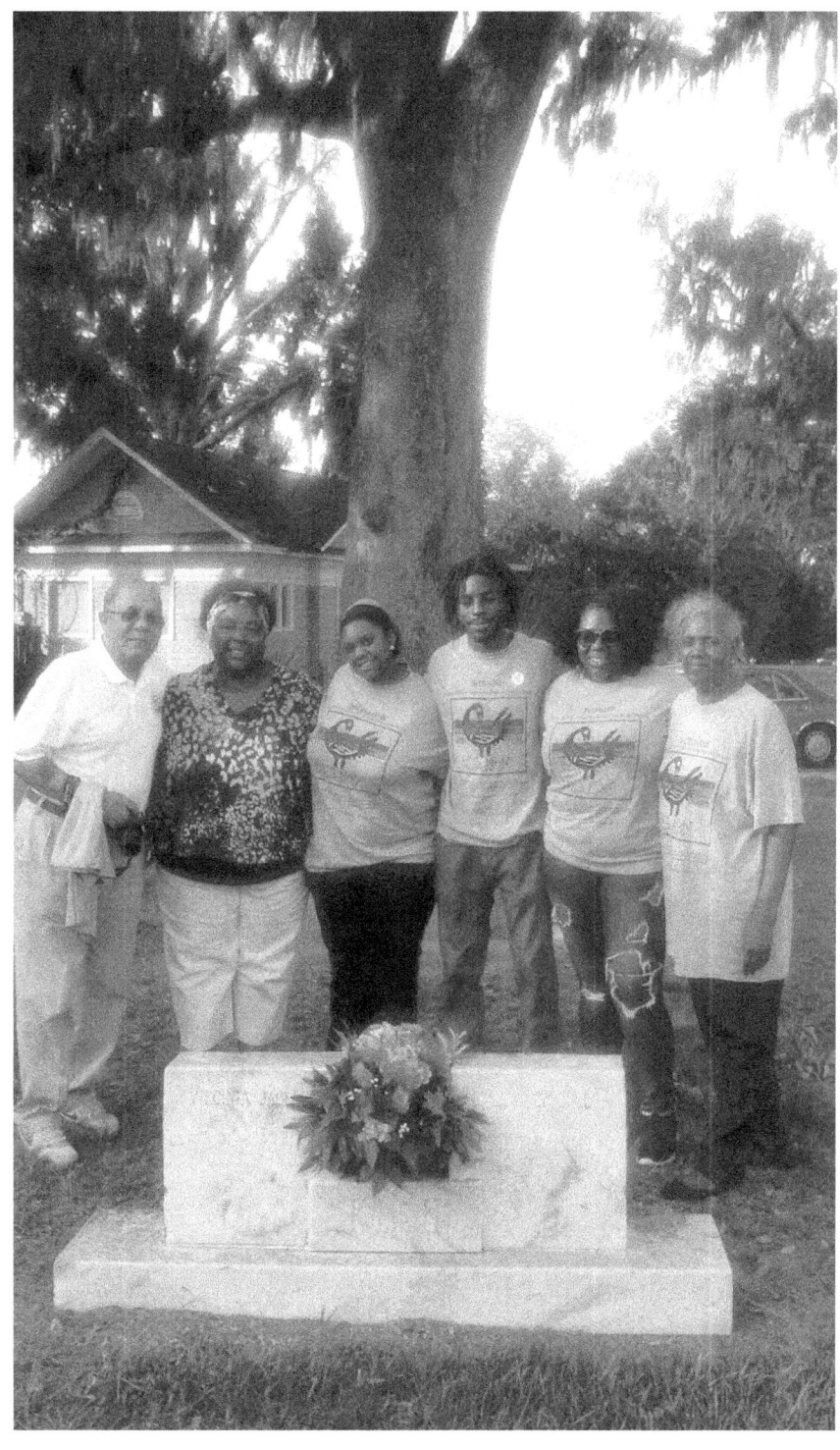

Dr. Richard Dozier, Tina Hicks, Mia Woodson, Damion Wynn, Tori Becks, and Dr. Johnson-Simon

Meet Some Folks Who Made It Happen

CFSAADMC Board of Directors

A Message from the CFSAADMC Secretary and CFO

CFSAADMC's volunteer program consists of a very active group of men, women, young adults, teens and young children working in every area of African Diaspora museum anthropology. Our volunteers come from all walks of life ... retirees, husband and wife teams, students, and people currently employed with full-time or part-time jobs.

I want to thank the Savannah participants for joining them in the research and planning efforts for our special event to celebrate the participants in the 1983 *Black in Museums Directory*. I would love to hear that all of you have decided to continue to play a part in ongoing projects and interpretation beyond the culminating event on September 9, 2016.

My job on the Board is the Secretary and Chief Financial Officer (CFO). I have been a part of this organization since it began in 2009 and I have served on the Board in my current position from the time of its move to Georgia. You might recognize my name among the "*We're Cookin It Up Again*" Cookbook/Workbook contributors. I was one of those who enjoyed the food and fellowship of this small band of Black museum supporters who were also learning about anthropology and the contributions of Black people to the field. Thank you for your support of our research center and Dr. D and ultimately being added to the team of researchers of the participants in the "Blacks in Museums" Family Reunion Project. Along this incredible journey you have taken I'm sure you learned about interesting people; the amazing collections of artifacts, manuscripts, and photographs; and learned more about the history of the Black museum experience through the vehicle of museum anthropology.

Join the fun! It is my privilege to welcome you to the CFSAADMC.

Shari Goins
CFSAADMC Secretary and CFO
P.O. Box 5261
Savannah, GA 31414

A Message from the CFSAADMC Founder and CEO

Dr. Deborah Johnson-Simon

As the Founder and CEO for the CFSAADMC I am delighted that my students in the Introduction to Anthropology class this semester will not only be learning about the major subfields of anthropology but will also be learning about the often neglected area of African Diaspora museum anthropology. The fact that students are working on the celebration of the participants in the 1983 Blacks in Museums Directory published by the African American Museums Association (AAMA) is very exciting. By doing this research they in essence joins a growing body of museum anthropologists who research Black museums, the professionals who work in them and the communities of African Descended Peoples who are served by them.

First, I want to thank all the Savannah State University students who have taken my Introduction to Anthropology class and special thanks to those who have become youth advisors to the CFSAADMC and its active departments. I am sure they will agree that this is not what you expected when they registered for this class. I hope they will count it as one very special experience in understanding anthropology and how it contributes to our views of the human experience with a focus on preserving African Diaspora culture and traditions.

There is no greater joy than seeing students finding ways to connect anthropology to their lives. That joy is increased when students know that the skills and critical thinking tools they receive about the world and the human experience gained through the applied ethnography concepts will help them with everything that they do. Anthropology is after all holistic.

I am sincerely grateful to the Savannah community beyond the campus who also were curious about this unusual Black woman telling them about museum anthropology like the Hudson Hill Golden Age Center. Your interest in, and commitment to, CFSAADMC is invaluable. You play a crucial role in making the "1983 Blacks in Museums Family Reunion Exhibition and Documentary's" and Kiah Museum Remembrance a rich historical resource come alive through your story quilts. I look forward to your research and quilt stories that will answer the question "Whatever Happened To…"? When people learn about AAMA and the story of the 1983 Blacks in Museums Directory it will be because museum anthropologists like you have contributed to this population never becoming extinct.
With best wishes,

Dr. D

A Message from the CFSAADMC Director for Programs

I am Dashana Lane and I am a student. I have not formally taken a class with Dr. D but I have been a part of her team of researchers for more than three years. First as a student at Florida State University in Tallahassee and now as a graduate student at Howard University in Washington, DC, I continue to incorporate time to learn about and work on projects for CFSAADMC. Dr. D learned of my love of Black history and Black museums from one of her grandsons who was a youth advisor for CFSAADMC. She recruited me as one of her research assistants and upon my graduation from FSU asked if I would serve on the Board of Directors of CFSAADMC as the first youth director with full Board privileges and responsibilities. I serve in the position of Director for Programs. In this capacity I oversee the research efforts and programs for each of the CFSAADMC Departments. I simply fell in love with this work. After this short time with the CFSAADMC I can confidently say that I am an African Diaspora museum anthropologist and I know that after you have worked on this program you will too. The AAMA 1983 Blacks in Museums Directory Day of Recognition and Kiah Museum Day of Remembrance is one program that we will all be proud of because of all of you.

Welcome to the CFSAADMC and **Thank You** for embarking on this amazing journey.

A Message from the CFSAADMC Business Manager

Welcome to the CFSAADMC.

I am Master Chief Paul E. King III and I serve on the Board of Directors of the CFSAADMC. I am also the Business Manager for this organization. I've been a part of this organization from the time of its beginning in Woodbridge, Virginia. Actually, the organization started in my home. My wife and I provided the first office space. They moved to Georgia when I was transferred to Japan but we never stopped caring about and participating in the work of the Center. I was the President of the Board and my wife was the organizations' first Secretary and Treasurer. Because of this experience I can truly say that you will have a different way of looking at the human experience of African Americans because of learning about anthropology and you will also see Black museums differently now that you're learning about museum anthropologists. I have recently been placed in the position of business manage and my job will be to guide the organization to a solid place as a non-profit that can strategically realize its mission and vision. I look forward to meeting all of you at the culmination program of your research on the 1983 Blacks in Museums Directory Project and the Exhibition and Documentary on September 9th.

Darlene Wilson

Darlene has been with the King-Tisdell Cottage Foundation for over 12 years as an Operations Manager/ Foundation's Interim Center Director, Chief Resident Archivist and as well other positions within the Foundation during her tenure. She was previously employed with the Savannah Chatham County Public School System as an educator for over nine years and over two years as a data clerk and researcher for the Chatham County District Attorney's Child Support Enforcement Office. Darlene is a native of Savannah, Georgia and a product of its public school system. She matriculated at Armstrong-Atlantic State University and earned a Master's Degree in Adult Education with three (3) concentrations in the following areas: Education Technology, Human Resources, and Literacy. Additionally, she earned a Bachelor of Arts degree in Liberal Studies with two (2) concentrations in the following areas: Teacher Education and Library Media and Science from Armstrong-Atlantic State University. She also attended Savannah Technical College and earned an Associate of Applied Technology Degree in Computer Programming.

Darlene is very active in the community. She holds memberships in the following associations and organizations: Friends of the Kiah Museum Committee, CFSAADMC , Telfair Museum of Art, Savannah Black Heritage Festival Committee Member, AME Church Savannah North District Christian Education Department (Treasurer), AME Church Savannah North District Area WMS (1st Vice President), Project DeRenne-Project Advisory Committee, Sisterhood Association of Tatemville, King-Tisdell Cottage Foundation, and the Tatemville Community Improvement Association, Inc.

Her past affiliations have been with the following organizations: Live Oak Public Library Board of Trustees, Building African-American Museum Capacity in Savannah and Southeast Georgia Collaborative Group Committee Member, Young Women's Initiative(YWI) Missionary Society, PAGE (Professional Association of Georgia Educators), SGAE (Student Georgia Association of Educators), Association of African American Museums, American Association for State and Local History, Coastal Museums Association, American Business Women's Association-Victory Chapter #1666, Georgia Association of Museums and Galleries, Society of Archivists, Georgia Historical Society and the Ralph Mark Gilbert Civic Rights Museum.

CFSAADMC- Friends of the Kiah Museum and Archivist and Collections Manager

Sauda Mitchell

Sauda Mitchell is an artist, archivist and educator from Winston Salem NC. As an artist Sauda predominantly works in the medium of relief printing to visually communicate her own personal narrative, the African American cultural experience and the archival content she arranges describes and makes available by processing archival collections of enduring value. Sauda seeks to explore and continue to further disseminate the information within the African Diaspora and African American collective memory.

Ms. Mitchell has held positions such as the W.W. Law Project Archivist for the City of Savannah Research Library and Municipal Archive, Reference Assistant at the Georgia Historical Society and Library Assistant II within the Zach S. Henderson Library Collections and Resource Services Department at Georgia Southern University. Mitchell currently serves as the CFSAADMC Archival Collections Manager.

Sauda holds an Associate's Degree in Elementary Education from The University of Phoenix, a Bachelor's Degree in Graphic Design with a minor in Art History from the Savannah College of Art and Design, and a Master of Science Degree in Library and Information Science from Drexel University with a concentration in Archival Studies. Mitchell is a member of the Society of the American Archivist (SAA), the Association of African American Museums (AAAM), the Georgia Library Association (GLA), and the Black Caucus of the American Library Association (BCALA).

Dr. Christina L. Davis

Born in Hillsboro, Alabama, Christina L. Davis credits her family for her decision to teach at the collegiate level. She ranks her roles as a daughter, sister, auntie, niece, and cousin as most important in shaping her character and personality. Christina's pride in her family is eclipsed only by her passion for academic engagement and teaching. A "Rattler" at heart, she received a Bachelor of Science in Psychology and a Master of Applied Social Science from Florida Agricultural and Mechanical University in 2003 and 2004, respectively. In 2016, she earned a Doctorate of Philosophy in History and a Women's Studies Certificate at the University of Georgia.

Currently an Assistant Professor in the Africana Studies program at Savannah State University, where she has taught since the fall of 2012, Christina celebrates opportunities to interact with students. Like the women she studies, Christina strives to connect with students within and outside of the classroom in efforts to cultivate growth in students' academic and personal development.

Kai Walker

Hailing from the Midwest, Kai Choque Walker was born and raised in Detroit, Michigan. In 1998, she received a Bachelor of Science Degree in Telecommunication and Film from Eastern Michigan University (EMU), and in 2002 she earned a MFA in Film and Video from the Savannah College of Art and Design (SCAD). Her credentials include the film *Lonnie's Cousin* (produced and directed by Kai Choque, 2001) for which she received an award for Creative Independent Achievement, and the short film *The Duet* (co-produced by Kai Choque and directed by Anwar Jaramogi, 1999). The film was recognized as the Best of Show. Her other works include participating on the live sound stage recording of the Grammy Award Winning CD, Dianne Reeves LIVE (Blue Note Records, 2000).

Shortly after completing her course of study in film and cinema, Walker began her career as an assistant professor of audio and video production in the Department of Journalism and Mass Communications (JMC) at Savannah State University (SSU), where she is a tenured member of the faculty. In 2008, she co-produced the documentary, and coinciding website, *From West Broad Street to MLK, Jr. Blvd* for the National Black Programming Consortium, and participated in subsequent lectures and presentations. Kai most recently added to her credentials a video documenting the 3rd Annual Tybee MLK Human Rights Celebration, held on Tybee Island, GA.

The beginning of 2016 placed pivotal benchmarks on Kai's timeline. While participating with the Quality Enhancement Program/The Write Attitude at SSU, Kai had the honor of conducting an interview with former White House Press Secretary Dana Perino, and joining the co-founder of the Black Panther Party for Self Defense, Bobby Seale, for a Q&A dinner.

Kai is a member of the Society of Cinema and Media Studies (SCMS), and the University Film and Video Association (UFVA). She considers herself truly fortunate to serve as a university professor and to pursue her passion as a filmmaker.

Winifred S. Mincey

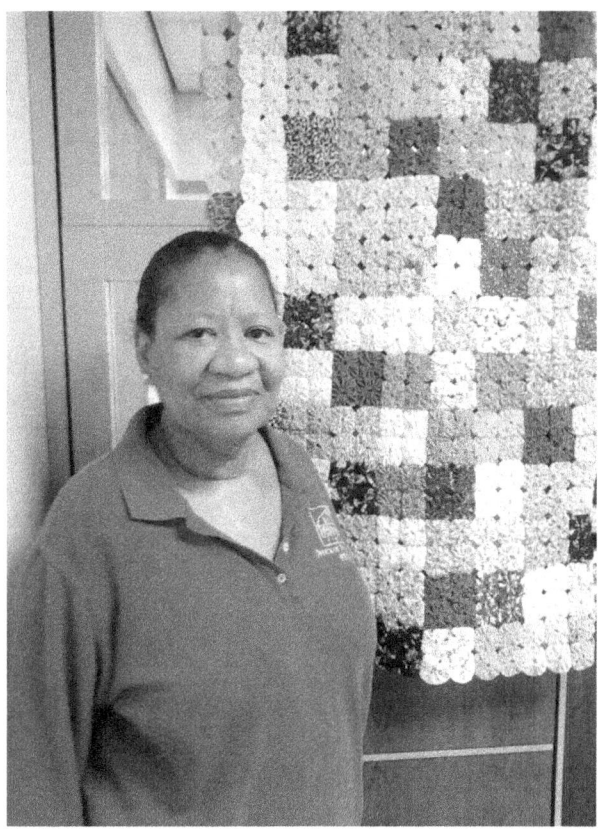

Winfred Mincey has been a part of Savannah State University for more than 40 years. Currently she works as a Financial Aid Counselor and Manager of the Federal Work Study Program. Winifred first came to SSU as a freshman in the fall of 1969. As a student, she worked as a student assistant in the Comptroller's Office and ESSA (evening services program) while earning a BS Degree in Business Administration from SSU. After graduation she became employed full-time at the University and held many positions including working in the Vice President's office for Business and Finance.
She is active in a variety of civic and cultural organizations include National Council of Negro Women, Savannah Section, and Top Ladies of Distinction, Inc. (TLOD) Clubs. An important aspect of her life is family, her husband, three daughters and a son. Outside of professional interests, she enjoys wedding planning, decorating and creating floral arrangements for varies special occasions. Winifred enjoys living in Savannah Georgia with her husband and son.

Quilting the Blacks in Museums Family Reunion Exhibition
And
Kiah Museum Day of Remembrance
Friday, September 9, 2016
Presented to you by
Hudson Hill Golden Age Quilters

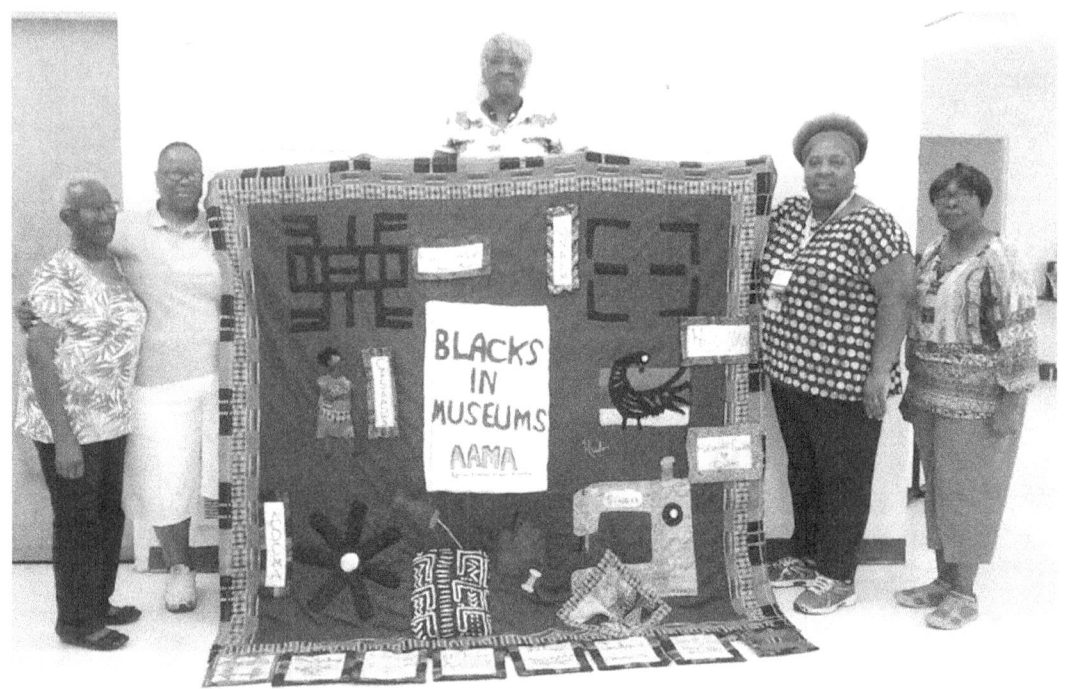

L-R: Sadie Williams, Patricia Howard, Jean Lemon, Tina Hicks, and Patricia Beaton
Savannah State University Introduction to Anthropology Students
And
CFSAADMC-Hue Man Research Institute

Shiraya Robb & Damion Wynn

Go Back and Fetch It

www.ingramcontent.com/pod-product-compliance
Lightning Source LLC
Chambersburg PA
CBHW080008210526
45170CB00015B/1920